AFRICAN SCULPTURE

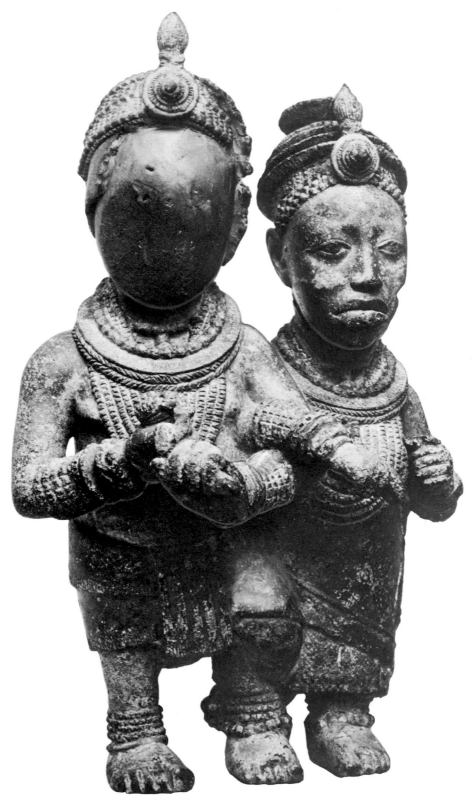

PAIR OF ROYAL FIGURES. Bronze, h. 12 in. *Ife, Nigeria*

African Sculpture

Selected, with an Introduction,
by James Johnson Sweeney

BOLLINGEN SERIES

PRINCETON UNIVERSITY PRESS

First Princeton/Bollingen Paperback printing, 1970

The contents of this Princeton/Bollingen Paperback edition
are extracted from *African Folktales and Sculpture*, Bollingen
Series XXXII, first published in 1952 and in a revised
edition in 1964.

LCC 78-106801
ISBN 0-691-01763-8
Manufactured in the United States of America

Note to the Paperback Edition

This book derives from *African Folktales and Sculpture*, Bollingen Series XXXII, first published in 1952 and in a revised edition in 1964. Since its original publication, most of native Africa has become politically independent. For the revised edition, place names in the captions, catalogue of plates, and index were corrected as of 1964; they are as of 1952 in the Introduction. This paperback reprint edition does not attempt to take historical changes since 1964 into account; it would not have been feasible to do so. Tanzania remains Tanganyika; Kinshasa is here still Leopoldville; etc. An index of place names and tribal names mentioned in the Introduction and plates has been prepared for this edition. Usage in the spelling of African tribal names varies considerably, and this volume follows, in general, the preferences indicated in the *Anthropological Bibliography of Native Africa*, edited by H. A. Wieschoff (American Oriental Series, vol. XXIII, New Haven, 1948).

ACKNOWLEDGMENTS

Acknowledgments of the photographs will be found in the catalogue of plates beginning on page 185. The editor wishes particularly to thank the following for their help: William Fagg, British Museum, London; Marcel Griaule and Michel Leiris, Musée de l'Homme, Paris; Dr. Frans Olbrechts, Musée de Tervueren, Belgium; Mr. and Mrs. Webster Plass, London; Frederick Pleasants, Brooklyn Museum; Charles Ratton, Paris; Basil Taylor, London.

For assistance in the preparation of the new material for the second edition, grateful acknowledgment is made to Dr. Robert Goldwater, Director of the Museum of Primitive Art, New York; to Mrs. Tamara Northern and Miss Elizabeth Little, of the Museum staff; and to Mr. John J. Klejman and Mr. Arnold Newman, both of New York.

Contents

AFRICAN SCULPTURE

Introduction[1]

THERE ARE two ways of looking at African Negro sculpture that, for fifty years, have impeded a true understanding of that art. One is the notion that an African carving or casting is "pure art" and that its quality can be fully assessed by European aesthetic standards, without reference to the culture in and for which it was made. The other and opposite view sees in an example of Negro sculpture not a work of art but merely a primitive utilitarian object made by a tradition-fettered artisan for a barbarous community devoid of aesthetic feeling of any kind.

It is true that African sculpture was first recognized in Europe as an art by a group of sophisticated painters living in Paris, who found it interesting because it expressed and satisfied some of their own aesthetic ideals. Vlaminck, Matisse, and Derain, among others, began about 1905 to collect African carvings. Before that, such work had been studied merely as ethnographic document (as in some quarters it continued to be until much later).

These were the French painters who, a few years later, were to be described as *les fauves*, "the wild beasts," because they intentionally distorted their drawing and intensified their colours to express strong emotions or to achieve forceful decorative contrasts. They thought they found similar characteristics in African art.

Up to this time practically nothing had been written upon African sculpture as art. This fact in itself appealed to the younger artists of the day, who were tired of art so overlaid with literature that its basic core of form was difficult to uncover. Anthropologists and ethnologists in their writings had completely overlooked the aesthetic qualities in the artifacts of primitive peoples or had only mentioned them perfunctorily. Leo Frobenius was the first European anthropologist to call attention to the productions of Africans as art.[2]

1. Some of the following material was originally published in an essay which the author contributed to *African Negro Art* (New York, 1935), the catalogue of an exhibition held at the Museum of Modern Art under the author's direction. It is used here, in revised form, with the kind permission of the Museum of Modern Art. Political names are as of 1952.

2. But his articles, "Die Kunst der Naturvölker," *Westermanns Monatshefte*, LXXIX (1895–96), 329–40 and 593–606, and "Die bildende Kunst der Afrikaner," *Mittheilungen der Anthropologischen Gesellschaft in Wien*, XXVI (1897), 1–17, still treated the subject primarily from non-aesthetic points of view.

The first book devoted entirely to what its author believed to be African sculpture—that is, plastic art—was Carl Einstein's *Negerplastik*. It was not published until 1915. Einstein felt that African art illustrated attitudes and qualities neglected or missing in modern European art. In his opinion African sculpture was "true sculpture," was in fact the only sculpture that, by direct methods, solved basic problems of expressing mass. For him European sculpture was infected by a pictorial treatment which, in the hands of modern sculptors, was "dissolving" three-dimensional form.

But those first painter-amateurs and their follower Einstein had only a subjective interest in African art. They treated it as if it were an adopted child of European art and not a self-consistent creation. They looked at it solely against a backdrop of European aesthetic theory, not against the spiritual setting from which it had sprung. European painters, sculptors, and critics in the first two decades of this century were constantly on the lookout for examples of primitive art that did not conform to the naturalistic convention which had dominated the art of their continent for most of two thousand years. African art gave them an ideal example of another tradition. More than that, it offered to their jaded taste the tonic of the unfamiliar, the appeal of the exotic, the intuitive and, from their point of view, the naïve. These were the qualities that attracted the first generation of European amateurs—and more especially such painters as Vlaminck and the others. And since their time European artists in each generation have been able to find in one or another aspect of Negro art something that seemed to justify their own theories; the expressionists found an emotional use of colour and distortion of shape, the cubists found "structure," the surrealists found fantasy, mystery—even a pathological inspiration.

Today such arbitrary and limited attitudes to African art are no longer tenable. Perhaps an undue emphasis on form in a work of art has lost its vogue. Perhaps in our own European art we are taking a more humanistic interest than did the painters and sculptors of forty years ago. Perhaps such field researches as those of Marcel Griaule, Michel Leiris, and their colleagues among the Dogon of French Sudan, or of Bernard and William Fagg in Nigeria, or of Frans Olbrechts among the Bushongo, have given new directions to our interest—and greater richness, too, by combining ethnographic and aesthetic viewpoints in expectation of the day when our meagre documentation will be expanded into a significant background.

In any case, we now realize that an over-simplified approach, long popular among amateurs of African art, has impoverished rather than enhanced our understanding. It seems as dangerous as it is absurd to separate an object from the thought that produced it and to look for emotions and seductions in material forms created by unknown hands, particularly when all the serious field research that has been done among Africans shows that their art's "aims, media, and products are primarily religious" and that "there is a sort of wilful misunderstanding in speaking of an art which should be separated from the

intentions of its users, in order to comply with our definitions." [3] To do so is practically to put ourselves in a position similar to that of an African native never out of his parklands or forests to whom we might present for critical appraisal a late Turner. Or more fundamentally, it is as if we were to try to study mediaeval sculpture or Renaissance painting without any knowledge of Christianity.

This is the generally accepted outlook today—a much sounder attitude than that upon which the appreciation of African sculpture was based, in Europe, in the two opening decades of the twentieth century. If we are serious in our effort to enjoy African art with any degree of discernment, our view of it must combine ethnographic and aesthetic considerations, not rely on one or the other in isolation.

During the past fifteen years such ethnographers as Griaule, Fagg, and Olbrechts have been steadily contributing to our fund of information regarding the beliefs and sentiments underlying those African productions, which by themselves (owing to the unfamiliarity of their representational conventions) would convey to us little, if anything, of their native inspirations. Griaule, for example, gives a vivid description of the origin of certain masks and figures of the Dogon people of the French Sudan in the light of their legends and religious beliefs.[4] William Fagg, in his observations of the contemporary Yoruba of southern Nigeria, has shown what a strong aesthetic interest exists among both the present-day sculptors and the native patrons of their work. "The tribal artist," as Fagg has recounted, "is, in reality, a distinguishable and original personality, just as much as Cellini or Turner or Matisse, even though in most cases we know him only through his works. . . . I was constantly surprised at the individuality of the work of different traditional carvers. . . . It is quite true that tradition usually prescribes the general nature of the work . . . , but these traditional influences are in effect the framework within which the artist must work and create; . . . if he is a poor artist he will be completely dominated by them, but I should doubt whether they are any more restrictive of genius than were the conventions of religious art in Renaissance Italy." [5]

Fagg reports that in a district of Nigeria where traditional carving still flourishes, though on a limited scale, in northeastern Yorubaland around the towns of Illa, Omu, and Otun, "one may readily refute the common idea that there is little or no conscious articulate aesthetic appreciation, as such, among the Africans." Certain sculptors whom he met "competed for patronage over a wide area; one minor chief at Illa commissioned [the sculptor] Bamgboye, twenty miles away, to carve two large masks, and [another sculptor] Areogun of Osi, thirty miles away, to make some small figures carved in memory of

3. Marcel Griaule, *Folk Art of Black Africa*, trans. by M. Heron (Paris and New York, 1950), p. 24. (Orig. published as *Arts de l'Afrique noire*, Paris, 1947.)

4. *Ibid.*, pp. 60 ff.
5. William Fagg, "The Dilemma Which Faces African Art," *The Listener*, XLVI: 1176 (Sept. 13, 1951), 414.

dead twins. Again, some owners of early works by Bamgboye apologized to me for their quality, as they were done 'before he became perfect.' " [6]

What Griaule and his colleagues have brought to light in the Sudan gives us a hint of the rich legendary and religious setting to which all the fine sculptures of Negro Africa belong, but from which, in most cases, they have been torn with little hope of any possible restoration. Fagg's observations among the Yoruba can be taken as indicative of the probable existence of a similar aesthetic consciousness among their ancestors, the people of Benin and Ife, as well as among less closely related peoples in other quarters of the sculpture-producing Guinea coast and Congo. Furthermore, Fagg's observations show us standards of judgment guiding both the creation and the evaluation of native arts in Africa that are quite foreign to ours.

For all this, however, we must still face the fact that our knowledge of the background of African art is elementary. And while we keep in mind the vital importance of enriching, wherever possible, the communication of a piece of Negro sculpture through the marriage of ethnographic and aesthetic considerations, we should not quixotically deny ourselves the aesthetic gratification which this art is able to provide each new generation of observers, foreign as that gratification may be to the essential character and message of Negro art. Too many scruples about our lack of background data, too much conscience about looking at an art from a foreign standpoint, would deprive us of some of our richest aesthetic pleasures.

For we look at all art, more or less, through a stranger's eyes. This holds for contemporary art that may be a decade in advance of the observer's experience and his ability to respond to it, as well as for paintings of the Ming period—and perhaps even more than we readily admit for European Renaissance and Baroque art. We may not appreciate the poetry of Homer, Dante, or Langland as their authors conceived it to be appreciated. When we enjoy reading it aloud, we may not even hear the same sounds their authors intended to give it. Still, it would be nonsensical to refuse on these grounds the pleasure our minds and ears are accustomed to receive from it. The same holds for much of the finest Negro sculpture, which has been torn from a framework that can never be completely replaced no matter how much we learn of other African works of art through the researches of Griaule, Fagg, Olbrechts, and their followers.

And we have to remember that it was artists, in spite of their limited information, not scholars, who revealed African Negro art to European taste. In fact they did so with little more knowledge of provenance or former history than in what curio shop they had been lucky enough to find the object and whether the dealer had a dependable source of supply.

Many examples of African art at the time had already been gathered into ethnographical museums, where they were usually lost in a clutter of other

6. *Ibid.*

exhibits, since their aesthetic character was of no interest to their discoverers or owners. One has only to look through the catalogues of W. D. Webster, an auctioneer of ethnological specimens, located in Bicester, Oxfordshire, at the prices paid for his sales from 1897 to 1904, to realize how little the finest African work was esteemed in those days. (It was from Webster that such fine continental collections as that of Berlin Museum für Völkerkunde drew some of their richest treasures.) Travellers, traders, and soldiers brought objects back to Europe as curiosities. The pieces of ivory or gold had an evident worth. Too often the gold objects would be melted down. Or the gold would be stripped off carved wood statuettes from the Gold Coast, where it was customary to cover them with precious metal. But objects made of material of no intrinsic value soon found their way into the hands of such dealers in ethnographical specimens as Webster, or, more often, into the hands of dealers in odds-and-ends. It was in such curiosity shops that the first French and Belgian amateurs made their acquaintance with Negro art.

The vogue at first was paid little commercial heed. But gradually it began to spread, and the supply, always extremely limited, dwindled. Dealers began to take steps to assure themselves of importations—practically always, without the slightest regard for any serious ethnographic documentation of their wares. An early and ready source of supply had been the liquidation of the estates of soldiers who had taken part in punitive expeditions against the natives. Then traders began to ship to Europe whatever they could persuade the Africans to part with. Even in Africa, however, the supply was small: fine pieces were no longer being produced in any quantity, owing to the decadence of the natives, which duly followed on their exploitation by the whites. Soon the traders were reduced to employing natives to manufacture copies for the growing market. When this in its turn failed to satisfy the demand, European forgeries, which soon surpassed the native copies in "character," began to appear in unfortunately generous quantities in Brussels, Paris, and other centres.

Today, Africa rarely yields art of the quality that we find in the great collections of Europe, formed half a century ago. From time to time, some unexploited region is opened up. But usually, as in the case of the Ife and Esie discoveries [7] of the last decade or so, it is work of a dead past, not the flowering of an active art. So, while African art may be considered "modern" on the ground that very few of the examples we know can have survived more than a century and a half (excepting, of course, certain ivories, the

7. ". . . in 1934 no fewer than seven hundred and sixty-five [stone] figures and heads were discovered in a clearing among oil palms, one and a half miles from Esie, in Ilorin province, Nigeria. . . . In the majority of these carvings the features are sufficiently individualized for them to be considered as portraits; their naturalism, however, is naïve and typically African."—Leonhard Adam, *Primitive Art* (revised edn., Melbourne [Penguin Books], 1949), pp. 120–21. Also see J. D. Clarke, "The Stone Figures of Esie," *Nigeria* (Lagos), No. 14 (June, 1938), 106–8, for a fairly detailed account.

Benin bronzes, and the Ife bronzes and terracottas), at the same time we must accept the fact that the art of Africa is already an art of the past.

But for all the physical youth of the examples of African art we know, particularly those carved from wood, there is no doubt of the antiquity of the tradition underlying their production. The collection of Armbraser and Weickmann in the Museum of Ulm, Germany, contained ivories and weapons brought back to Europe before 1600. And since the Middle Ages we have heard tales from travellers and explorers of kingdoms along the Gulf of Guinea and to the south of the Sahara, tales of fabulous wealth and culture. Undoubtedly there was a certain exaggeration in the reports. Still, we find sufficient evidence of a basic element of truth. And while the sculptures that we actually know are for the most part modern, there is no doubt that the traditional forms which they reflect in a broad way as a guide or framework have been handed down within the tribes for generations.

Long before the Portuguese, encouraged by Prince Henry the Navigator, had actually reached Great Benin in the last quarter of the fifteenth century, we have reports of other great Negro kingdoms to the north and west. In the early fourteenth century some Genoese seamen had already worked their way round the west coast of Africa considerably beyond the Canaries; and, in 1364 a party of Dieppe sailors are said to have gone probably as far as what is the Gold Coast of today. But it was usually from travellers in the interior and from traders that the more striking reports came; for example, descriptions of the vast Negro kingdom of Ghana (Guinea), which in the tenth and eleventh centuries extended from the Senegal River east to the bend of the Niger; of Melle, successor to Ghana in the thirteenth and fourteenth centuries; and of the Songhai empire of Gao, in the Niger bend, which rose from Melle's ruins, reaching its great power in the sixteenth century, when it extended from Lake Chad west to the Atlantic. To the north lay the Hausa states that grew out of the seven towns of Biram, Gobir, Kano, Rano, Zaria, Katsina, and Daura and were originally peopled by a Negro nation apparently related to the early Songhai. These original inhabitants were conquered in the tenth century by another people of obscure affinities, from the east. And these conquerors in their turn founded an empire which survived (with intervals such as the conquest by the Songhai, in 1512, and that by the Moors, in 1595) until they were subjected by the Fula, in 1807. Further south, along the coast, lay the kingdom of the Yoruba. At its height it comprised the whole region between the Niger and the Gulf of Guinea, extending westward from the mouth of the Niger as far as Ashantiland. And among the native civilizations of Africa it is of an outgrowth of Yoruba, the kingdom of Great Benin, that we possess the fullest documentation.

While this documentation is not really extensive, or even historically exact, the fact that we have some concrete information regarding Benin has inclined us to lay a very likely undue importance upon it and its culture, in

contrast to the other great Negro kingdoms and empires that have left us no records beyond such evidence of artistic genius as surviving sculptures may provide. Nevertheless, our few facts about Benin have played an important role in the consideration of African art. For they have helped to dissipate the notion that Negro art is a chance production of a people entirely lacking in culture or social organization.

The first Europeans to reach Benin were, as we have said, a group of Portuguese; this was in 1472. The company actually reached Great Benin, or Oedo, as the capital was then called; and from its members we have report of other important contemporary Negro kingdoms to the north and west. The chronicler João de Barros tells us that Alfonso d'Aveiro brought back with him from Benin a native ambassador to the court of Portugal.

The first descriptive details of the capital, however, became known in Europe about 1600. The publishers De Bry printed a description given them by a certain mysterious traveller, "D.R." The city, according to this account, lay about seventy-five miles inland from the mouth of the Benin or Formosa River. Its main street was seven or eight times wider than the great street of Amsterdam and stretched out of sight into the distance.

Somewhat later, in 1668, a Dutch traveller, Dr. Olfert Dapper, added some further details about the wealth and importance of the city. It was fortified by a solid rampart ten feet high. A similar wall protected the royal palace, which "was as large as the whole city of Haarlem." The magnificent structures that composed it were linked together by impressive long colonnades of wooden pillars, covered from top to bottom with bronze plaques depicting battle scenes. Thirty broad streets ran the length of the city, each lined with carefully constructed houses. The dwellings were low but large, with long interior galleries and numerous rooms, the walls of which were made of smooth red clay polished till it gave the appearance of marble.

In 1704, another traveller, named Nyendael, found the city practically in ruins, scarcely inhabited. The corridors of the palace were now supported by wooden pillars so rudely carved that the chronicler was scarcely able to discern what was represented. There was no longer any evidence of the bronze plaques that had formerly attracted so much attention. And since no traveller after Nyendael makes any mention, it may be supposed that, during the civil war which ravaged Benin in the last years of the seventeenth century, they had been hastily pulled down and hidden in the storehouses where the British were to find them two hundred years later.

In the course of the eighteenth century, the city rose again from its ruins. It never returned, however, to its ancient splendour. And in 1820, the palace was again destroyed during an insurrection.

It was not until 1897 that the first bronzes from Benin reached Europe. The British had established themselves in 1851 at Lagos, on the coast. The oba, or king, of Benin had for centuries maintained by force of arms a hegemony

over a wide area of southern Nigeria west of the Niger. In 1896, the British consul, J. R. Phillips, attempted to enter the capital city during a religious festival, to come to an understanding with the reigning oba, Overami, who was notorious for the savagery and scale of his human sacrifices. Overami had prohibited the consul's visit during the festival. Phillips and his party were ambushed and killed. "A punitive expedition reached Benin in January 1897, deposed the Oba, established British rule there, and removed, as an indemnity, the accumulated riches found, largely in a state of dire neglect, in the Oba's palace, and in the houses of some of the chiefs. . . ." [8]

The bronzes and ivories were shipped to London either as curiosities or as scrap. Felix von Luschan, in his catalogue *Die Altertümer von Benin*,[9] was later able to list twenty-four hundred objects. So at a stroke almost the entire artistic remains of a great but decayed culture left Nigeria for Europe. Pieces soon began to reach the market through such channels as Webster, the Oxfordshire auctioneer, or second-hand shops in England or on the continent to which the returning officers of the British expedition or their families had sold them.

Out of these spoils three great collections (as well as many smaller ones) came into being, two of which are still in England—in the British Museum and in the Pitt-Rivers Museum, at Farnham, Dorset—while the largest of all, which went to Berlin in 1898, was, as William Fagg has written, "evacuated to Silesia during the late war and has vanished, apparently eastwards." [10]

These Benin pieces both from a technical and an artistic point of view completely mystified Europeans who realized what their quality implied. At the turn of the century Africa was still regarded as the "dark continent" as much for its unenlightenment as for its vast unexplored areas. The natives were "savages," and their productions hitherto had held no interest for Europe save as evidence of their barbarism or at best as souvenirs of a sojourn rarely looked back upon with relish. When the bronzes from Benin appeared, of which von Luschan wrote, "Cellini himself could not have made better casts, nor anyone else before or since to the present day," an explanation had to be found. It could not be supposed that unenlightened savages had produced such remarkable examples of bronze-casting without aid. Finally the representation of certain figures in Portuguese garb on some of the plaques suggested that the method of bronze-working had been imported by the Portuguese on their first visit to the capital, in the fifteenth century. To bear out the theory, one English researcher managed to discover a tradition, allegedly local, to the effect that one Ahammangiwa, a member of the first party of white men to set foot in Benin, in the reign of the Oba Esigie, introduced bronze-casting.[11]

8. William Fagg, "Ancient Benin," foreword to the catalogue of an exhibition, "Art of Primitive Peoples," Berkeley Galleries, London, Dec. 1, 1947, to Jan. 31, 1948. 9. Berlin, 1919; 3 vols.

10. Fagg, "Ancient Benin."
11. C. H. Read and O. M. Dalton, *Antiquities from the City of Benin and Other Parts of West Africa in the British Museum* (London, 1899), pp. 6–7.

This theory, however, has now been generally abandoned. There is no evidence that the Portuguese had any such skill to communicate. And in the light of a better knowledge of African history, an analysis of the stylistic features of Benin art shows it to be fundamentally negroid. Finally, the discoveries made in 1910 by Leo Frobenius at Ife, only a hundred and ten miles away, as well as subsequent disclosures there, confirm the tradition of the Bini, the natives of Benin, that they had learned the art of casting bronze from the Yoruba of Ife, who in their turn had possibly come under the influence of the cultures of the upper Nile. While the actual origins of this art are still a matter of deep uncertainty, Fagg offers the following as a working hypothesis: "In the course of the first centuries of the Christian era, the Yoruba, having come from the east (perhaps the banks of the upper Nile), had already before this migration a knowledge of the techniques of bronze-casting by the *cire-perdue* process [12] well known to the Egypt of the Pharaohs and to the last Graeco-Nubian civilization of Meroë (although their casts were of a much more reduced scale than those of Ife and of other bronze manufacturers); and a germ, if one may so express it, of decadent realism appropriate to Greek art subsisted, slight as it was, from the odyssey of the Yoruba and found its re-birth and a considerable development after their establishment on the Gulf of Guinea." [13]

Despite the great weight of historical data we possess in regard to the kingdom of Benin, the chronology of its artistic productions is still almost as uncertain as that of other regions of Africa. Tradition among the Bini has it that bronze-casting by the *cire-perdue* method was introduced into Benin from Ife under Oba Oguola about 1280. [14]

This date is not impossible in view of the attributed resemblances between the Benin and Ife work and the superior quality of the latter. The age of the Ife heads that we know is still uncertain. But it is generally accepted that they date from the fifteenth century, at the latest before the arrival of the Portuguese. In any case, we can feel safe in dating the period of production of the finest Benin bronzes earlier than the decadence which set in after the civil war in the latter part of the seventeenth century.

The German ethnologists von Luschan and Bernhard Struck have attempted to date the Benin bronzes by a system of reference to the royal

12. In the *cire-perdue* ("lost wax") process of metal-casting the sculptor builds up a wax model around an earthen core. The wax of the model is then covered with several coats of fine potter's clay in a completely liquid state. Each coat is allowed to dry separately. When the coats are of a satisfactory thickness, the model is enveloped in earth, which solidifies in drying. When sufficiently dry, the whole is heated, and the wax melts and escapes through vents arranged for the purpose. Molten metal is then poured through these holes and takes the place left empty by the melted wax. After the metal within has cooled, the mold is broken off, leaving a precise reproduction in metal of what the artist had originally modelled in wax. The oldest method of metal-casting known, it is still practised throughout the world.

13. William Fagg, "De l'art des Yoruba," in *L'Art Nègre* (Présence Africaine 10-11; Paris, 1951), p. 116. (Author's translation.)

14. Adam, *op. cit.*, p. 114.

chronology of Benin. Such a classification is clearly unsatisfactory. Perhaps a greater precision may be possible when scientific excavations on the site of Benin itself have been carried out.

We can see that the history of African art still remains its least rewarding facet. Such a summary review, however, of what we know of Benin, the most powerful kingdom of the Guinea coast over a long period—how it was influenced by Yoruba and in turn exerted its artistic influence over such neighbours as Abomey and Zagnanado, in Dahomey—gives us a notion of what may have been the culture and power of those great empires of Melle and Ghana in the north and of Lunda in the region now Belgian Congo, of which we know even less than we know of Benin. Also it helps us to envisage, at least in part, the standard of culture that doubtless obtained there and its results: seemingly a general prosperity; large, populous cities; extensive areas of land under cultivation; and orderly, peace-loving inhabitants keenly sensitive to beauty in their environment, habiliments, and art. Finally, we may agree with Frobenius, who observed that the legend of the barbarous Negro current in Europe during the latter half of the nineteenth century is primarily the creation of European exploiters who needed some excuse for their depredations.

Those regions, however, of whose past we possess any information (even through oral tradition) make a very small part of the vast area of central and west Africa which has produced art which may be said to offer predominantly negroid characteristics. At the same time, when we consider the vast areas drawn upon, the production of Negro sculpture as we know it seems incredibly small. For the area from which this art comes embraces the greater part of that region in which the "true" Negro peoples predominate, as well as the immense "heart of Africa" peopled by the western branch of the Bantu-speaking peoples. The relative integrity of this sculpture-producing area, its more or less stable racial pattern over the last several centuries, is actually the result of ethnic movements. Tribal expansion was the prime stimulus to migration. But we also find another reason for it among the Negroes: a craving for salt and a concomitant desire to control the sources of supply. As a result, in west Africa there was a continuous movement towards the sea, which had its effect in disseminating tribal traditions. And the difficulty in allocating stylistic traits of Negro art with certainty to definite regions or tribes may in great part be attributed to it.

Cultures were also bound to vary with different types of country, different conditions of environment. For example, the large states and federations such as Ghana, Melle, the Hausa, the Yoruba, and Lunda were all outgrowths of parkland and forest edge, where communication was not difficult. In the denser forest, central control of a wide area was impossible—each village remained small and independent, and architecture never received the attention accorded it in the capital cities of the more open areas.

The type of religion of the Negro, also determined in great part by environment, we find particularly reflected in his art. Ancestor worship is most common among peoples who through seeing men wielding great power in this world come to feel that the souls of the great should still be powerful after death. This is the cult that in many regions of Africa has been productive of the finest sculpture, not only through symbolizing the dead as in the stylized burial fetishes of the Ogowe River district, in Gabon (Plates 142–44), but also through actual portraits. Without doubt many of the ancestor figures of Sudan, Benin, and Congo fall into this category—for example, the famous royal statues of the Bakuba kings (Plates 81, 82), which the English ethnologists E. Torday and T. A. Joyce found in the Belgian Congo and felt could be dated with confidence on the basis of their portrait character. They were clearly individualized in feature—evidently intended as realistic portraits though somewhat altered in keeping with the sculptural conventions of the region—and recognized by the natives as representing certain rulers still known and reverenced by name.

Still more realistic "portraits" survive in the bronze heads, the terracotta heads, and the half-length figures found at Ife and nearby. In the bronze heads, particularly such as those in Plates 132–38, African sculpture in the naturalistic convention achieves a level of subtlety rarely matched, much less surpassed, in the Mediterranean region during classic times or the Renaissance.

Ancestor worship, however, is practically confined to the parklands and the forest edge. In the denser jungle, where the tribes are disseminated, we find little evidence of it. There animistic beliefs predominate. Trees, streams, rocks, even animals, take the character of minor supernatural forces, and each has its cult celebrated by rituals in which sculptured masks and fetishes play an important part.

Religion with the Negro, as with all races, has been the main stimulus to artistic expression. Even in minor manifestations we find it as productive in Africa as in Europe. For example, some of the finest expressions take the form of fertility idols such as those in Plate 46 from the Sudan, Plate 60 from northeast Yoruba, or Plate 84 from the Belgian Congo; fetishes for conjuration, such as Plates 96–97, and the well-known "Konde" nail-studded figures (Plate 79) used for driving away illnesses by one's hammering a nail into the figure at the moment of conjuration; representations of the spirit of the dead (Plate 142); and figures to insure successful childbirth as well as protect the child till the age of puberty.

Certainly the broadest variety of expression, if not the highest, in Negro art is in the ritual mask. Masks range in form from the most realistic, employing monkey hair (Plates 34–35), or even human hair, to heighten the representation, to the most purely architectonic (Plate 6) or non-realistic (Plate 29); in size, from the immense casques of the Baluba fetish-men (Plate 22) or the huge and awesome "Kakunga" masks of the Bayaka (Plate 28), to the small dance masks worn by women and children. Some masks that are intended to be

handed down from one fetish-man to another within the tribe are meticu-lously carved; others, to be worn at a single ceremony then to be thrown away, may be crudely contrived out of soft wood and painted with gaudy colours in some traditional pattern. The purposes of the masks are as numerous as their varieties: sanctuary masks, fetish-men's war masks, hunting masks, circumcision-ritual masks, masks worn at funeral and memorial ceremonies—different variations of type in every tribe for every purpose—in wood, wicker, cloth, straw, parchment, ivory, and endless combinations of materials.

Still, African Negro art is by no means restricted to ritual objects. In prac-tically every accessory of life, even the commonest utensil, the Negro's sensi-tivity and craftmanship are illustrated; spoons (Plates 54–55), bobbins (Plates 56–58), headrests (Plates 93–95), musical instruments (Plates 53, 63, 76, 78, 80). In the Belgian Congo, particularly among the Bushongo along the Kasai River, we find textiles woven of coco-palm fibre in elaborate patterns which have their relation to the surface patterns of the sculpture of the region.

Even tattooing among the Negroes is art itself, to such an extent that the patterns which we find on the bodies of the natives are often the basis of those with which they decorate their sculptures (Plates 85, 86–87) and permit us in many cases to assign them to styles of specific tribes. On the northern shore of the Gulf of Guinea, especially in the Gold Coast and Ivory Coast, we find a curious expression of lyric fantasy in small bronzes produced by the *cire-perdue* method and used by the natives for weighing gold dust. These are frequently as remarkable in their technical mastery as they are individual in their imaginative conceptions (Plates 106–8).

Although the materials employed are usually dictated by circumstances of environment and expediency, immediate availability is not always a con-trolling factor. This we see illustrated by one of the main arguments in favour of the theory of Egyptian rather than Portuguese influence in the Benin bronzes. For while tin is ready to hand in southern Nigeria, it has been found that the copper employed by the Bini in their earliest work was brought down from Egypt. In most cases, however, we find carving done in wood because of its ease of handling. When stone is used, it is almost universally steatite (soapstone). Gold work is practically limited to those regions where the mineral is found in surface soil or streams. The finest matting and tufted textiles are produced from the fibre of the coco-palm in the Congo region. Ivory, however, is widely employed, from the Ivory Coast as far east as Tanganyika.

Because of the migrations and intermingling of tribes, it is difficult to at-tribute stylistic traits in African art with any confidence. And our knowledge of Africa is still so slight that names are frequently as misleading as they are helpful. In an attempt to simplify the classifications of types, names have been applied with very little scientific basis. And the political boundaries dictated by Europeans mean little to influences which have been spreading among the natives for generations. As an example, the characteristics which we might be

tempted to associate with Gabon are frequently to be found in Rio Muni (Plate 74) and the Cameroons (Plate 68).

Certain features, however, are notable. For example, the definite character of surface decoration in Bakuba cups and boxes (Plate 91) offers a ready contrast to the simpler, more architectonic though somewhat more naturalistic sculpture of the Baluba tribe (Plates 83–84), also of the Belgian Congo. In carvings from Gabon, masks and figures alike, we find a suavity of harmonious relationships in the rounded surfaces and a swelling, bulbous character in the volumes (Plates 72, 77) that offer a distinct contrast with the severe staccato counterpoint of angular forms in Sudan statuettes (Plates 39–43) or masks (Plates 1, 2). And the surface decoration of an ornate Ivory Coast mask is readily distinguished by the emphasis it lays on relationships among its unit masses (Plate 9) from the strictly linear patterns of the Belgian Congo (Plates 90, 91).

In the end, however, it is not the tribal characteristics of Negro art nor its strangeness that are interesting. It is the sculptural quality—its vitality of forms, its simplification without impoverishment, its consistent three-dimensional organization of structural planes in architectonic sequences, and above all its uncompromising truth to material.

This is the basic language through which African Negro art must always speak to outsiders and possibly through which the great African art of yesterday must speak even to African Negroes of today. But a view of African art in this light should not exclude the importance of as full a knowledge as possible of the framework in which and for which it was made.

We speak of the African sculptor's "respect for his materials." This was one of the qualities which first recommended African Negro sculpture to European artists. In it they recognized an apparent willingness on the part of the Negro sculptor to allow the material in many cases to dictate form or variations of form—to allow it to collaborate, as it were, in the final product. Griaule stresses the fact that as a result of the Negro's animistic religious outlook the raw materials he employs are never inert. "The trees they cut down are the elaborate dwellings of supernatural powers; the Mbanga, the Na, and the Kulfa of [the river] Salamat kill them with assegai blows as if they were alive." [15] The European's sensibility to natural materials and their quality has gradually dulled, but the African Negro, through his religous respect for the spirit immanent, continued to enjoy his; and the vitality of the result appealed even to those Europeans who were unaware of what lay behind it.

Form and the organization of forms are the language through which sculpture of all ages and peoples must first speak to us—our own, as well as the Sumerian, the Mayan, or the Egyptian. Without some knowledge of the human setting in which and for which it was made it remains only the bare bones of expression, much as the music of the *Paradiso* would remain to one with no knowledge of thirteenth-century philosophy, history, or religion.

15. Griaule, *op. cit.*, p. 47.

The non-African can only hope to respond directly through his visual experience—his personal non-African eye. But the more he can bring to the basic sculptural expression the richer will be his response and enjoyment. That will be the gift of the ethnographer; the widening of horizons, the broadening of our embrace, the opening of new fields of aesthetic experience to explore into which, alone, we might never find our way.

1952 *JAMES JOHNSON SWEENEY*

Postscript (1963)

And that is what has happened in the past dozen years. Not only have fresh sources of African art been opened up and numerous hitherto unfamiliar expressions of it been disclosed, but by study and research we have acquired a deeper understanding of its meaning within the philosophico-religious system that tribal art embodies—a meaning largely foreign to Western thought and action and the West's more materialistic basis. The result is that African art has today an aesthetic interest per se which it did not have for its first European amateurs five decades ago.

In 1905 the newly found art of African tribes interested its discoverers primarily for the remedies it offered to European art. For that earlier generation it was a dramatic example of what might strengthen certain weaknesses, supply lacks, or correct abuses which they recognized in the Western painting and sculpture of their day. They saw in African art, on the one hand, a frank stress on basic three-dimensional form and its aesthetic order and, on the other, an encouragement of emotional expression, reinforced by the exaggeration and distortion of conventional representational forms. The consequence of this approach was that African art was seen more often than not in this subsidiary relationship to European art rather than as an artistic expression in its own right.

But within the past thirty-five years African art has assumed its place as an art entirely independent of European associations and has shown itself to possess its own logic—"far from the Cartesian," as William Fagg has said, but equally as rigorous. This changed perspective is due principally both to the wealth of objects that have come out of Africa—or have been discovered in Africa and remained there—and to the broader and deeper interest in the psychological, sociological, environmental, and philosophical background of African tribal art which these new disclosures have stimulated.

The variety of fresh work of quality is in itself astonishing. Each month for the past ten years and still today there are unfamiliar arrivals from Africa or the report of new discoveries there: new types of ritual items—masks and fetishes—and new types of utilitarian objects carved as symbolic figures. These finds have been in many widely separated places—Ijara, Ife, Guinea, Mali, Upper Volta, Chad, Esie, Nok—and often they are vastly different in character from those objects which first won the interest and admiration of Europeans in the early years of this century.

An example is the "porpianong" (Plate 175), a type of stylized representation of the hornbill, made by the Senufo, of Ivory Coast. Though sometimes more than seven feet tall, these birdform fertility symbols are worn on the heads of members of the tribe's Lo Society during rituals. They have become known outside Africa only in recent years. Another unfamiliar cult object is the "kakilambe" (Plate 177). These great serpent figures of polychrome wood are made by the Landuma, in Guinea, and are nine or more feet in height. They are stylizations of the Gabon viper and symbolize at once both fertility and survival after death. Butterfly masks of painted wood and braided rope (Plate 173) are worn by the Bobo, of Upper Volta, in dances celebrating the approach of spring, heralded in that region by swarms of butterflies. When the butterflies appear, the tilling of the fields begins afresh, and ritual dances invoke the "do" spirits to imbue the soil with their divine powers. From this area also come the same tribe's owl-like bird masks (Plate 166), worn principally in hunting rites, and the antelope head-dresses (Plates 167 and 168) of the Kurumba, worn in the mourning ceremonies to drive the souls of the deceased out of the village. And an object strictly utilitarian, but dignified by symbolic carving, is a housepost over six feet high made by the Dogon, of Mali (Plate 178). In the past dozen years there have also been major new examples of familiar styles to come out of Africa, such as the famous "Queen" (Plate 181), from the Bambara (Mali), so closely akin to other masterpieces of dramatic carving previously known to us.

But perhaps more important than the discovery of such types of cult expression, stimulating as they may be, are the links in the chain of tradition which have appeared during the past decade and the breadth of development they illustrate, as well as the antiquity of the sculptural arts in Africa to which they testify. For example, in November 1957 a workman leveling a low mound at Ita Yemoo, on the outskirts of the town of Ife, came upon a group of evidently ancient works of art, "the first fruits," as Fagg has described them, "of what may well prove to be the richest site yet discovered in all West Africa." And this small group, according to Fagg, "has thrown much new light on the Ife culture already, and, what is perhaps more valuable, it has raised a number of new problems." [1] One of the most unusual items of the Ita Yemoo find is the pair of royal figures with linked arms (frontispiece). The face of one figure was damaged by a workman's pick; but, as Fagg points out, entirely aside from any aesthetic considerations, this piece and the figure of

an Oni of Ife found with it establish a major point in our view of African bronze sculpture. Frequently in the past it was suggested that the idealized naturalism of the Ife bronzes in contrast to African wood carving—even those of the Yoruba, in the same region of Nigeria—was a consequence of the importation of foreign metalworkers. Until this recent discovery no full-length Ife figures had come to light. Now with this royal pair and the Oni statue found with it we have the fact established, as Fagg writes, "once and for all that the sculptures were made by Africans." Their proportions evidence this: the heads, despite the idealized naturalism of the faces, are on a markedly larger scale than the bodies; they are twice as large as the natural proportion— just as in modern Yoruba wood carvings. "Modern Ife," Fagg writes, "is built on twenty-five feet of potsherds and other remains. . . . If it is not, as its traditions hold, the place where the world and man were created, it was without doubt a fountainhead of artistic impulses whose diverse effects on neighbouring peoples have still, for the most part, to be brought to light."

Compared with the Nok terracottas, the Esie stone figures, and the recent discoveries at Ijara—all in Nigeria—and with the 15,000 pieces of bronze and terracotta found in 1948 at the sanctuary of Tago in the Republic of Chad, these Ife works are, for all their mystery, relatively young. But young or old, it is just such discoveries as these which have given the scholar during the past few years a wider and more profound view of the religious, philosophic, and even historical environment of African art. And from this wider view and the greater familiarity with the fundamentals of African expression which it provides has come that desire to look at African art for itself rather than for its associations with the art of Europe: a desire that has developed so notably in the recent past and continues to grow in the present.

JAMES JOHNSON SWEENEY

1. William Fagg, "Ife, the Original City," foreword to the catalogue of an exhibition, "The Latest Ife Finds," The Museum of Primitive Art, New York, October 29–December 2, 1958.

PLATES

The Catalogue of Plates follows the plates.

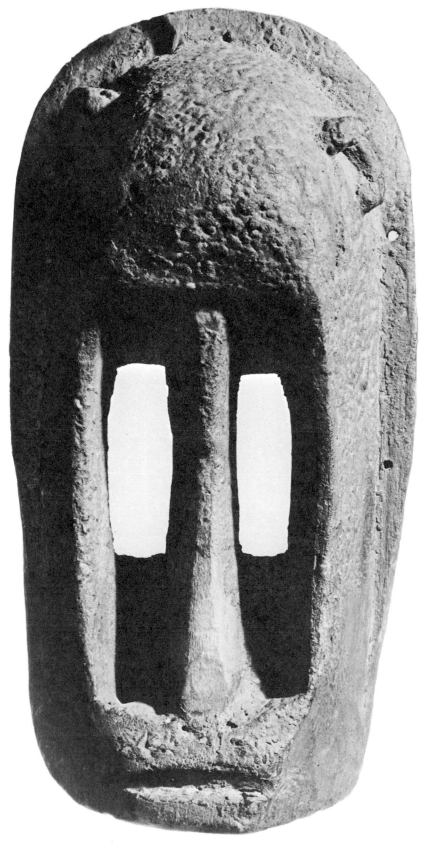

1. MASK. Wood, h. 14½ in. *Dogon, Mali*

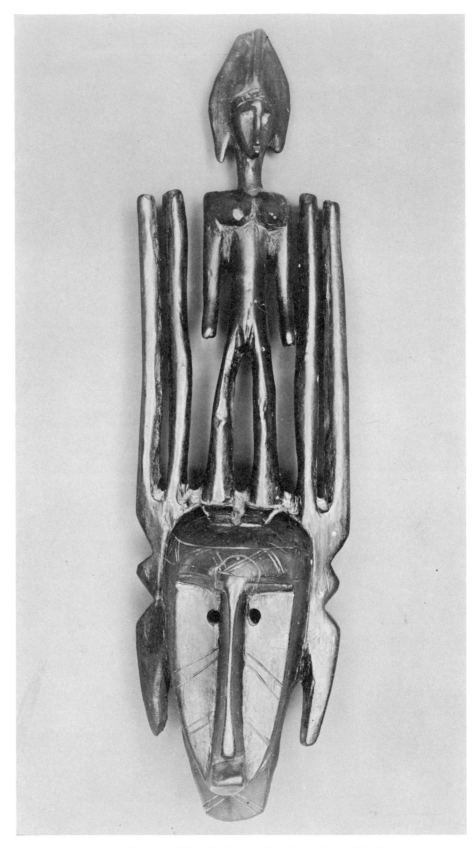

2. MASK. Wood, h. 25 in. *Bambara, Mali*

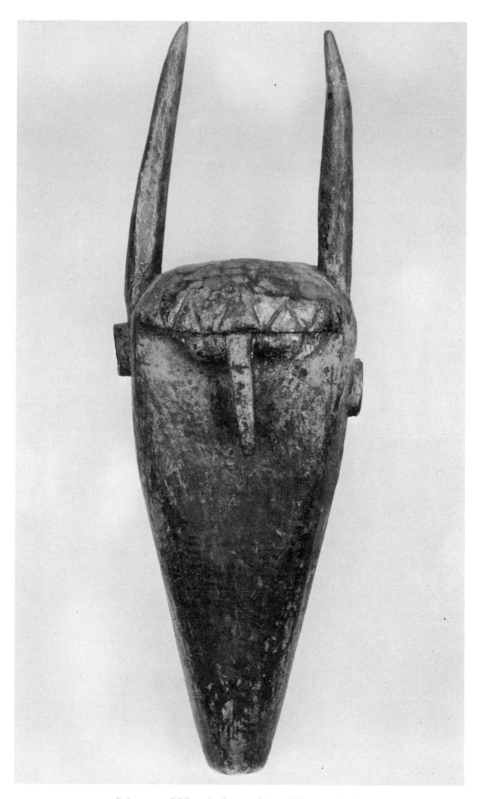

3. MASK. Wood, h. 22½ in. *Toma, Liberia*

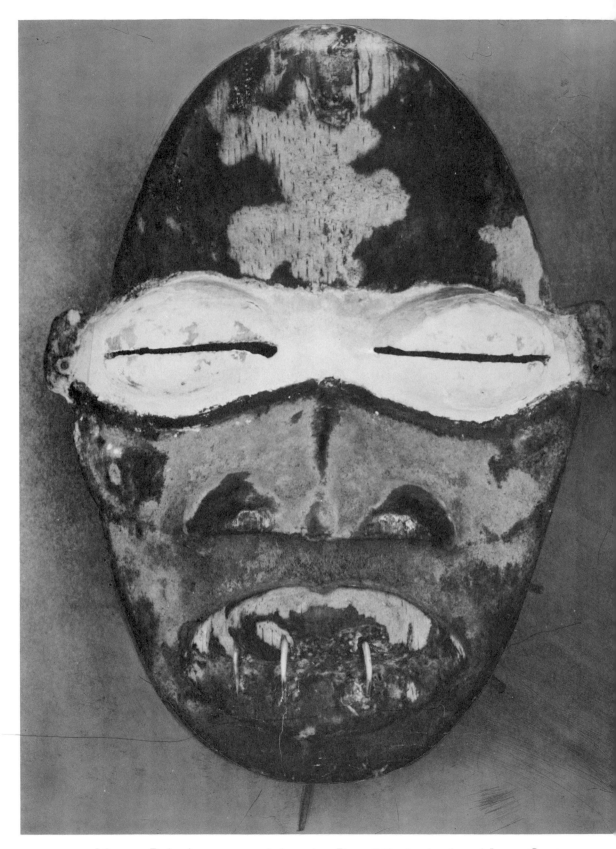

4. MASK. Polychrome wood, h. 9 in. *Dan, Liberia, border of Ivory Coast*

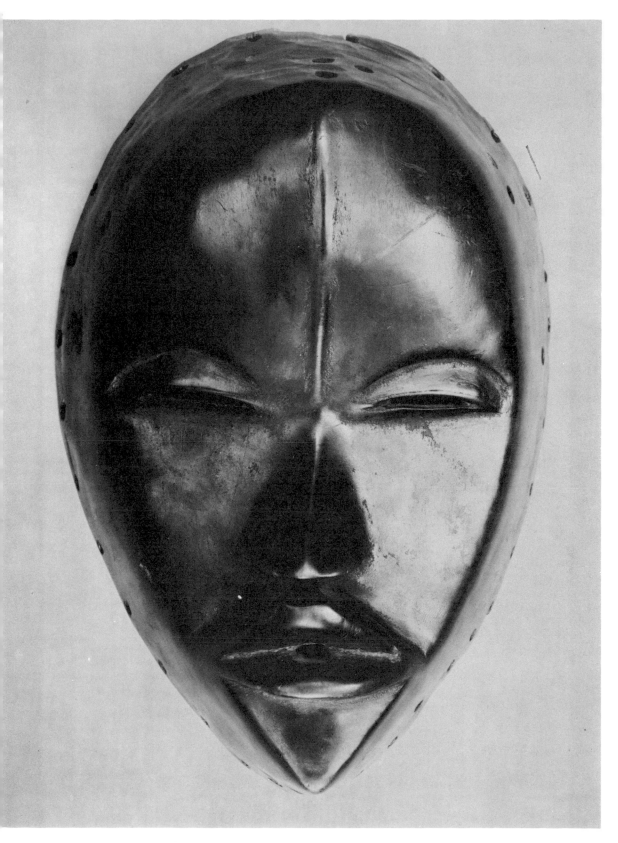

5. MASK. Wood, h. 9⅛ in. *Dan, Ivory Coast*

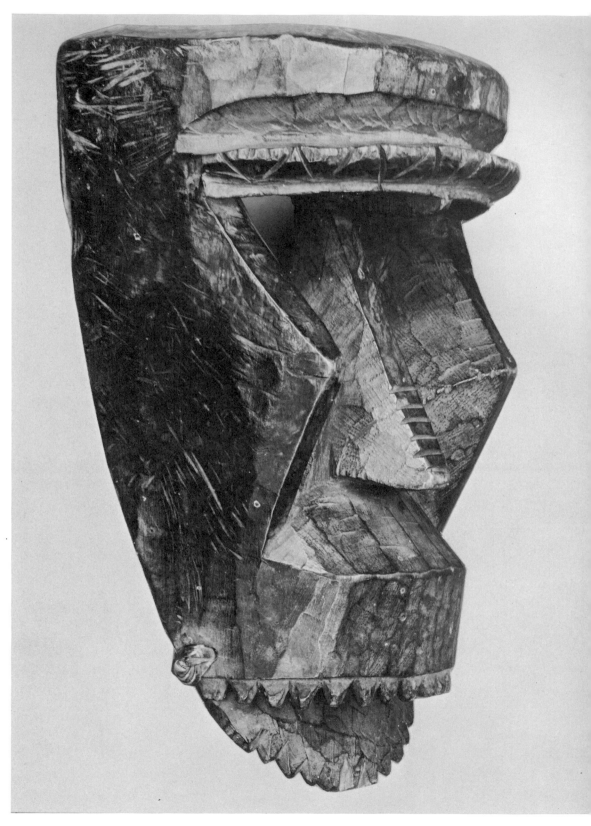

6. MASK. Wood, h. 9½ in. *Dan, Ivory Coast*

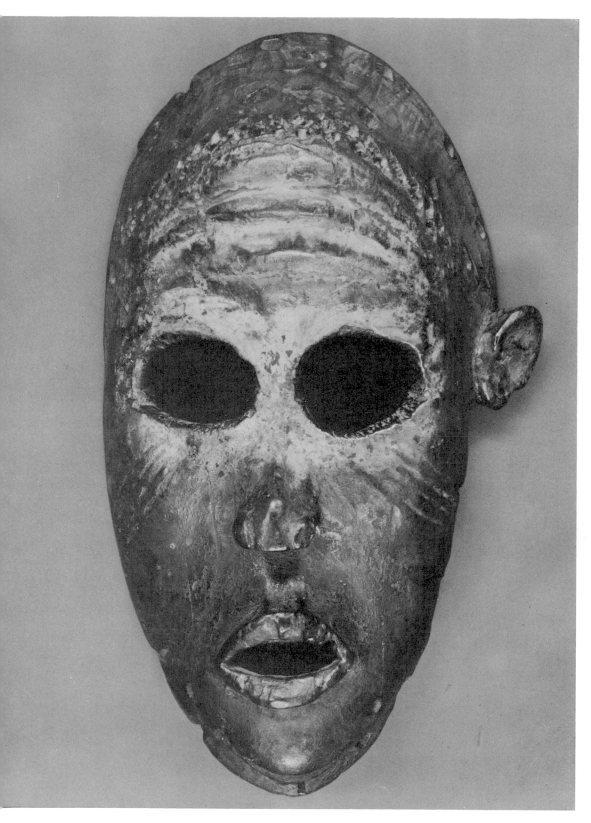

7. M A S K. Wood, h. 10⅝ in. *Dan, Ivory Coast*

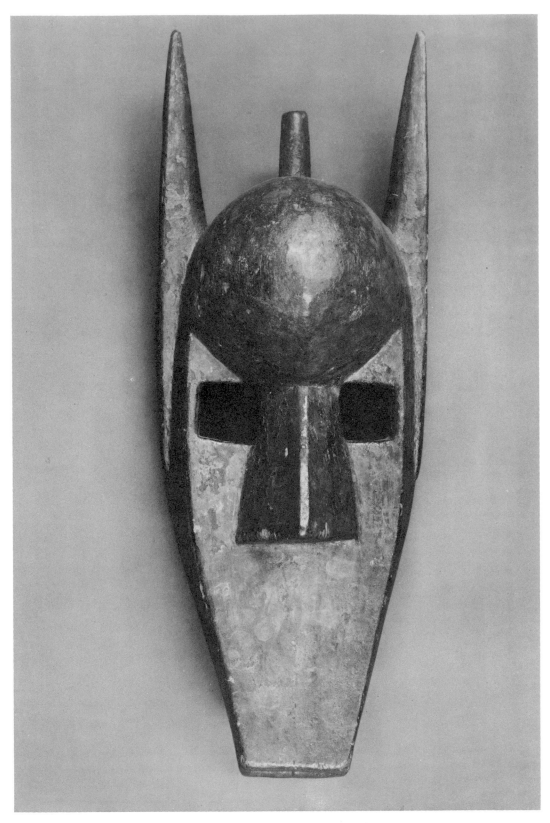

8. MASK. Wood, h. 18½ in. *Bambara, Mali*

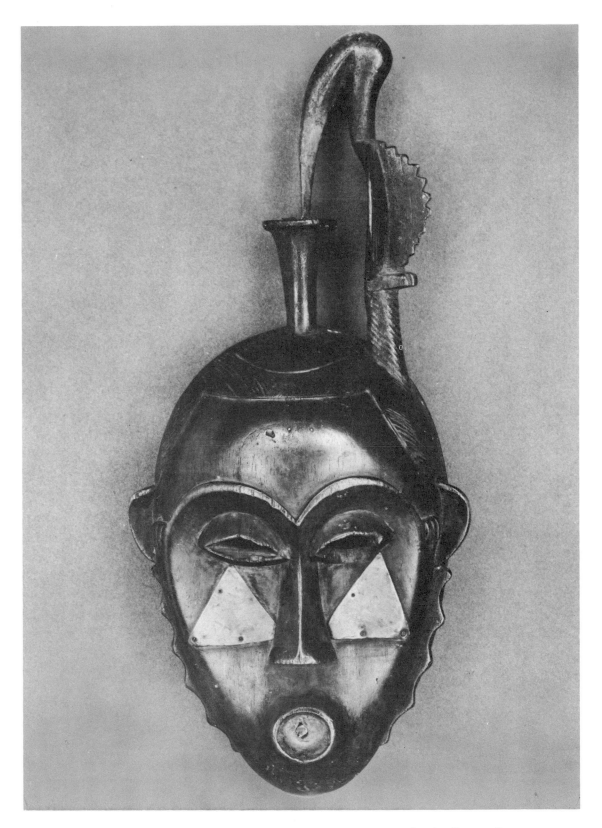

9. MASK. Wood with metal plates, h. 15¾ in. *Baule, Ivory Coast*

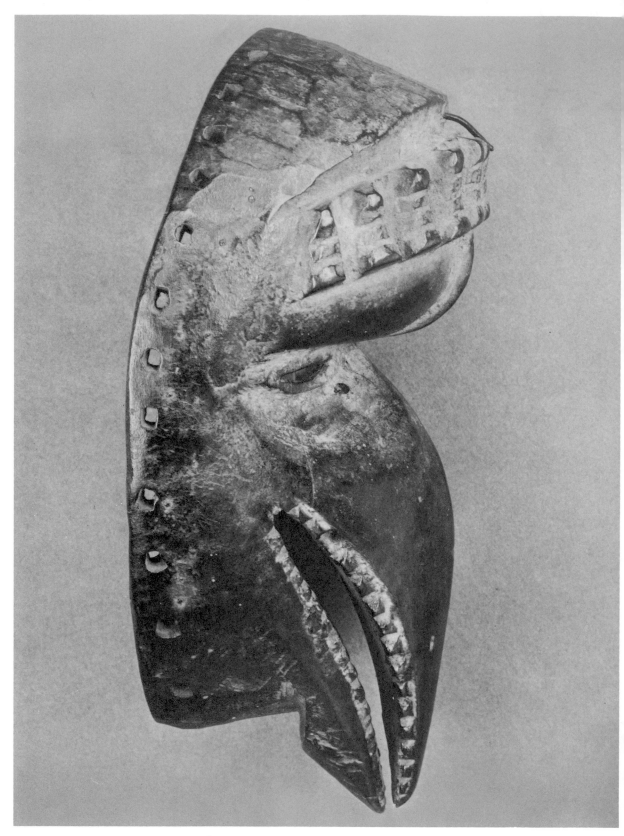

10. MASK. Wood, h. 8 in. *Dan, Liberia*

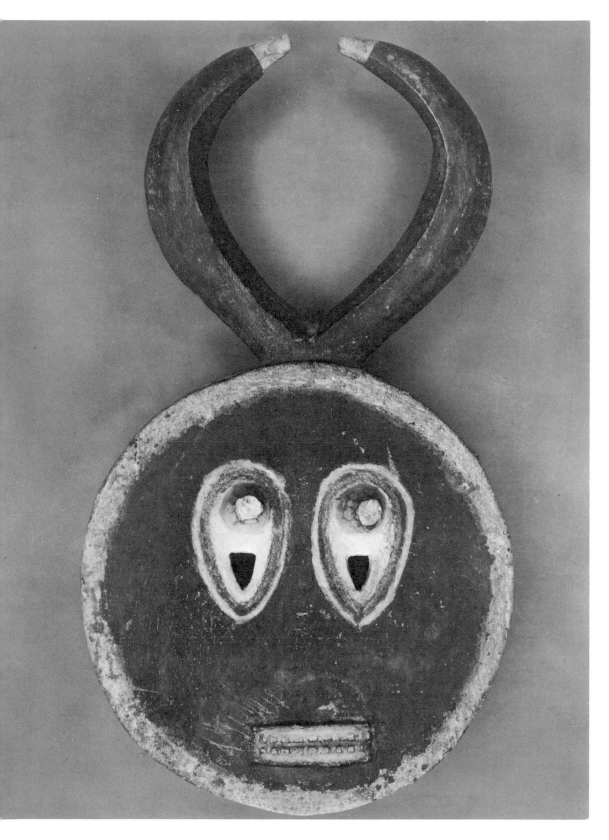

11. MASK. Polychrome wood, h. 15 in. *Baule, Ivory Coast*

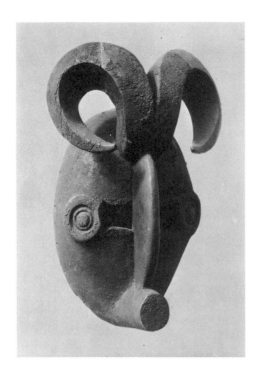

12. MASK. Wood, h. 17 in.
Ekoi, Nigeria

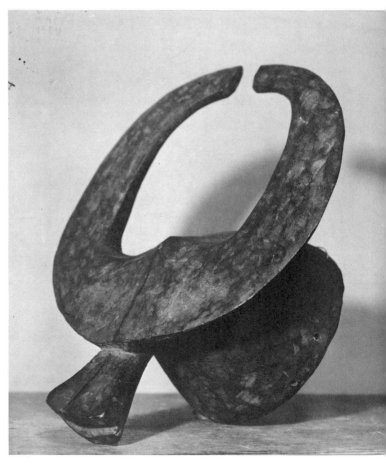

13. MASK (HEAD-DRESS). Wood, h. 14½ in.
Mama, Nigeria

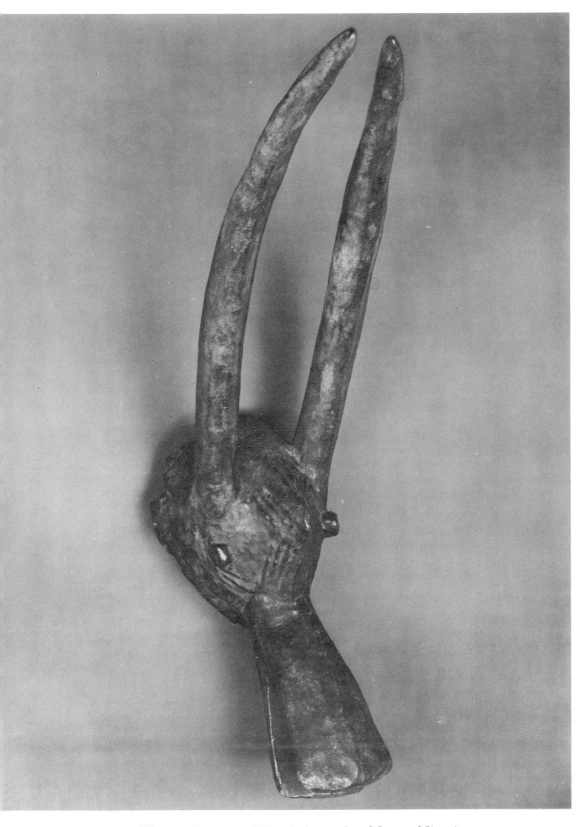

14. HEAD-DRESS. Wood, h. 26 in. *Mama, Nigeria*

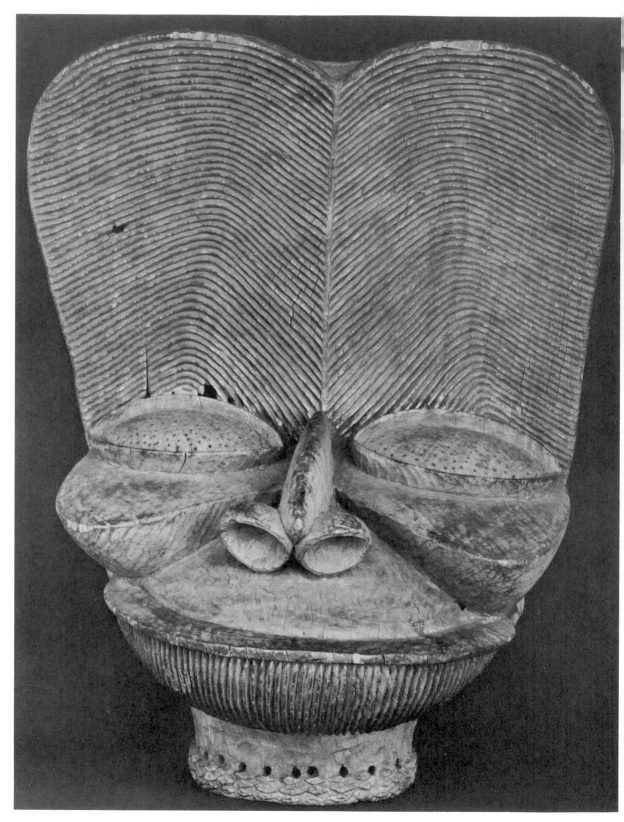

15. MASK. Wood, h. $26\frac{3}{8}$ in. *Bamenda, Cameroon*

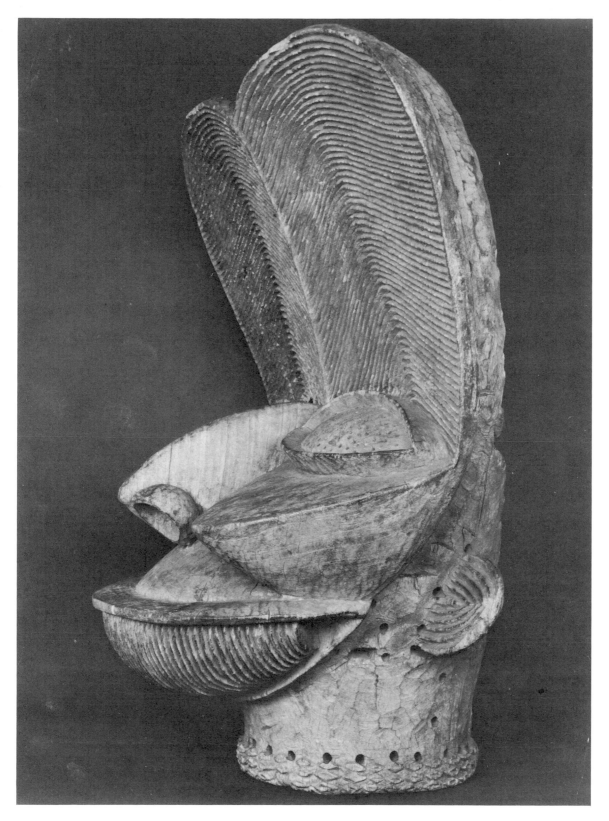

16. Same, profile

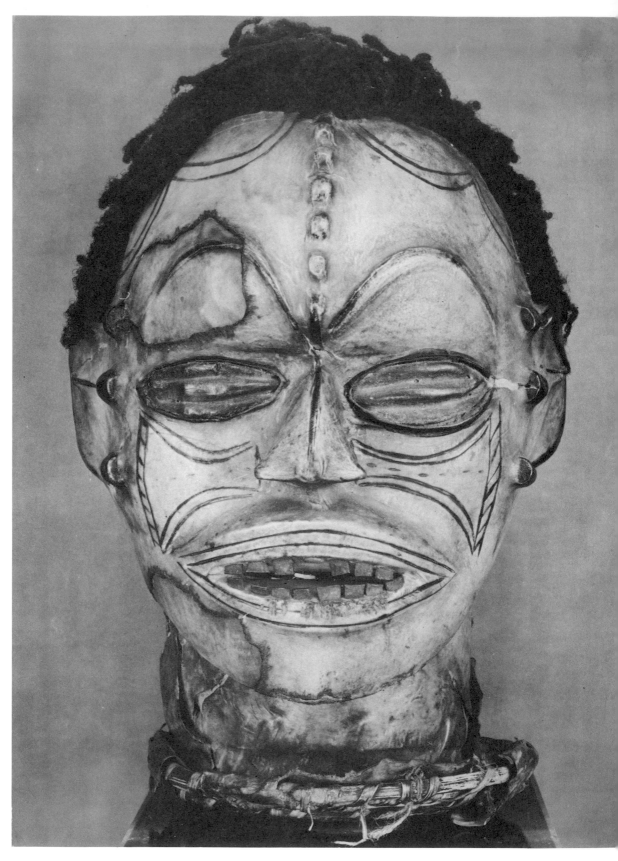

17. JANUS HEAD (view of one face). Parchment over wood, h. 9⅞ in. *Ekoi, Nigeria*

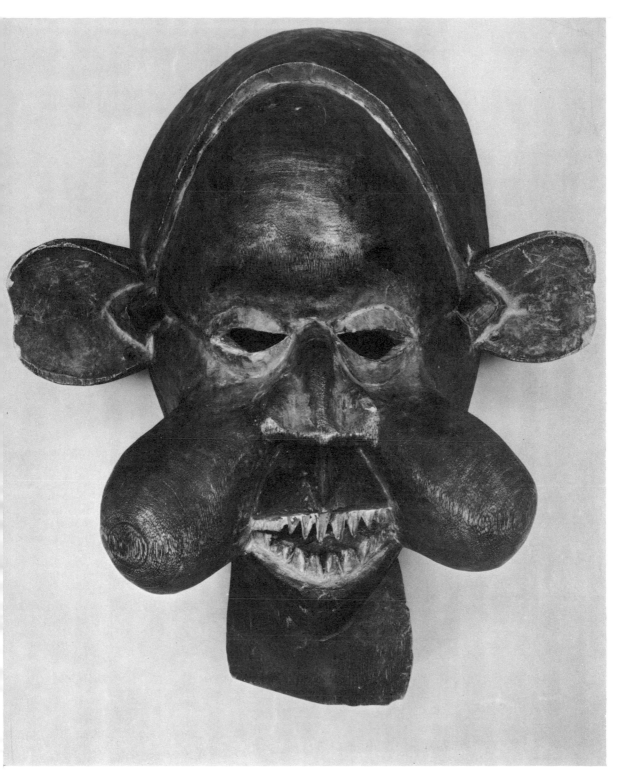

18. MASK. Wood, h. 17¼ in. *Bamenda, Cameroon*

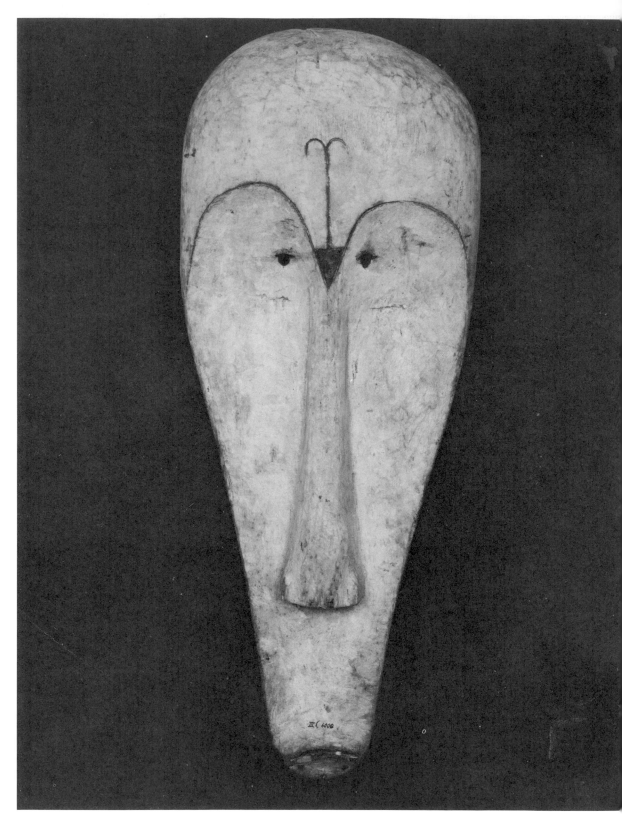

19. MASK. Whitened wood, h. 29½ in. *Fang, Gabon*

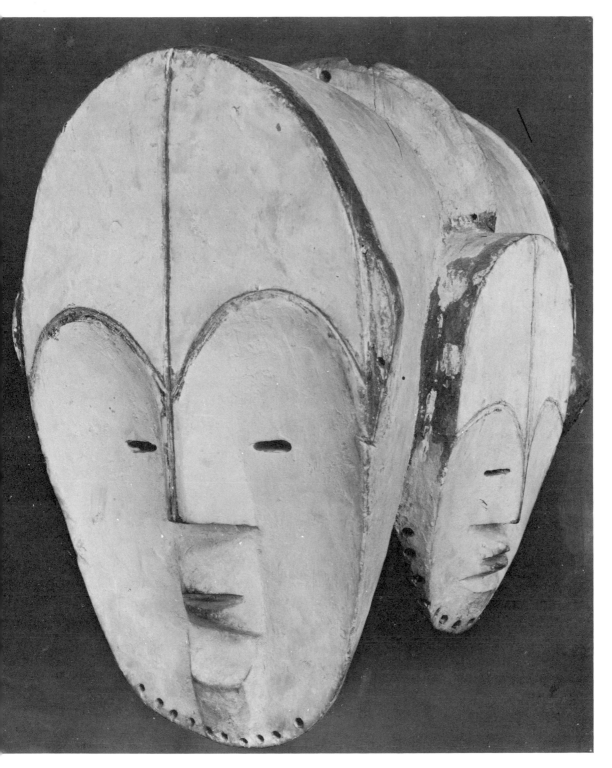

20. FOUR-FACED MASK, IN CASQUE FORM. Whitened wood, h. 13⅜ in.
Mpongwe, Gabon

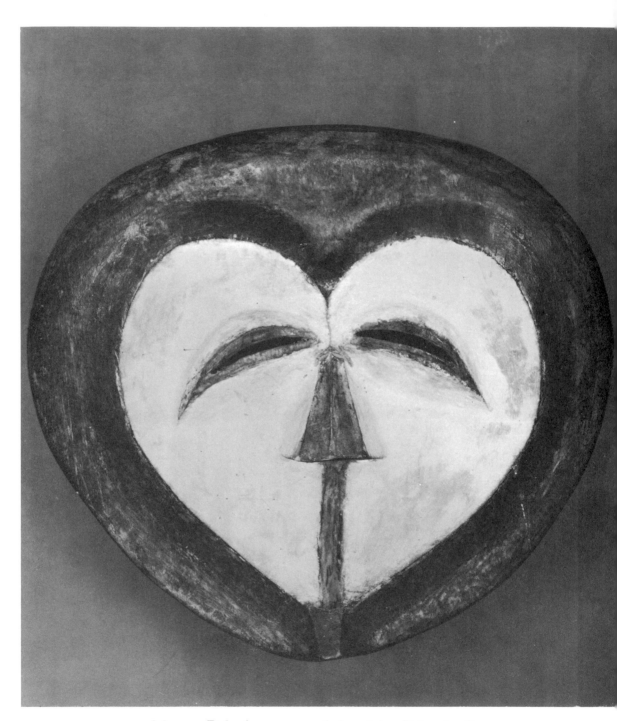

21. MASK. Polychrome wood, h. 9½ in. *Bakwele, Cameroon*

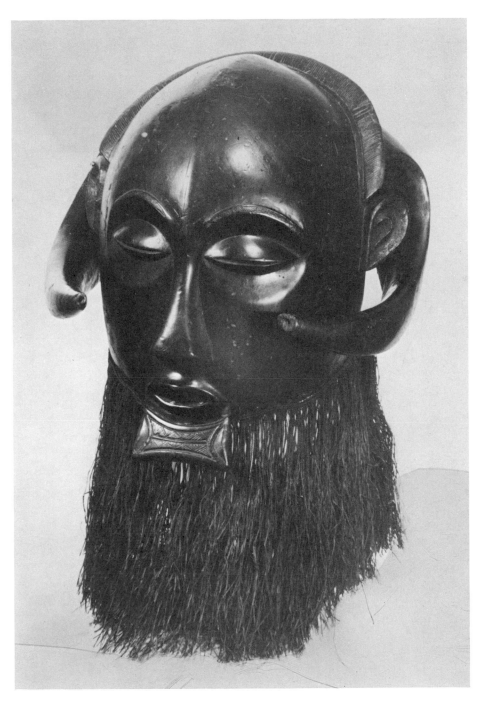

22. MASK, IN CASQUE FORM. Wood, h. 24½ in.
Baluba, Congo (Leopoldville)

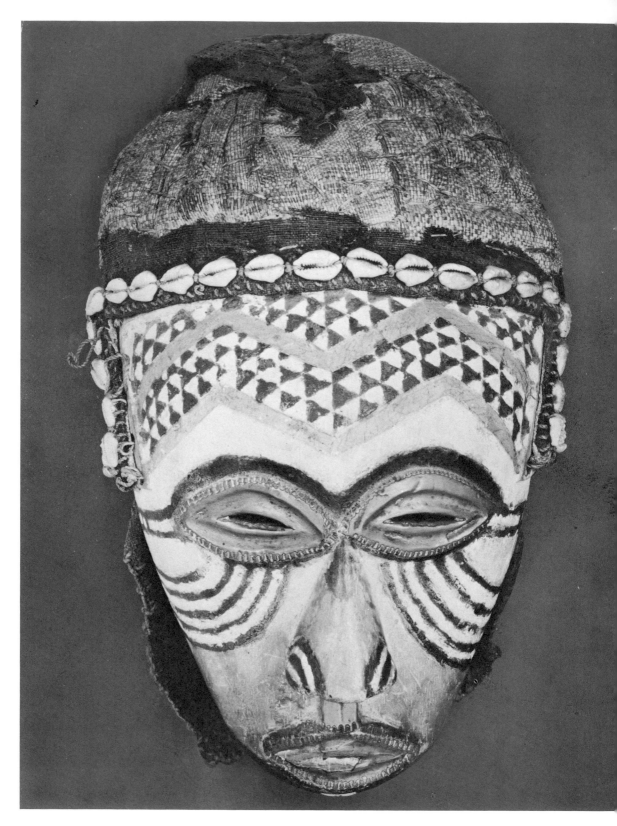

23. MASK. Polychrome wood, metal, cloth, and shells, h. 12¾ in.
Baluba, Congo (Leopoldville)

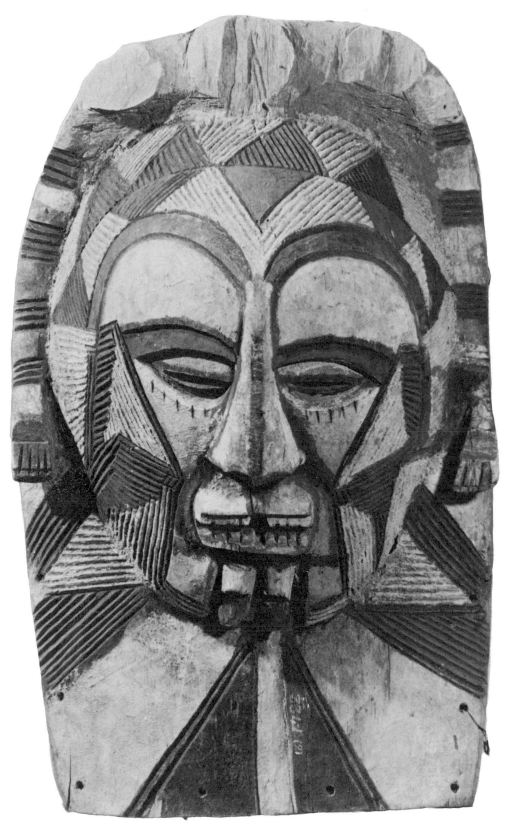

24. MASK. Polychrome wood, h. 20 in. *Baluba, Congo (Leopoldville)*

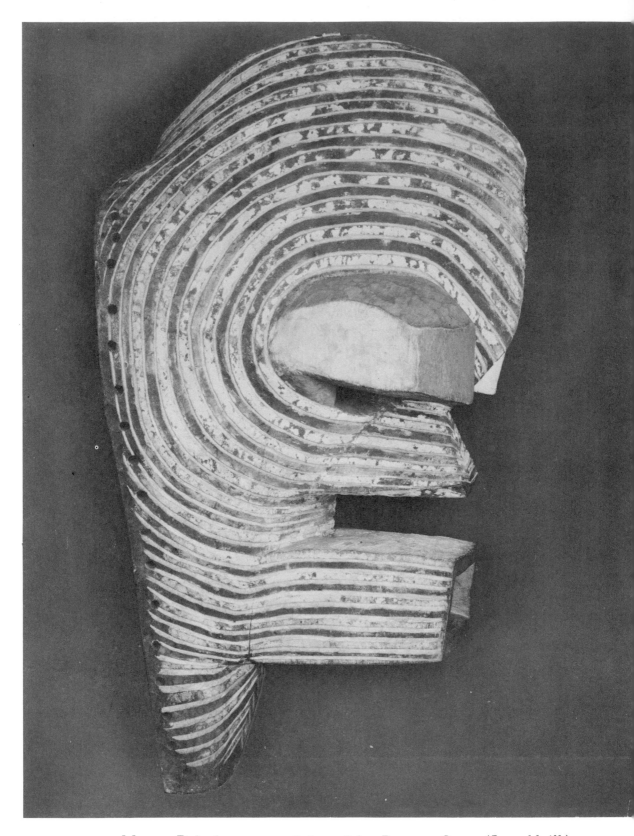

25. MASK. Polychrome wood, h. 24¾ in. *Basonge, Congo (Leopoldville)*

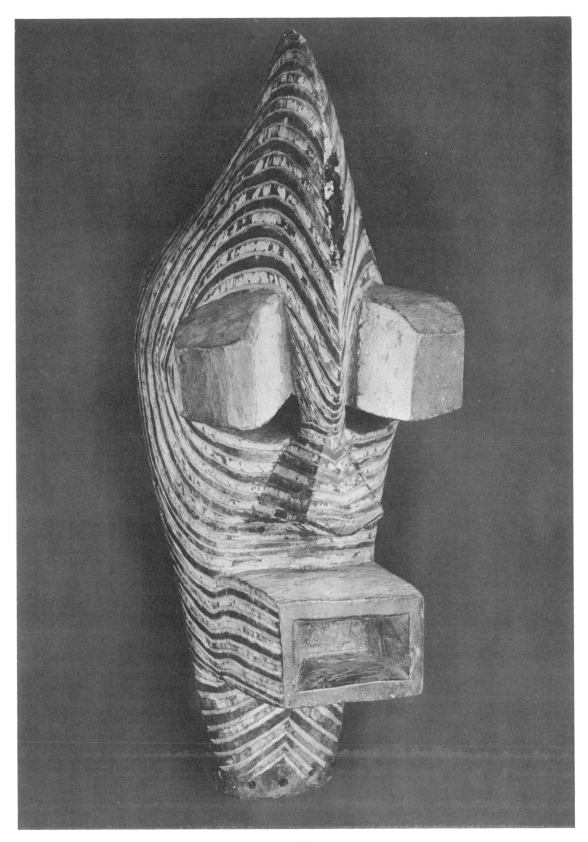

26. Same, front view

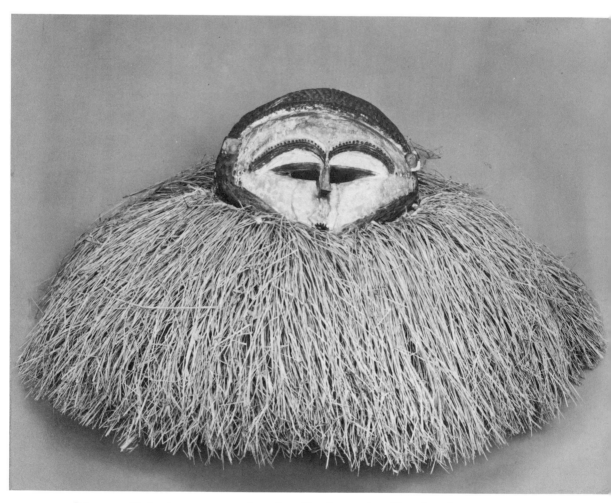

27. MASK. Polychrome wood and raffia, h. 12 in. *Bayaka, Congo (Leopoldville)*

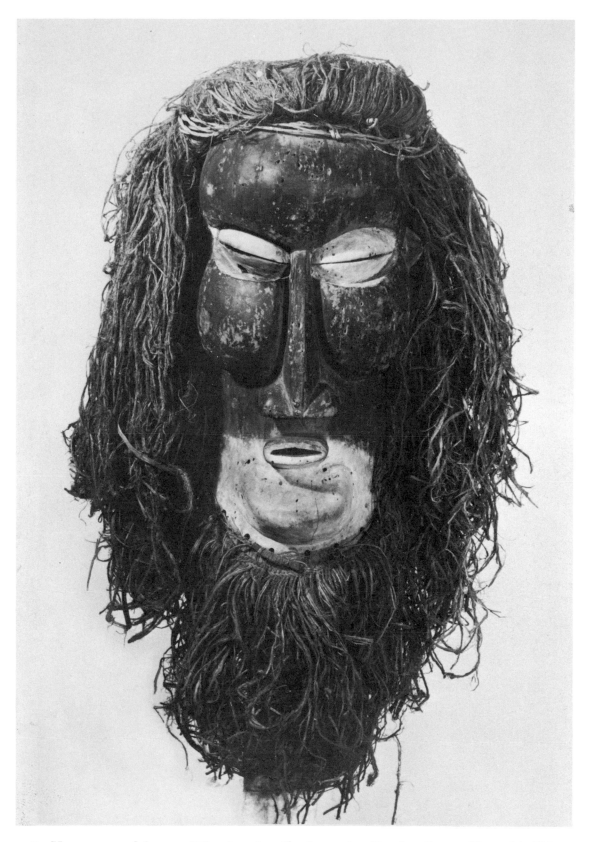

28. KAKUNGA MASK. Wood and raffia, h. 36 in. *Bayaka, Congo (Leopoldville)*

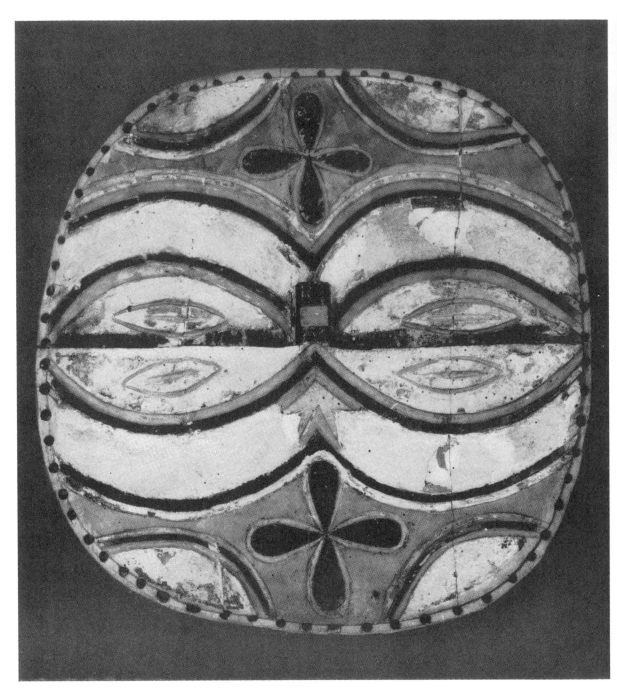

29. MASK. Polychrome wood, h. 11½ in. *Bateke, Congo (Leopoldville)*

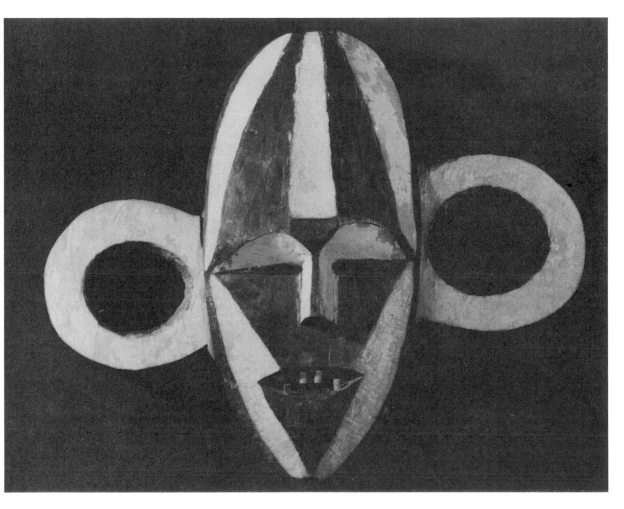

30. MASK. Polychrome wood, h. 12 in. *Baboa, Congo (Leopoldville)*

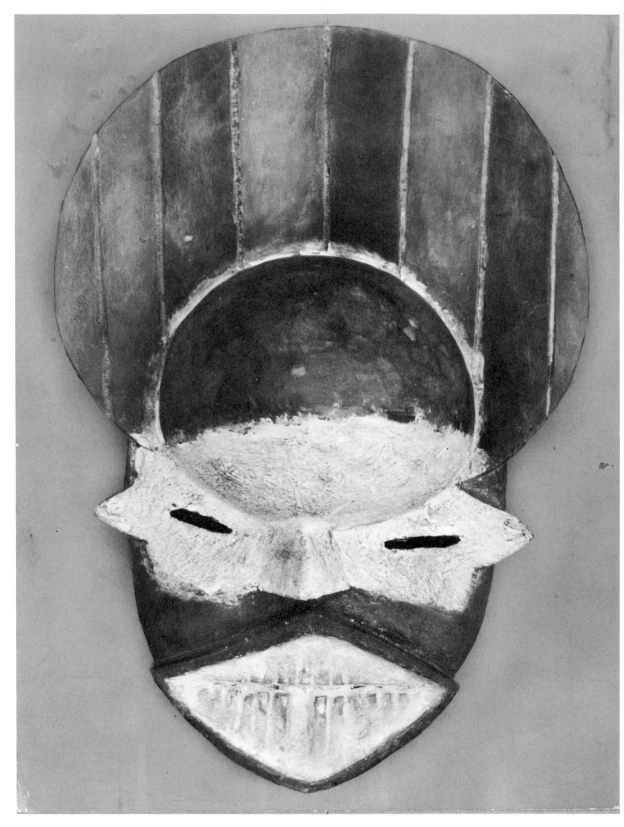

31. MASK. Polychrome wood, h. 11¾ in. *Kanioka, Congo (Leopoldville)*

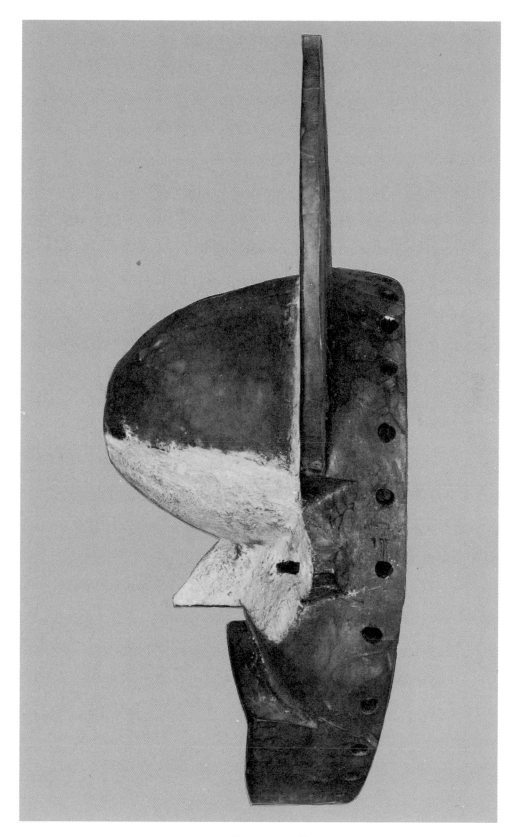

32. Same, profile

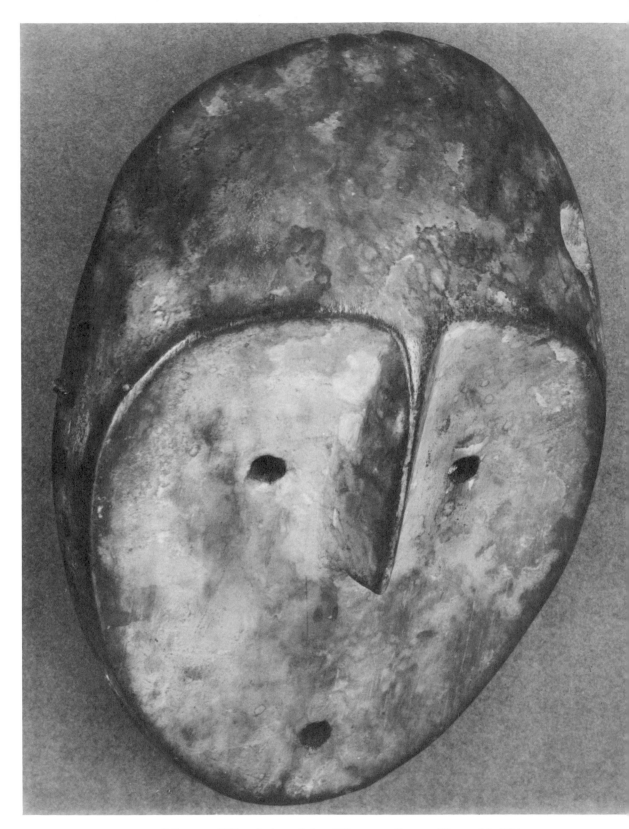

33. MASK. Wood, h. 8⅝ in. *Warega, Congo (Leopoldville)*

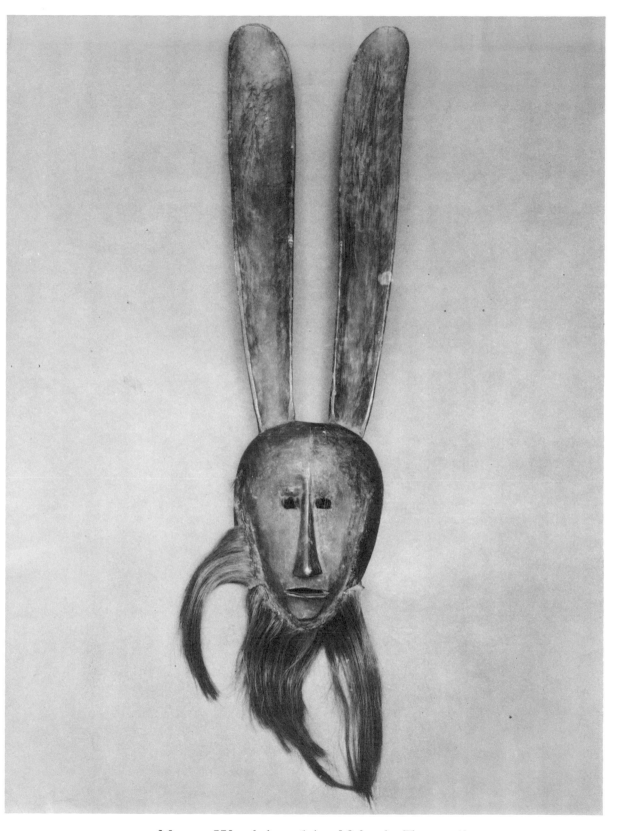

34. MASK. Wood, h. 23¼ in. *Makonde, Tanganyika*

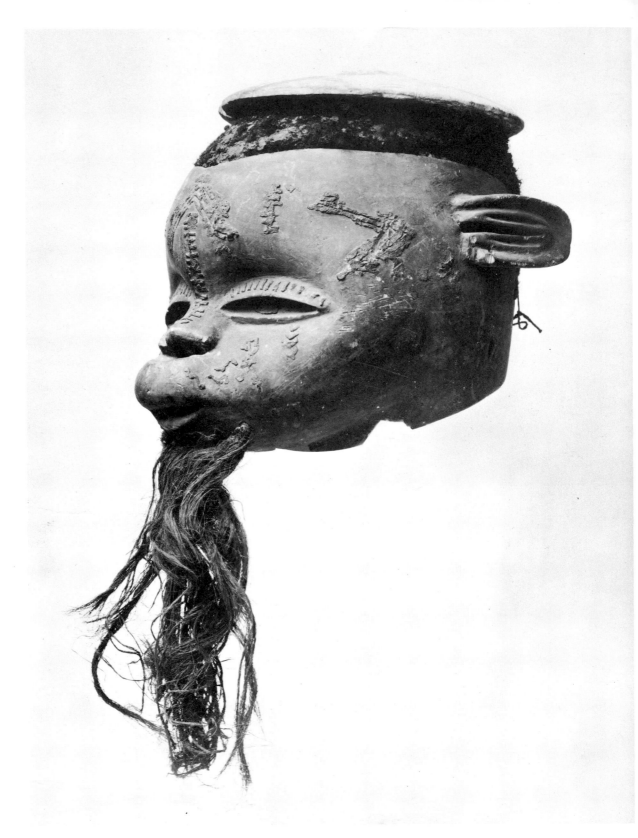

35. MASK. Wood, h. 10 in. *Makonde, Tanganyika*

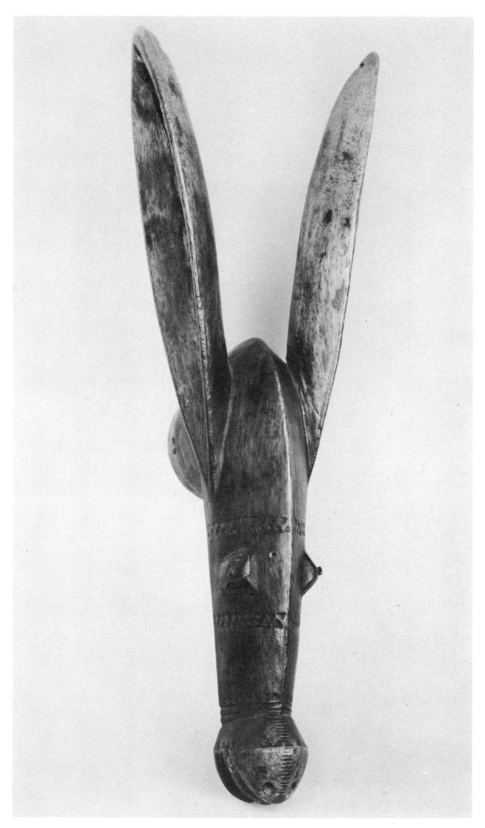

36. Hobbyhorse Head. Wood, h. 14½ in. *Bambara, Mali*

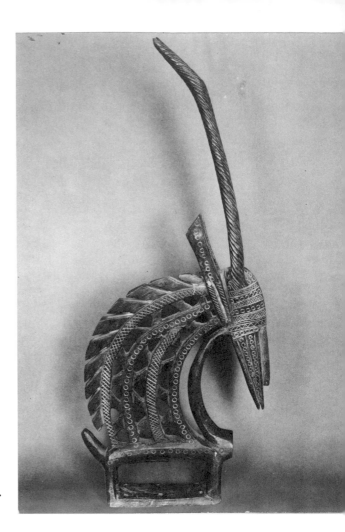

37. HEAD-DRESS. Wood, h. 31⅞ in.
Bambara, Mali

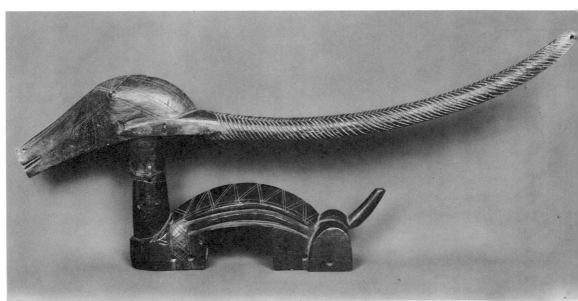

38. HEAD-DRESS. Wood, h. 26 in. *Mandingo (Suguni), Mali*

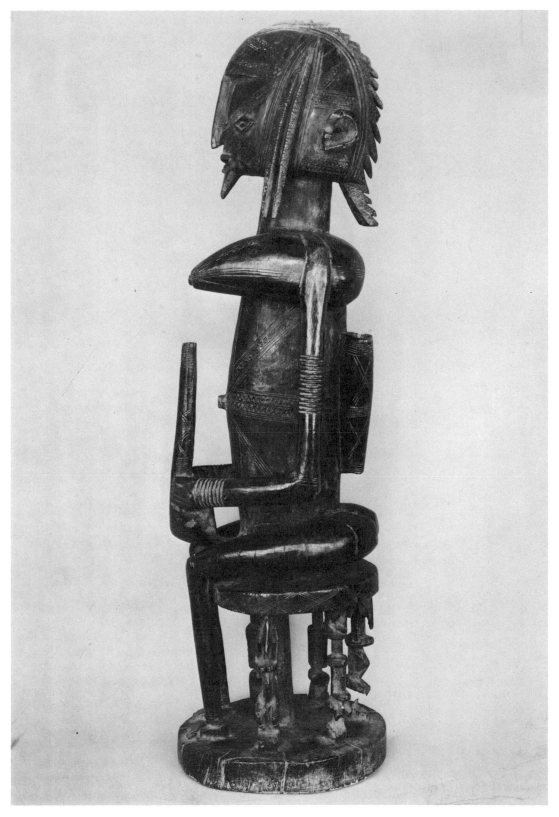

39. Hermaphroditic Figure. Wood, h. 27½ in. *Dogon, Mali*

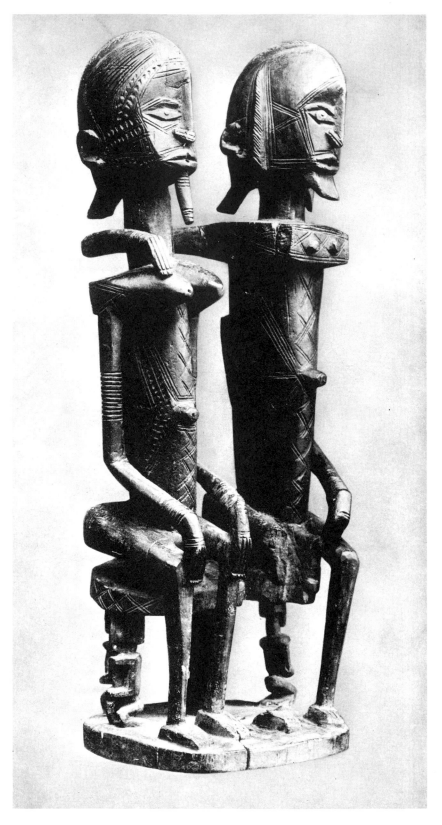

40. MALE AND FEMALE FIGURES. Wood, h. 15 in. *Dogon, Mali*

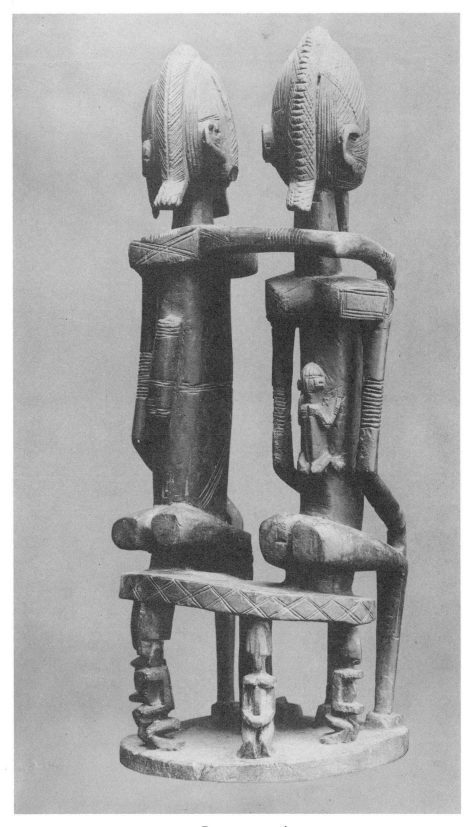

41. Same, rear view

42. STATUETTE. Wood, h. 17½ in. *Dogon, Mali*

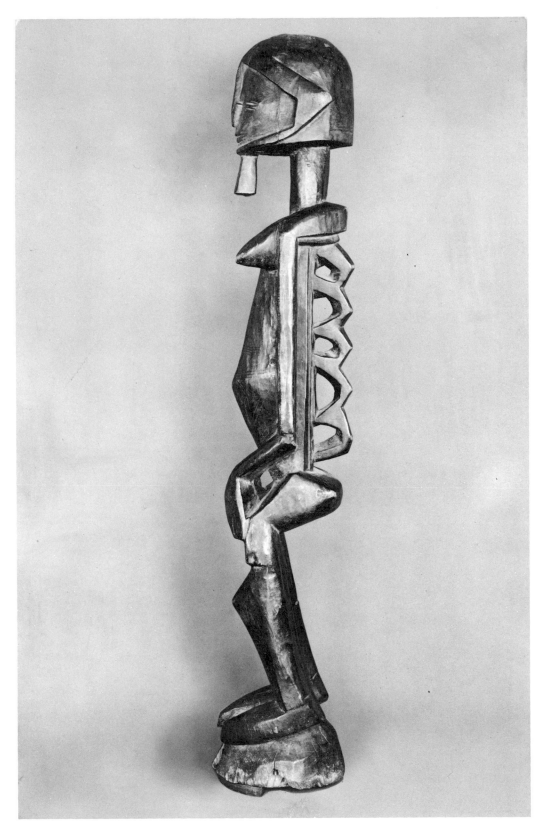

43. FIGURE. Wood, h. 30 in. *Dogon, Mali*

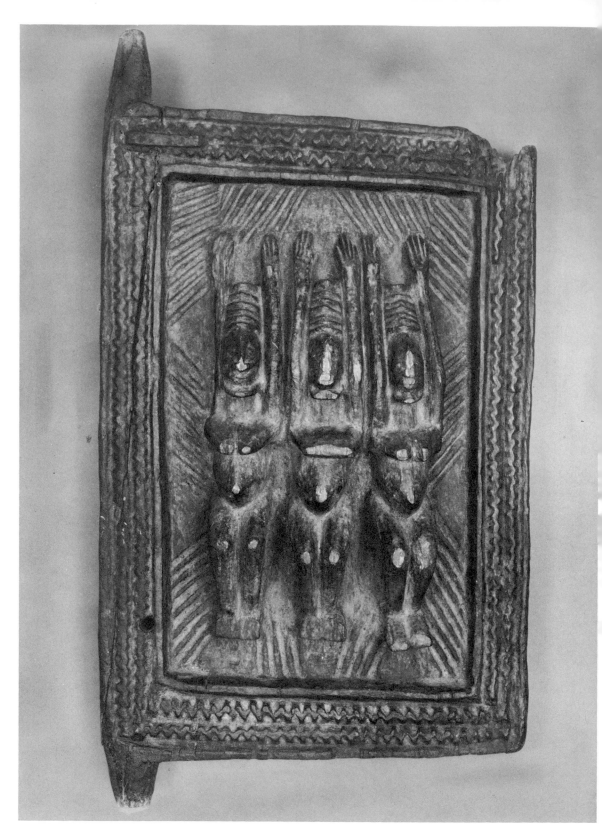

44. Door. Wood, h. 18⅞ in. *Dogon, Mali*

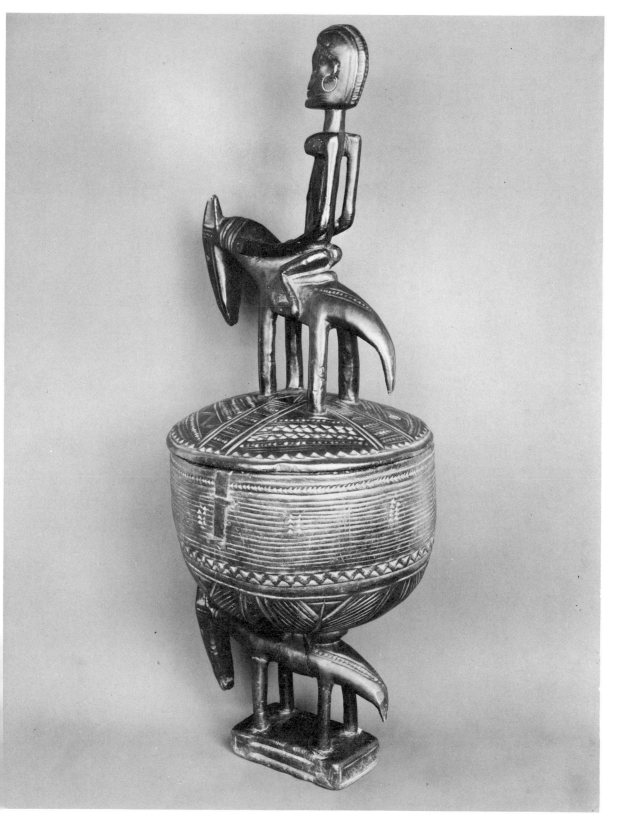

45. URN. Wood, h. 29½ in. *Dogon, Mali*

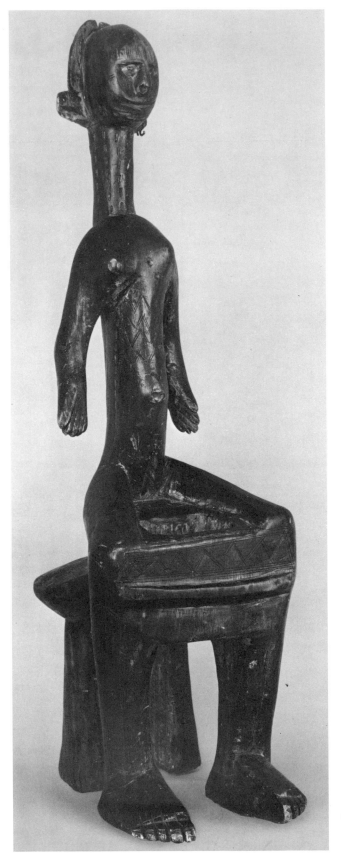

46. FEMALE FIGURE. Wood, h. 21½ i
Dogon, Mali

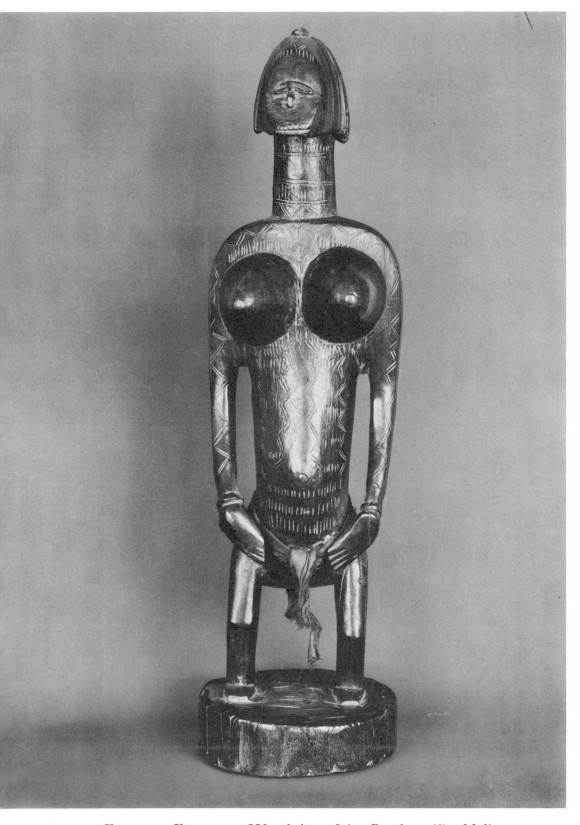

47. FEMALE FIGURE. Wood, h. 19⅝ in. *Bambara (?), Mali*

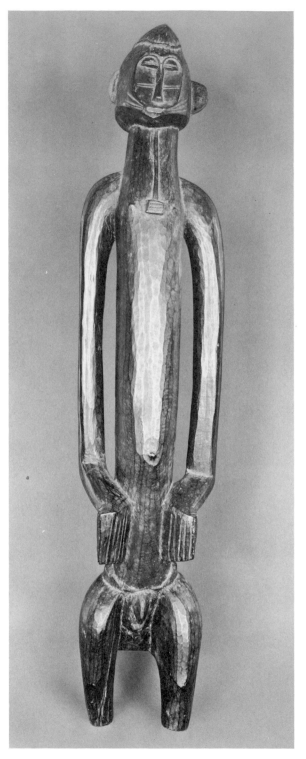

48. Figure. Wood, h. 35 in.
Senufo, Mali and Ivory Coast

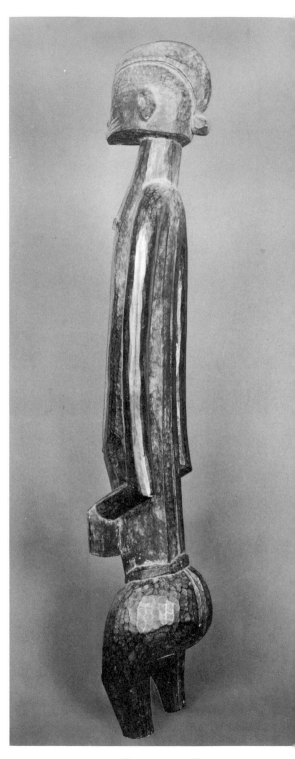

49. Same, profile

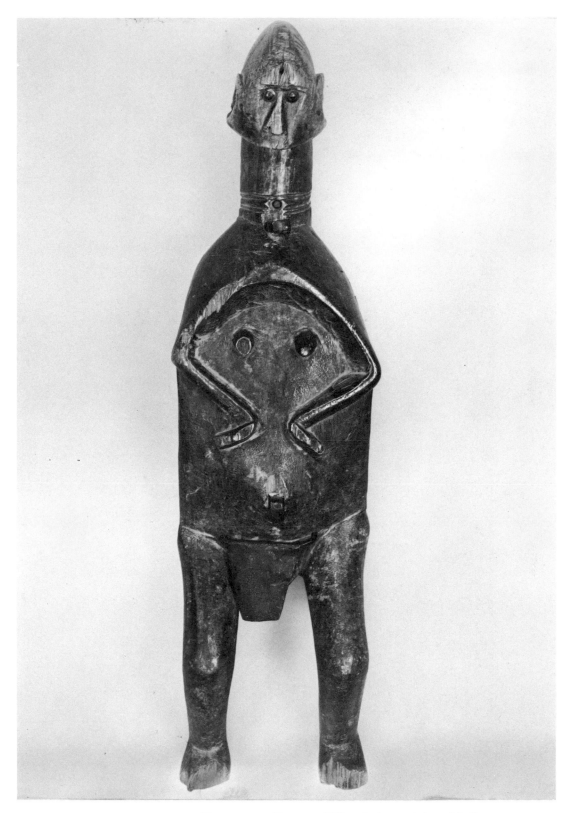

50. LATCH IN FEMALE FORM. Wood, h. $21\frac{1}{2}$ in. *Mali*

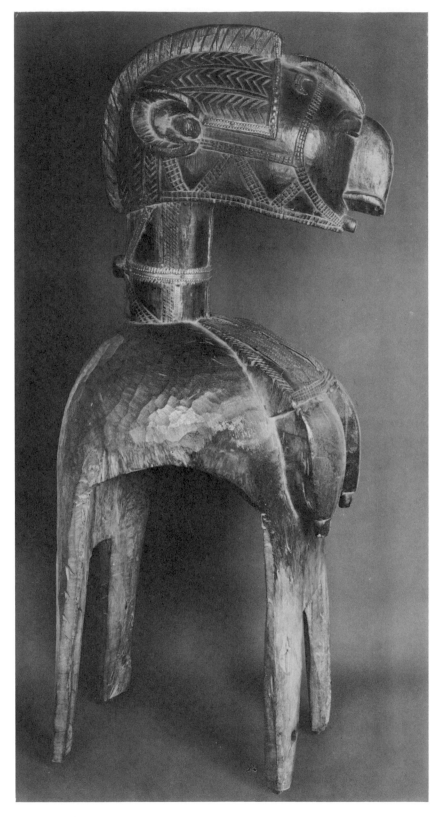

51. HEAD-DRESS. Wood, partly overlaid with metal, h. 40½ in.
Baga, Guinea

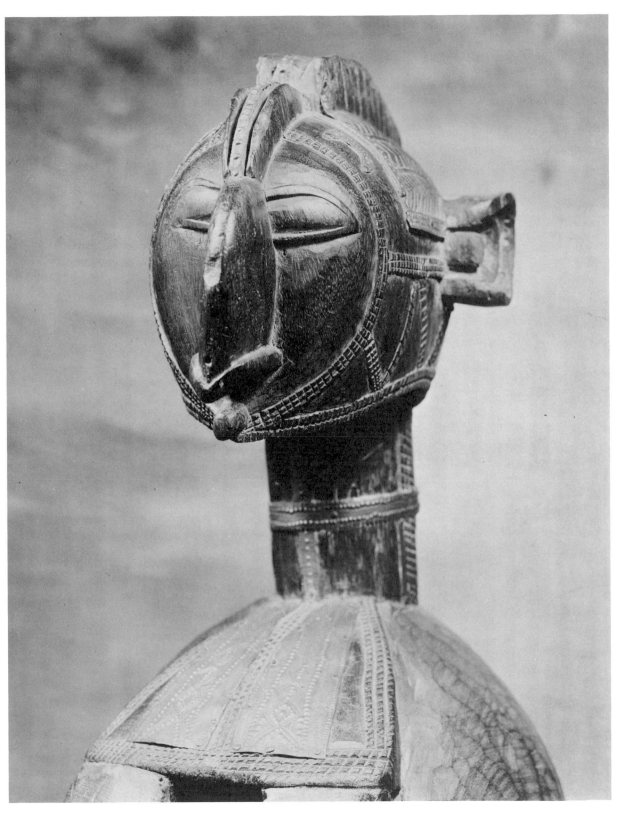

52. Same, detail of front

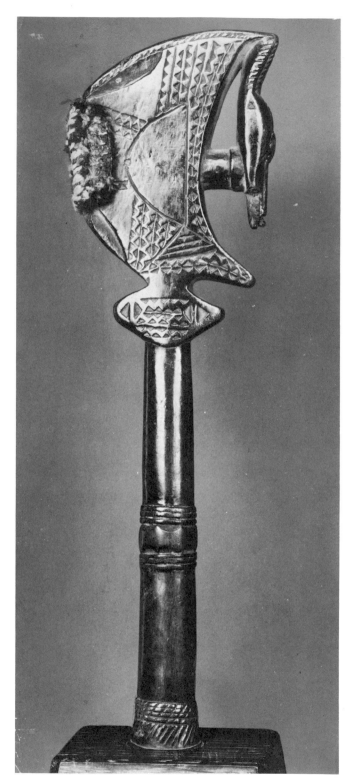

53. Two Gong Hammers. Wood, h. 9 and 6⅞ in. *Baule, Ivory Coast*

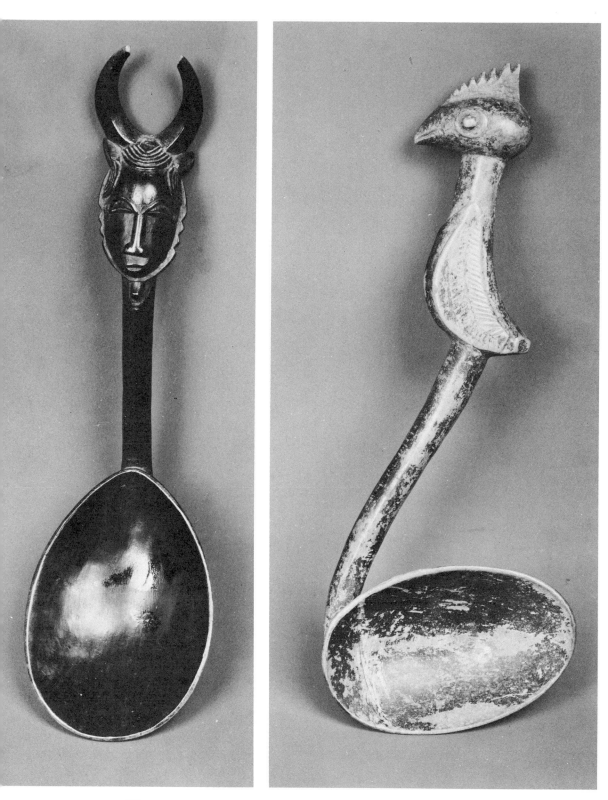

54–55. TWO SPOONS. Wood, h. 8⅝ and 8¼ in. *Baule, Ivory Coast*

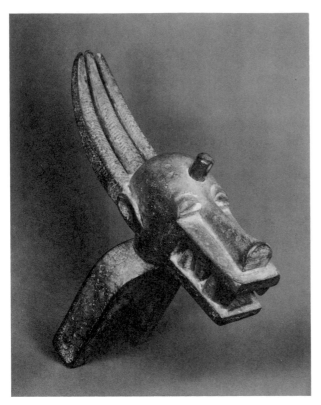

56. BOBBIN. Wood, h. 5⅞ in.
Senufo, Ivory Coast

57–58.
TWO BOBBINS. Wood, h. 7½ and 6⅛ in.
Guro, Ivory Coast

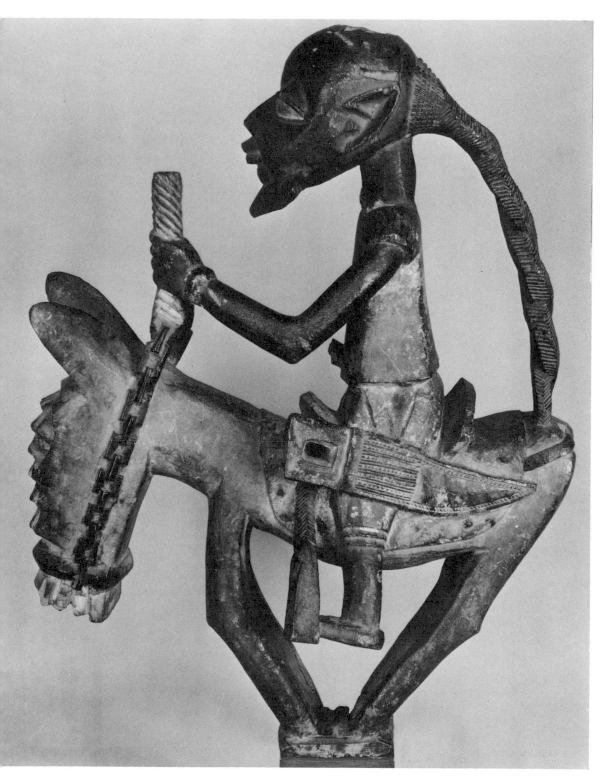

59. EQUESTRIAN FIGURE. Polychrome wood, h. 15¾ in. *Yoruba, Dahomey*

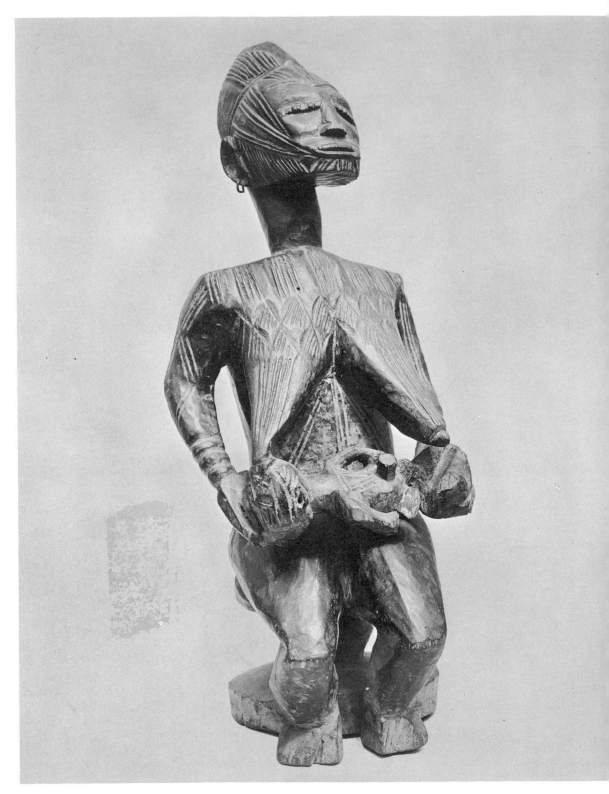

60. MOTHER AND CHILD. Wood, h. 20 in. *Yoruba (?), Nigeria*

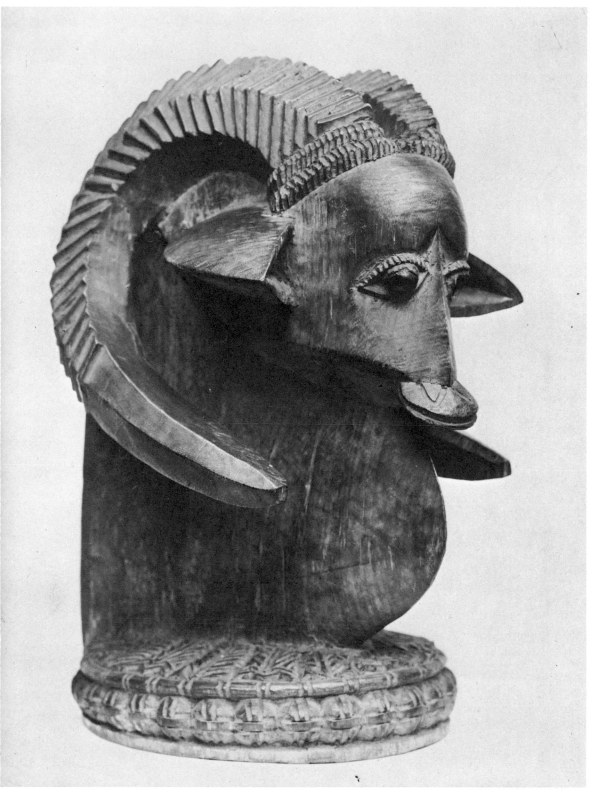

61. RAM'S HEAD. Wood, h. 15 in. *Yoruba, Nigeria*

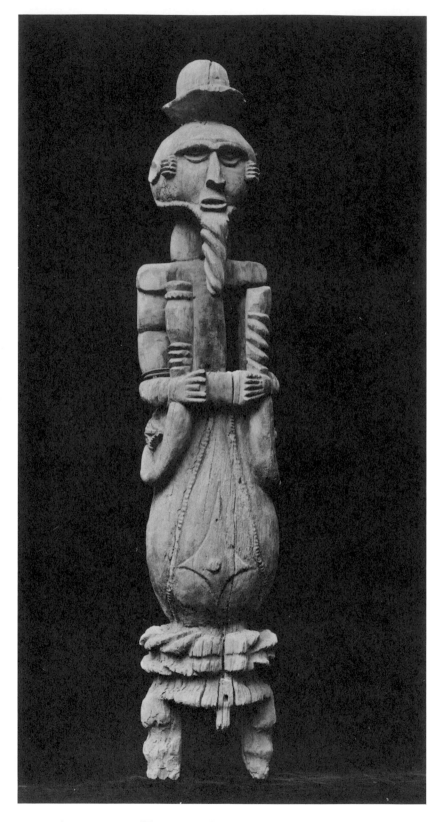

62. ANCESTOR FIGURE. Wood, h. 42 in. *Ibibio, Nigeria*

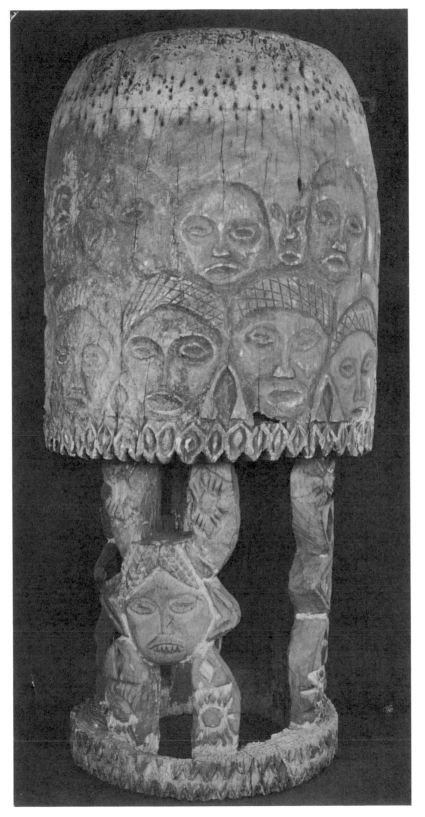

63. DRUM. Wood, h. 44⅛ in. *Bamenda, Cameroon*

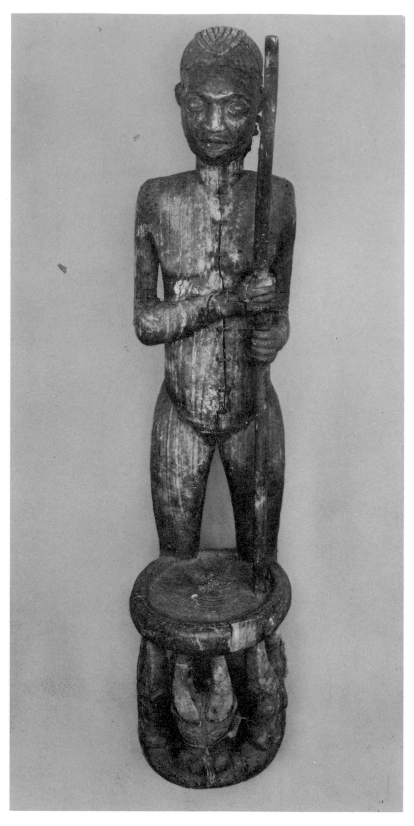

64. CHIEF'S STOOL WITH FIGURE. Wood, h. 71 in.
Bekom, Cameroon

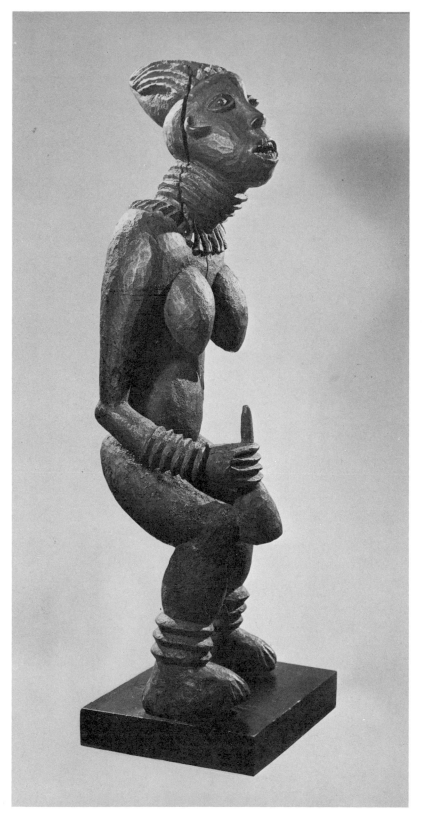

65. MORTUARY FIGURE. Wood, h. 32 in.
Bangwa, Cameroon

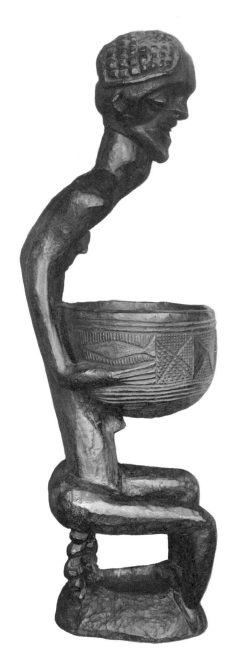

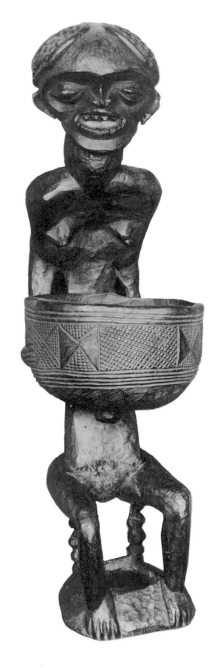

66. MENDICANT FIGURE WITH BOWL.
Wood, h. 33$\frac{1}{8}$ in. *Bangwa, Cameroon*

67. Same, front view

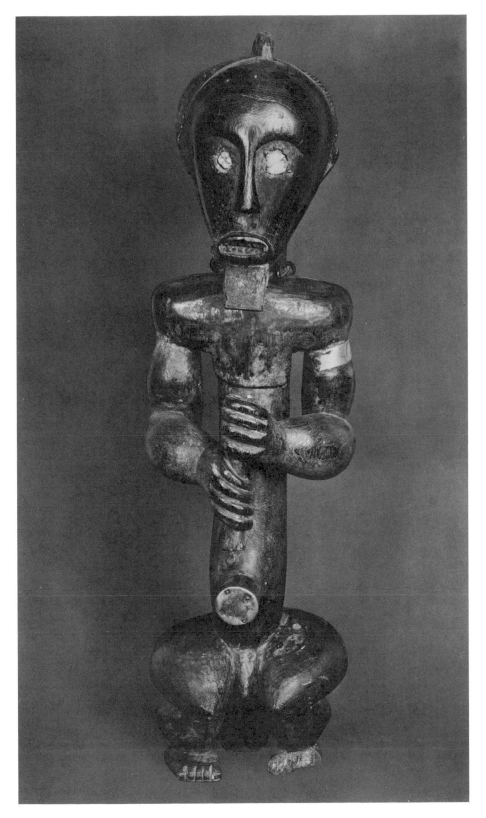

68. ANCESTOR FIGURE. Wood, h. 23 in. *Fang, Gabon*

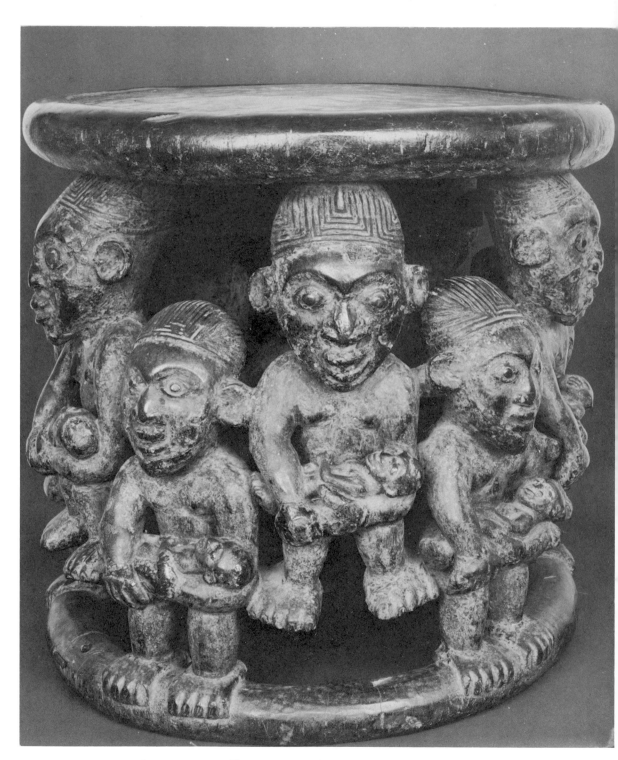

69. Seat with Figures. Wood, h. 22 in. *Yoko, Cameroon*

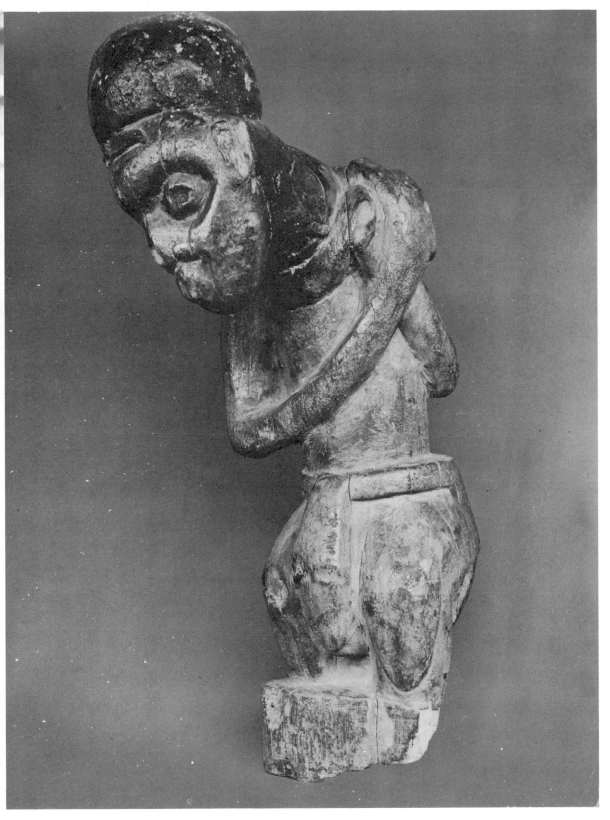

70. FIGURE. Wood, h. 17¼ in. *Bamum, Cameroon*

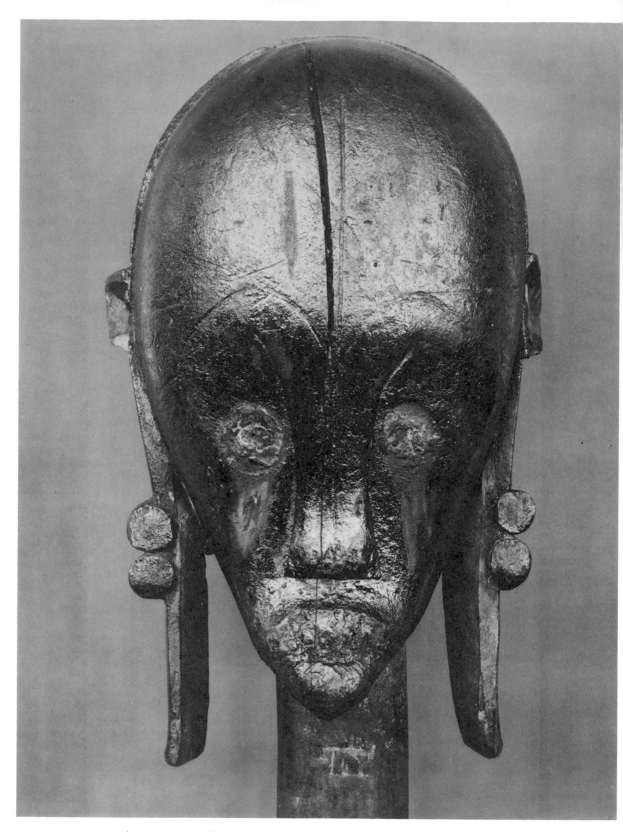

71. ANCESTOR FIGURE, HEAD. Wood, h. 17¾ in. *Fang, Gabon*

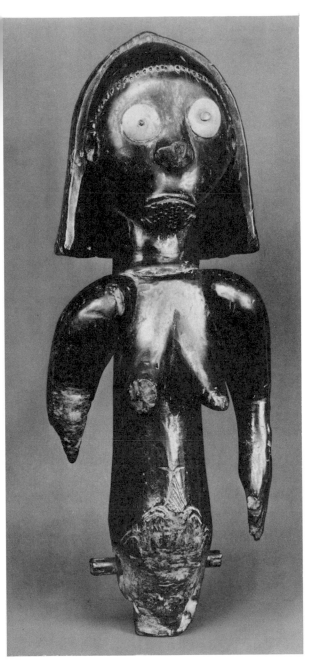

72. ANCESTOR FIGURE.
Wood, h. 11¾ in. *Fang, Gabon*

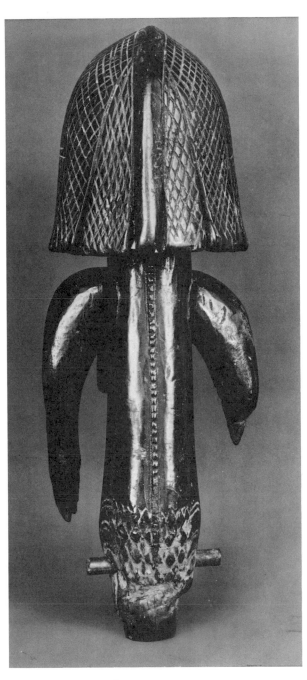

73. Same, rear view

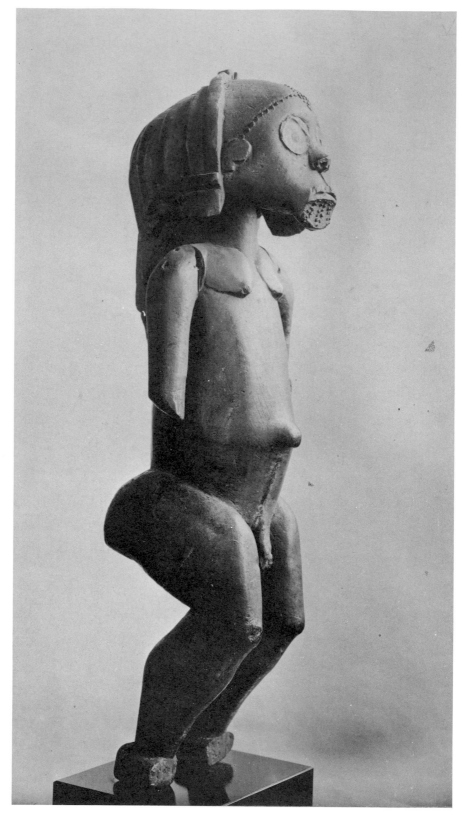

74. MALE FIGURE. Wood, h. 27 in. *Fang, Gabon*

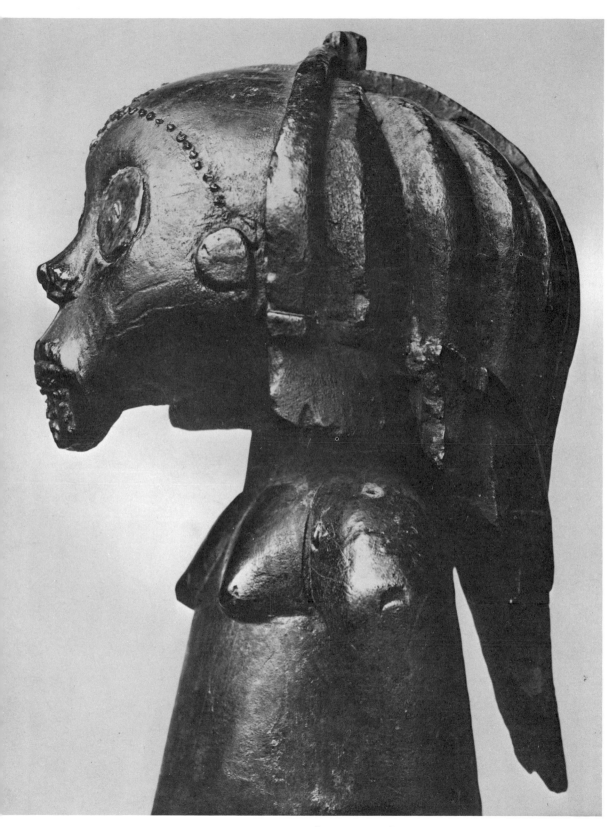

75. Same, detail of head, profile

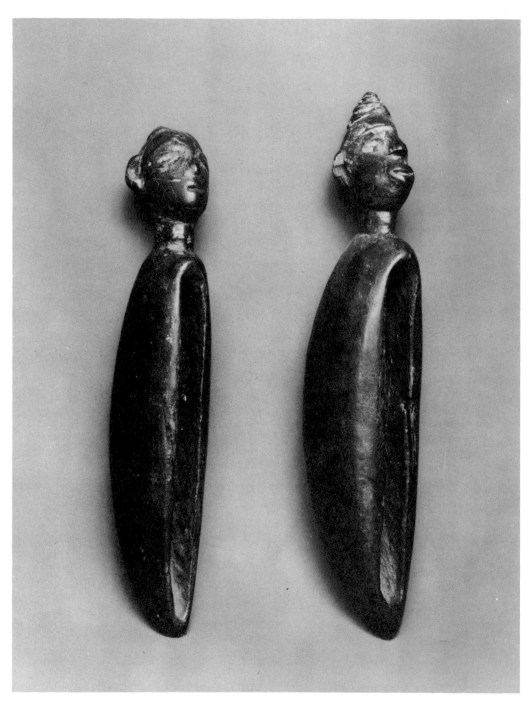

76. Two Musical Instruments. Wood, h. 6½ in.
Loango (?), Congo (Brazzaville)

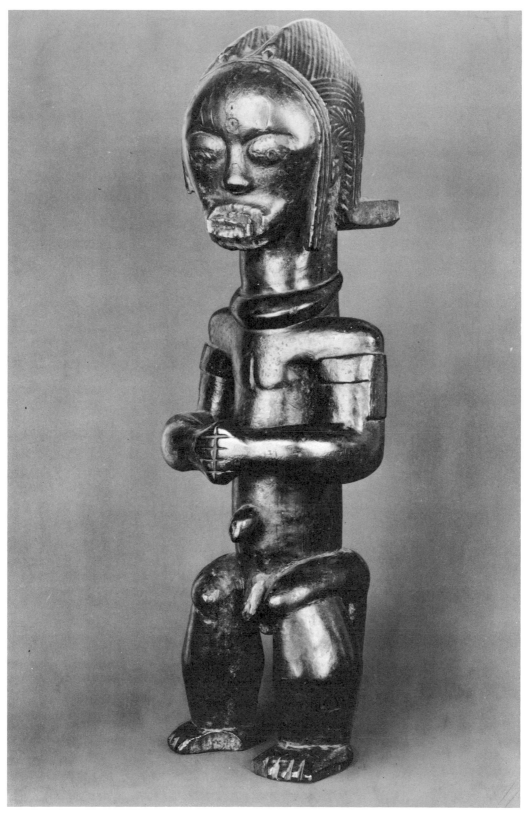

77. ANCESTOR FIGURE. Wood, h. 24⅞ in. *Fang, Gabon*

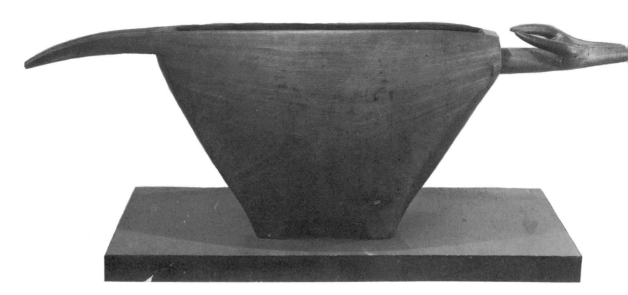

78. DRUM. Wood, h. 39⅓ in., l. 79½ in. *Yangere, Congo (Leopoldville)*

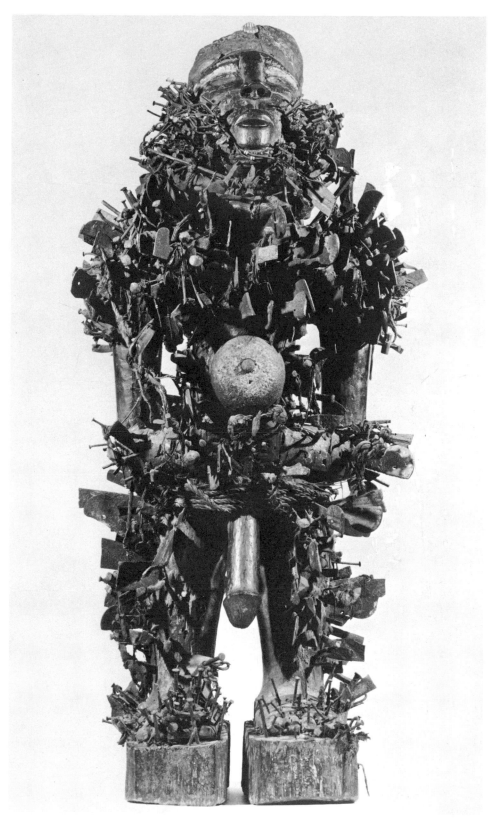

79. NAIL FETISH. Wood, h. 3½ ft. *Bakongo, Congo (Leopoldville)*

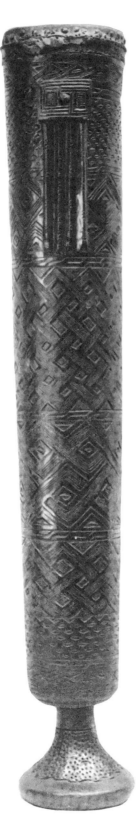

80. DRUM. Wood, h. 72 in. *Bashilele (?), Congo (Leopoldville)*

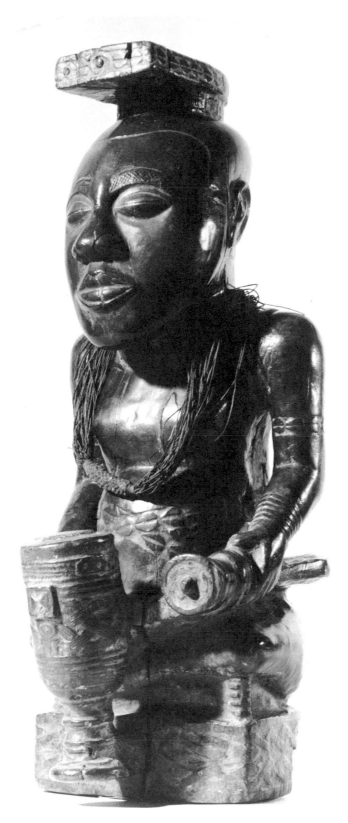

81. PORTRAIT FIGURE. Wood, h. 24 in. *Bakuba, Congo (Leopoldville)*

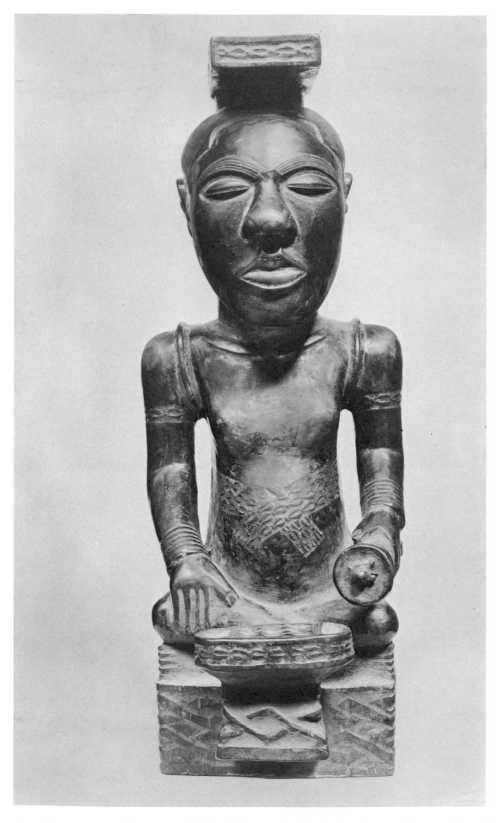

82. PORTRAIT FIGURE. Wood, h. 24 in. *Bakuba, Congo (Leopoldville)*

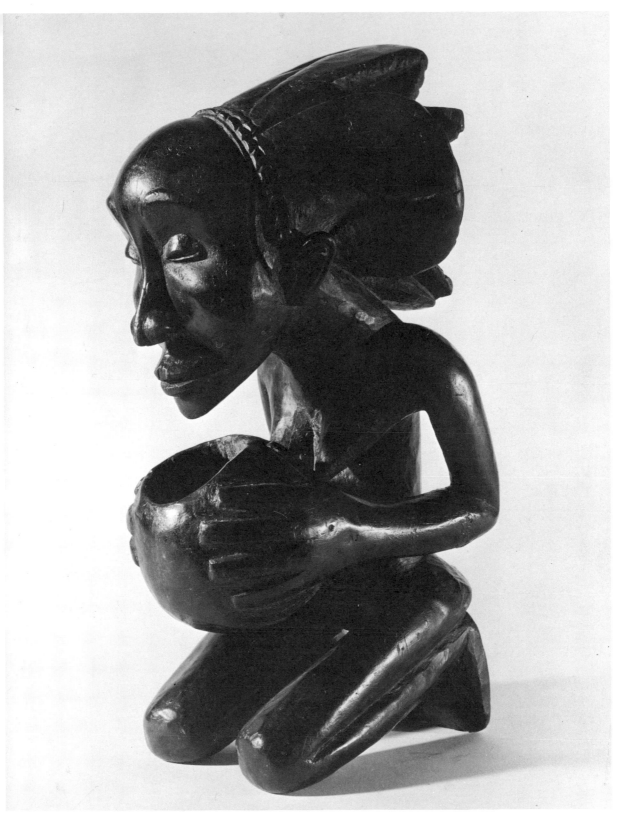

83. FEMALE FIGURE. Wood, h. 18, in. *Baluba, Congo (Leopoldville)*

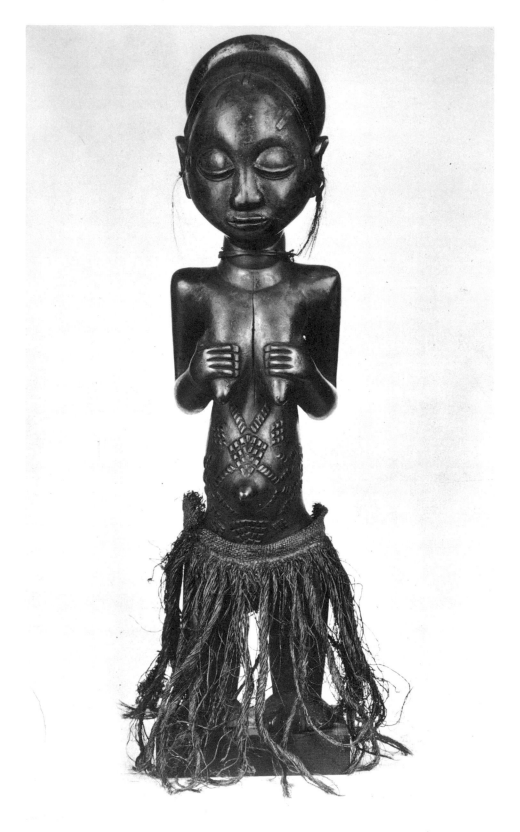

84. FEMALE FIGURE. Wood, h. 18 in. *Baluba, Congo (Leopoldville)*

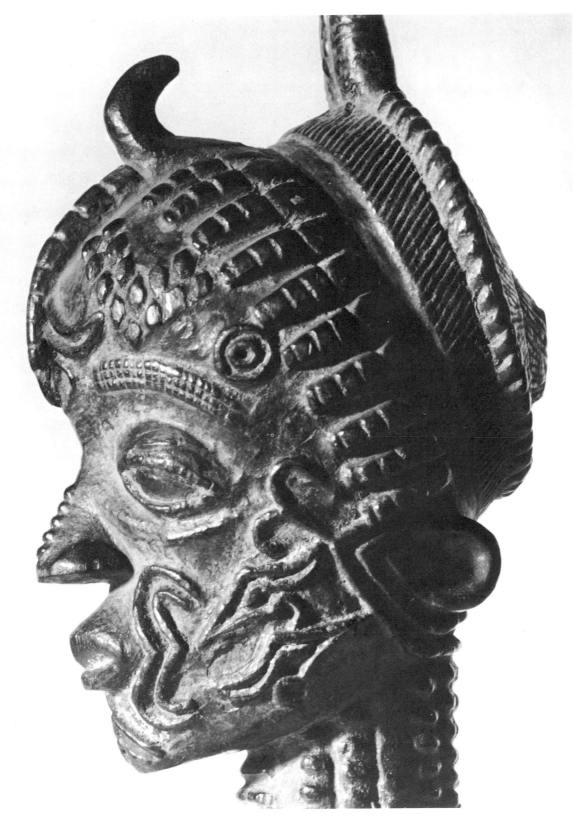

85. FEMALE FIGURE: DETAIL. Wood, h. 5 in. *Bena Lulua, Congo (Leopoldville)*

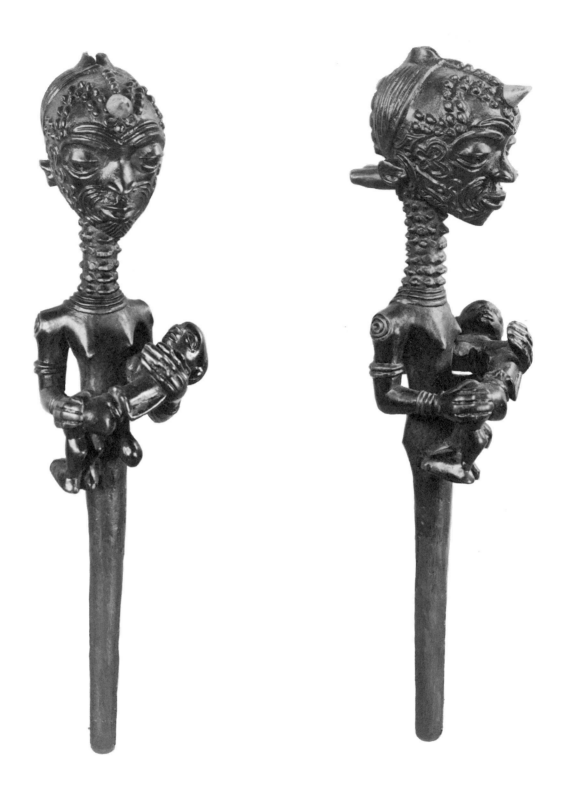

86. Carved Baton. Wood, h. 14 in.
Bena Lulua, Congo (Leopoldville)

87. Same, profile

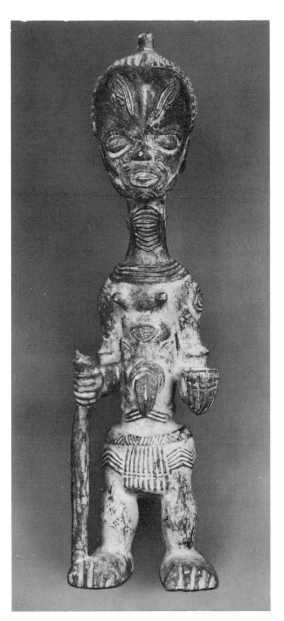

88. Figure. Wood, h. 17⅜ in.
Bena Lulua, Congo (Leopoldville)

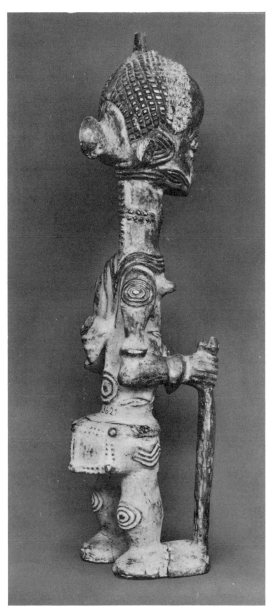

89. Same, profile

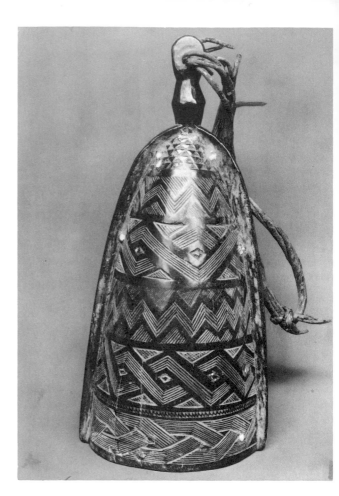

90. CUP. Wood.
 Basonge, Congo (Leopoldville)

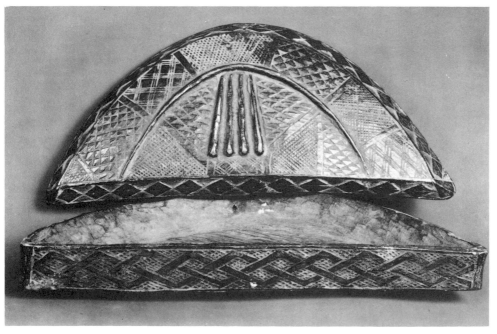

91. BOX, WITH COVER. Wood. *Bakuba, Congo (Leopoldville)*

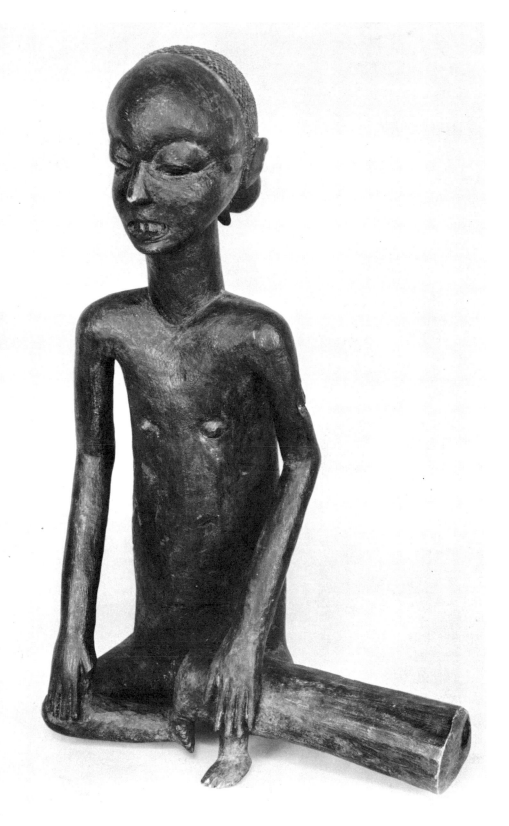

92. FIGURE WITH DRUM. Wood, h. 15¼ in. *Kanioka, Congo (Leopoldville)*

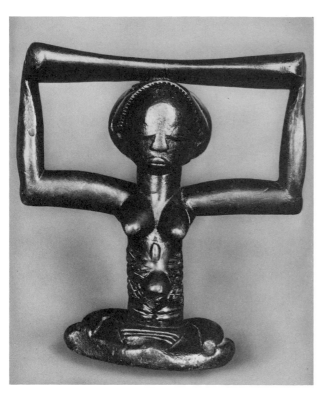

93. HEADREST. Wood, h. 6¾ in.
Central Baluba, Congo (Leopoldville)

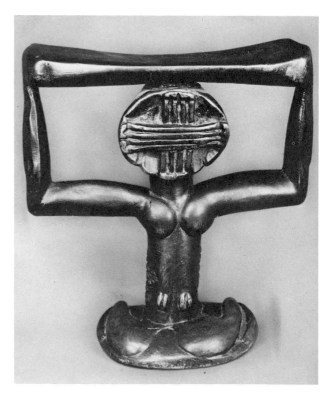

94. Same, rear view

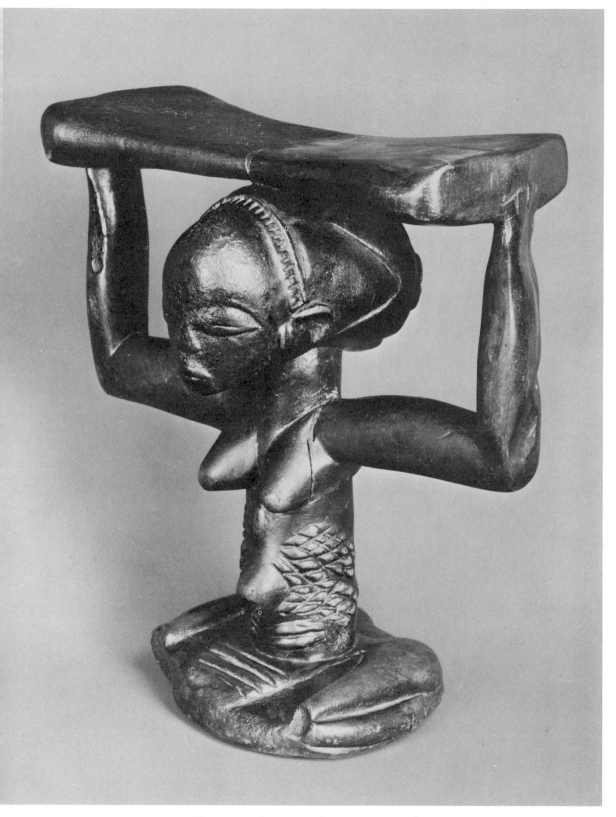

95. Same as plate 93, three-quarter view

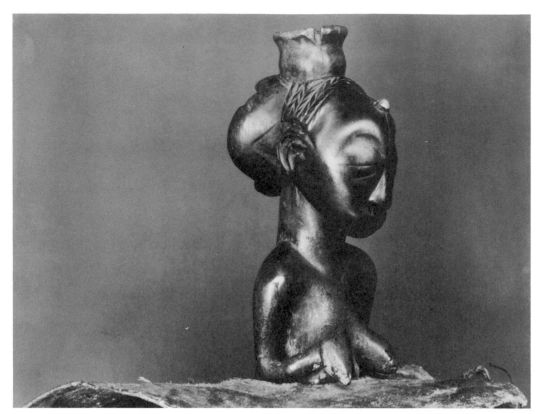

96. FIGURE. Wood, surmounting a cala-
bash, with shells, h. 14⅛ in.
Central Baluba, Congo (Leopoldville)

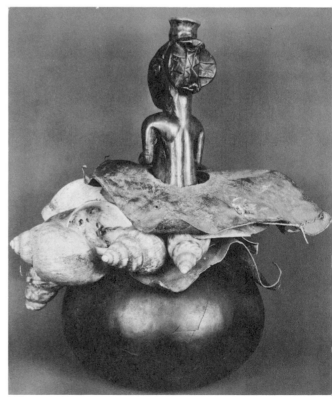

97. Same, in full, rear view

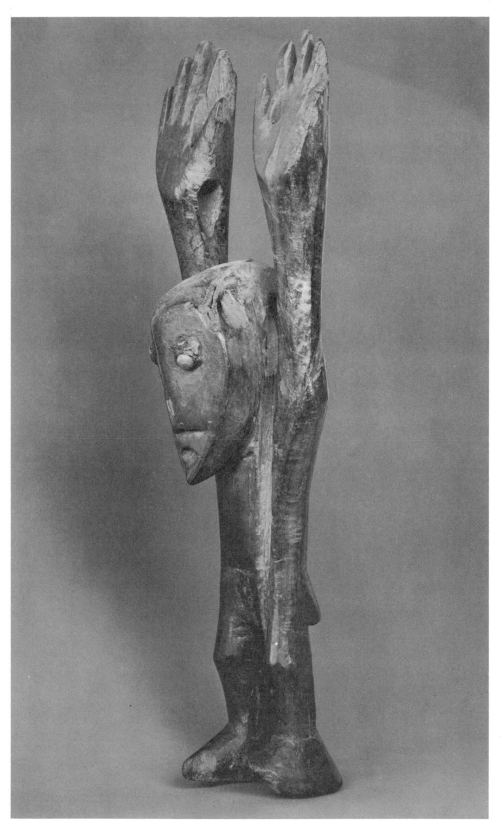

98. FIGURE. Wood, h. 9¼ in. *Warega, Congo (Leopoldville)*

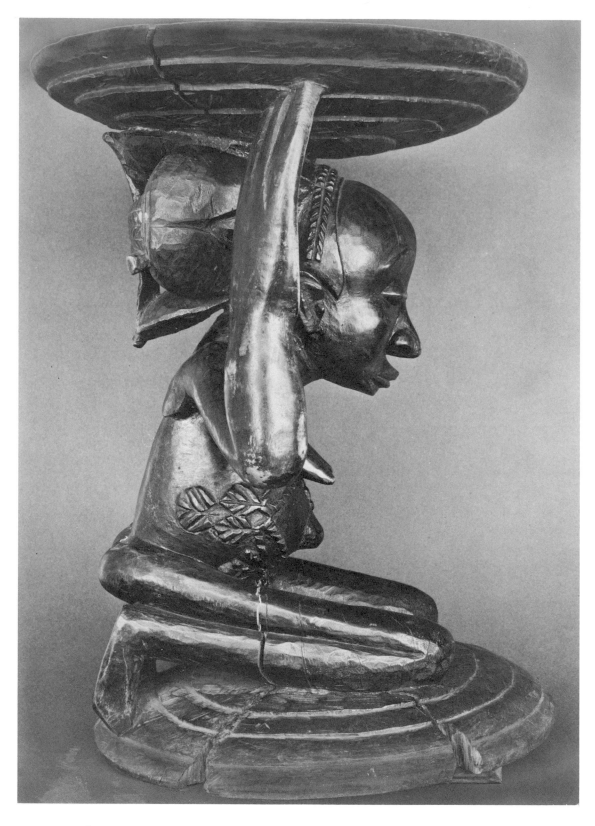

99. STOOL. Wood, h. 18½ in. *Northeastern Baluba, Congo (Leopoldville)*

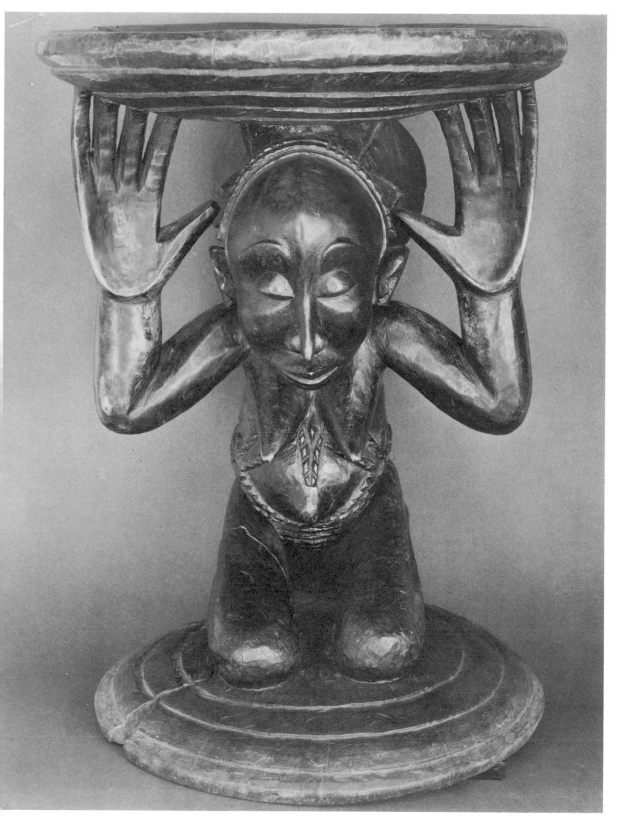

100. Same, front view

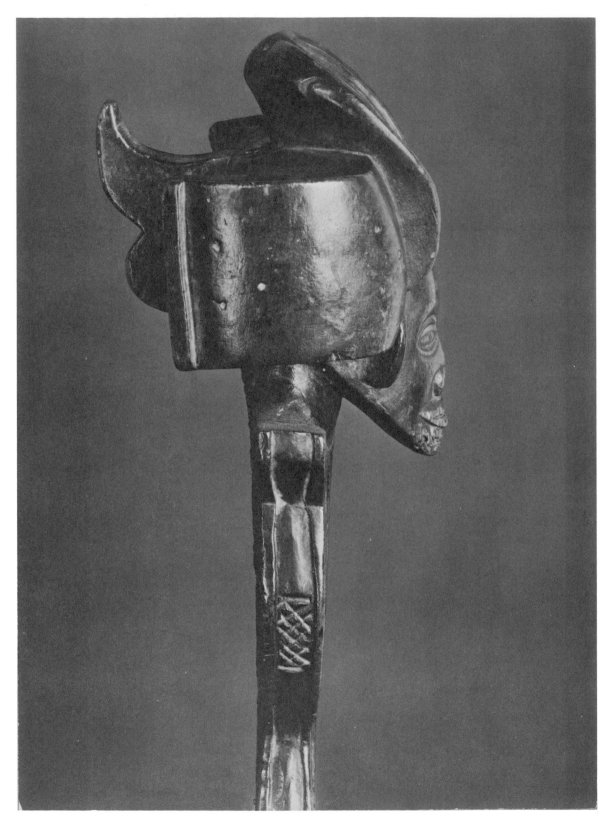

101. SCEPTRE. Wood, h. 15¾ in. *Bachokwe, Angola*

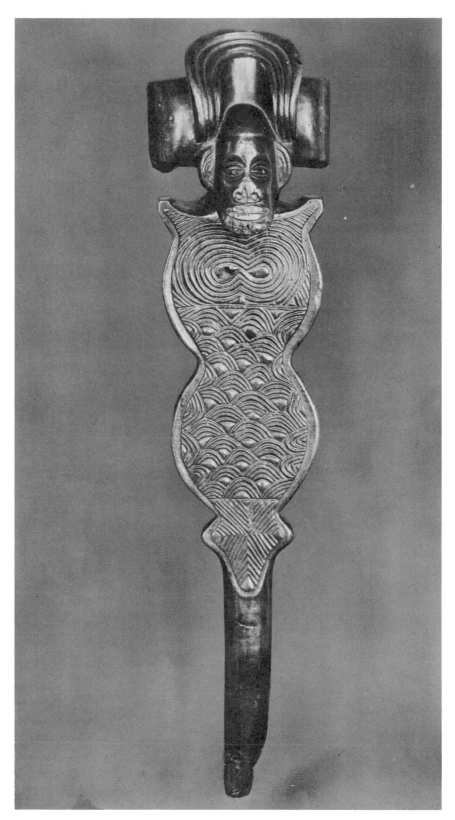

102. Same, in full, front view

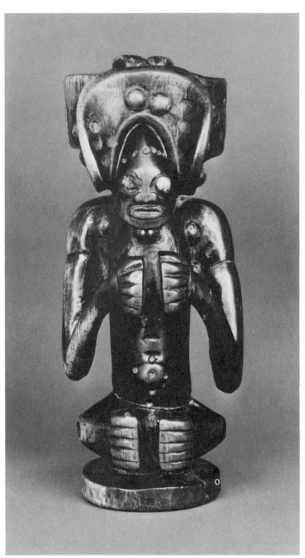

103. FIGURE. Wood, h. 5¾ in.
Bachokwe, Angola

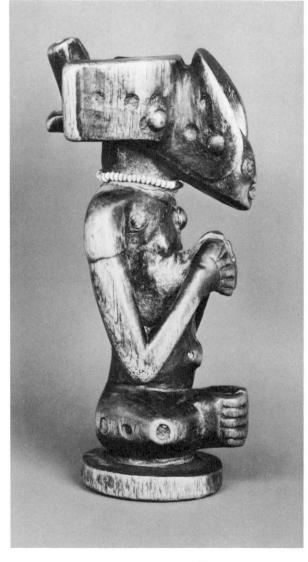

104. Same, profile

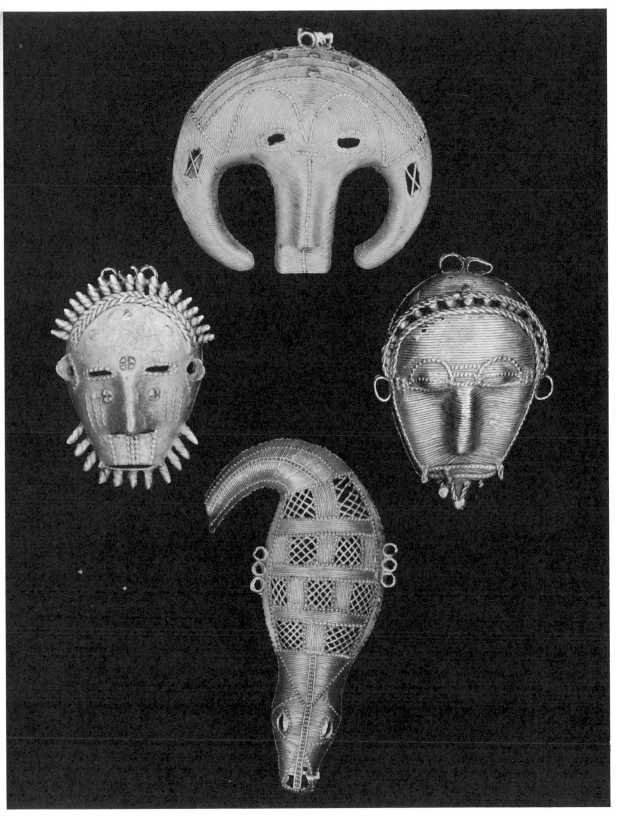

105. ORNAMENTS. Gold, cire-perdu technique, h. about 3 to 4 in.
(top and bottom) *Baule, Ivory Coast* (center), *Lobi, Ghana*

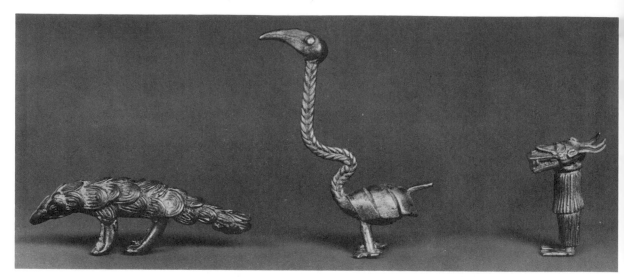

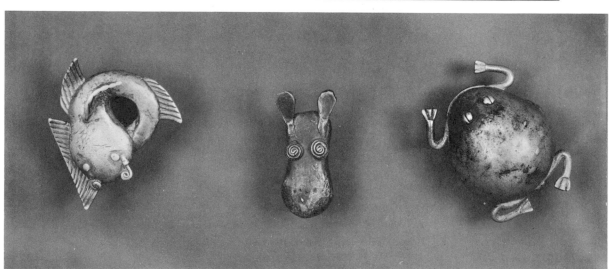

106–108. GOLD-DUST WEIGHTS. Bronze, cire-perdu technique, actual size.
Baule, Ivory Coast or *Ashanti, Ghana*

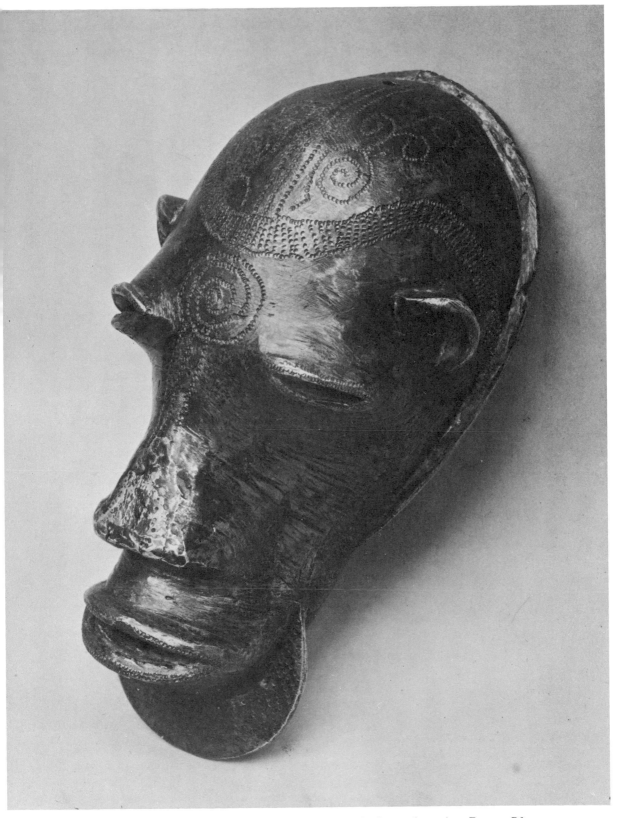

109. MAN'S HEAD. Bronze, cire-perdu technique, h. 6 in. *Bron, Ghana*

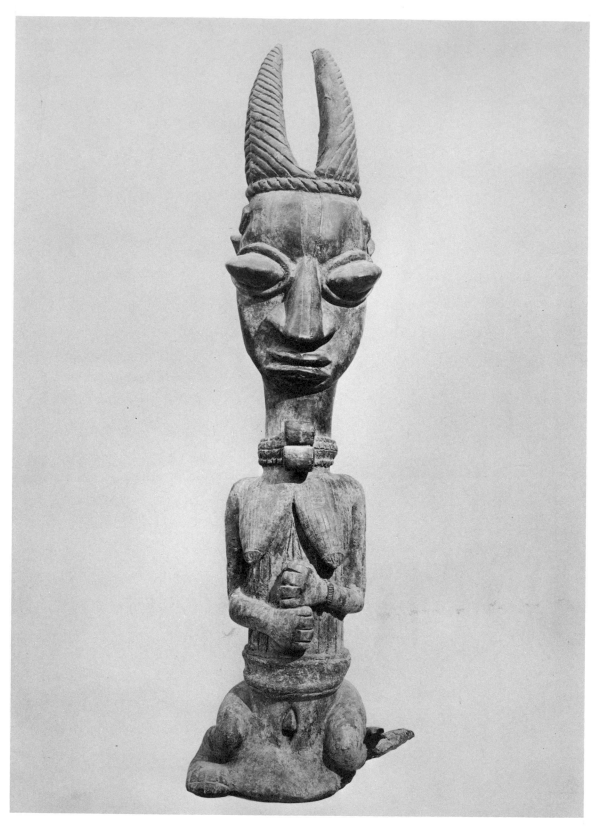

110. FEMALE FIGURE. Bronze, h. 30 in. *Yoruba, Nigeria*

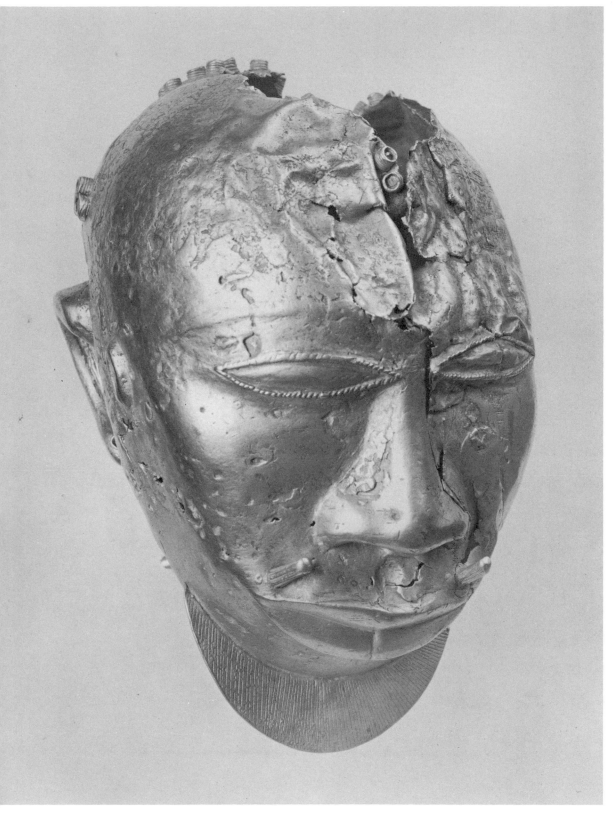

111. Mask. Gold, hollow cast, h. 6⅞ in. *Ashanti, Ghana*

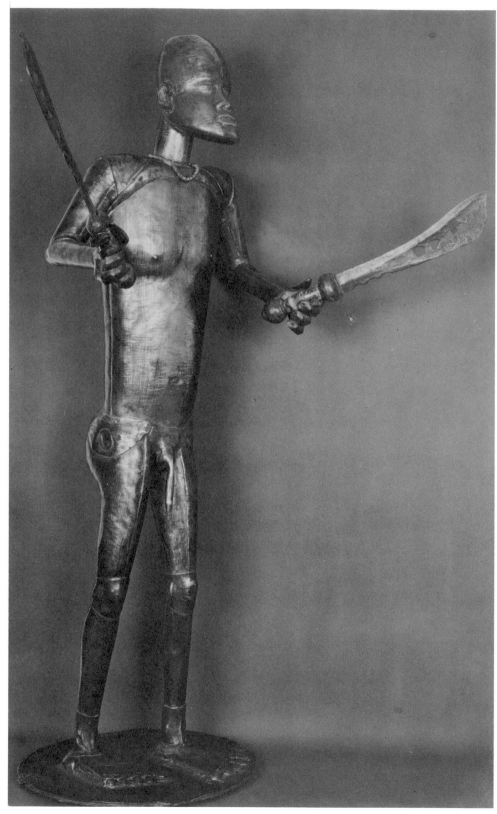

112. FIGURE. Hammered brass, h. 41½ in. *Fon, Dahomey*

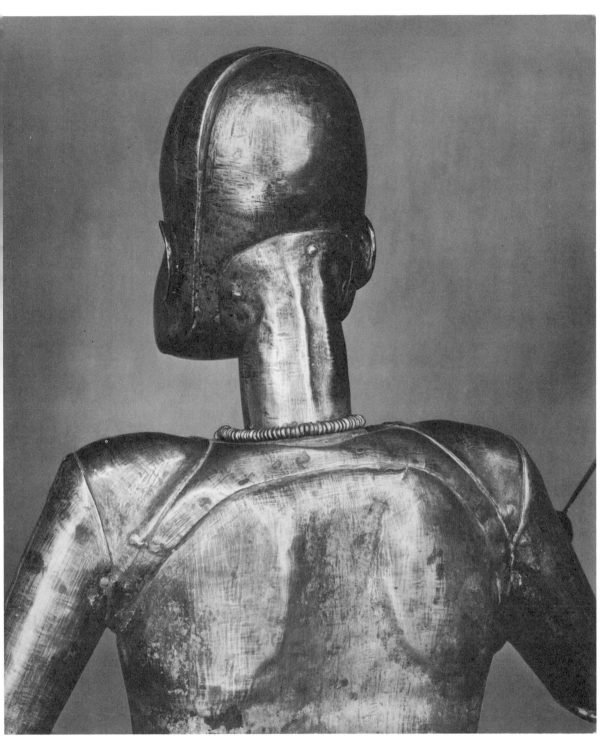

113. Same, detail

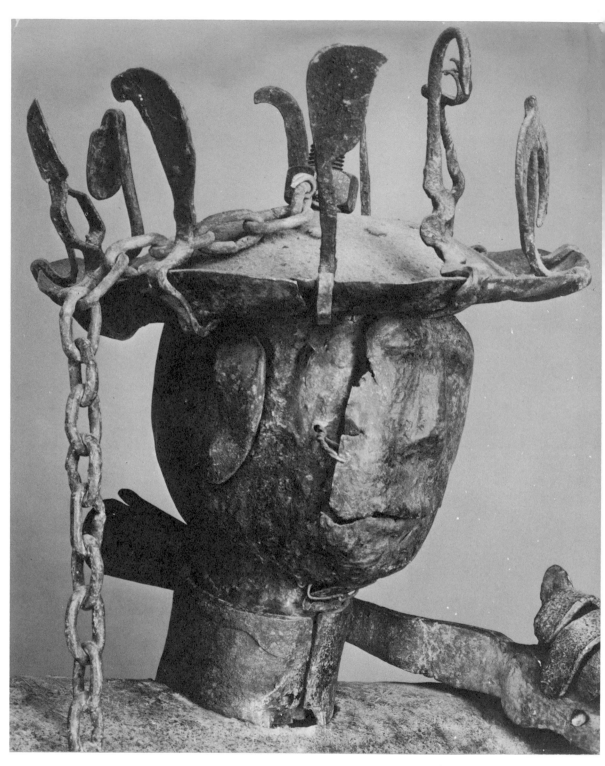

114. Same as plate 115, detail of head, side view

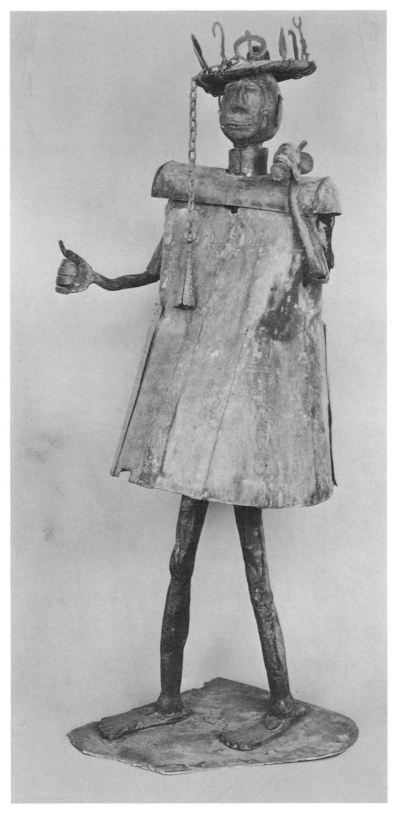

115. FIGURE. Iron, h. 65 in. *Fon, Dahomey*

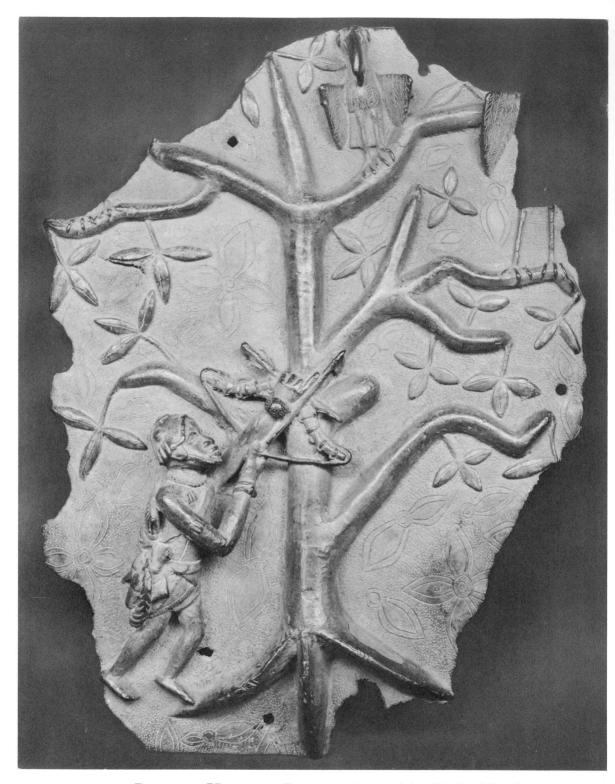

116. PLAQUE: HUNTER. Bronze, 18½ x 12⅝ in. *Benin, Nigeria*

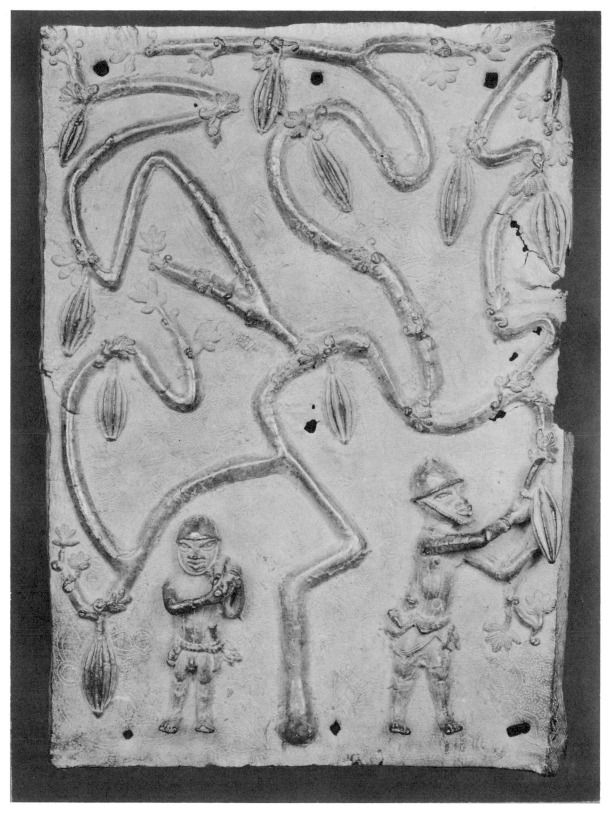

117. PLAQUE: FRUIT-GATHERERS. Bronze, h. 21⅞ in. *Benin, Nigeria*

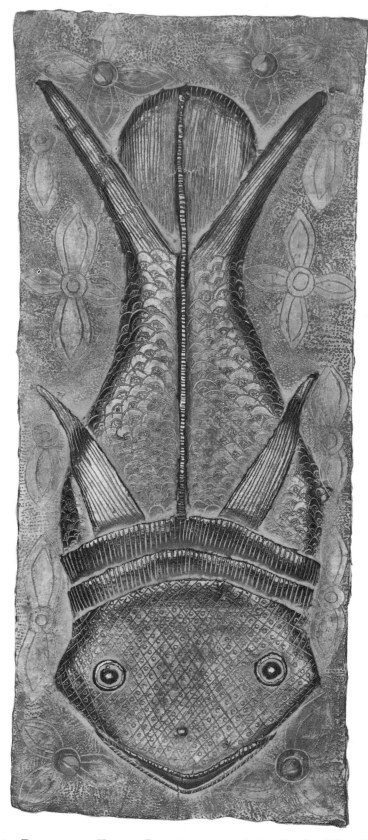

118. Plaque: Fish. Bronze, 17 x 7⅛ in. *Benin, Nigeria*

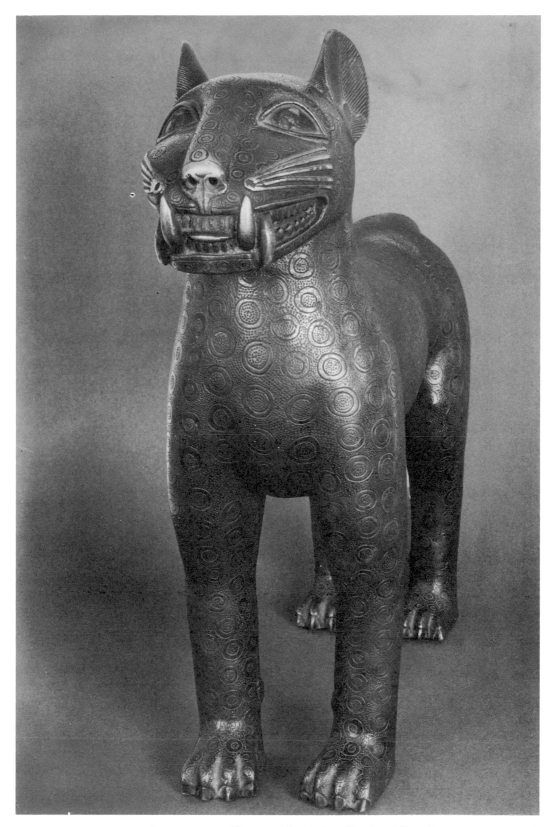

119. LEOPARD. Bronze, l. 28 in. *Benin, Nigeria*

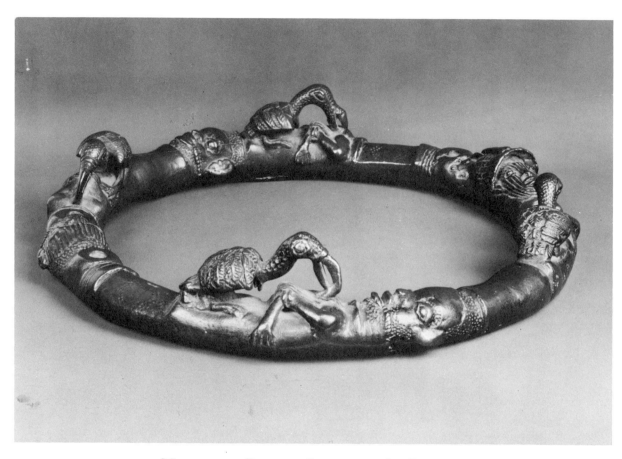

120. NECKLET. Bronze, diameter 10 in. *Benin, Nigeria*

121. REPTILE HEAD. Bronze, l. 20$\frac{1}{8}$ in. *Benin, Nigeria*

122. FIGURE. Bronze, h. 13$\frac{3}{8}$ in. *Benin, Nigeria*

123. Same, rear view

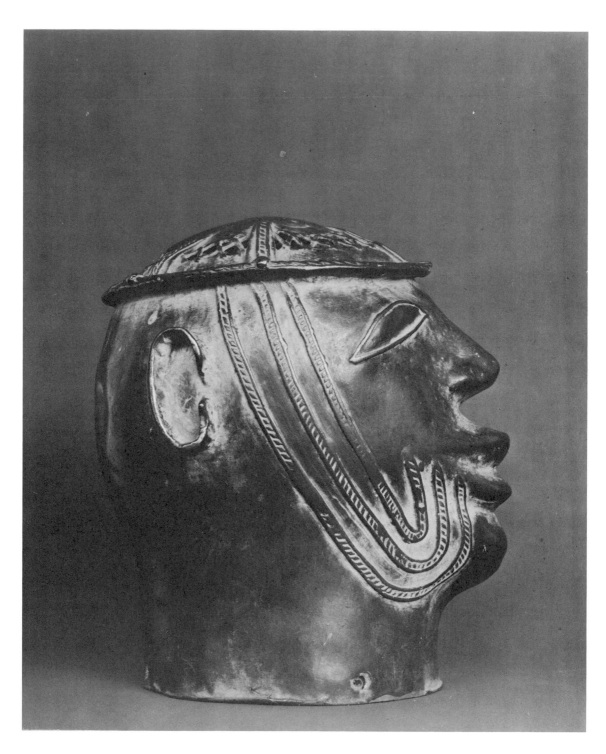

124. HEAD. Bronze, h. 6⅜ in. *Benin, Nigeria*

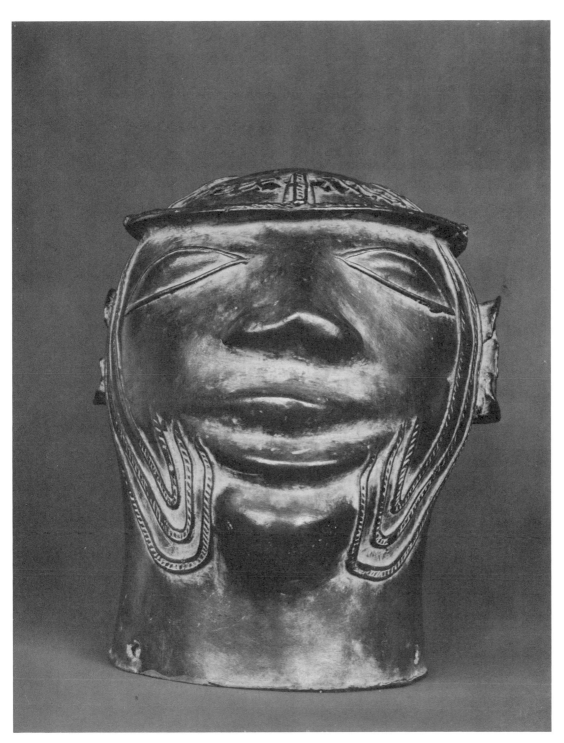

125. Same, full view

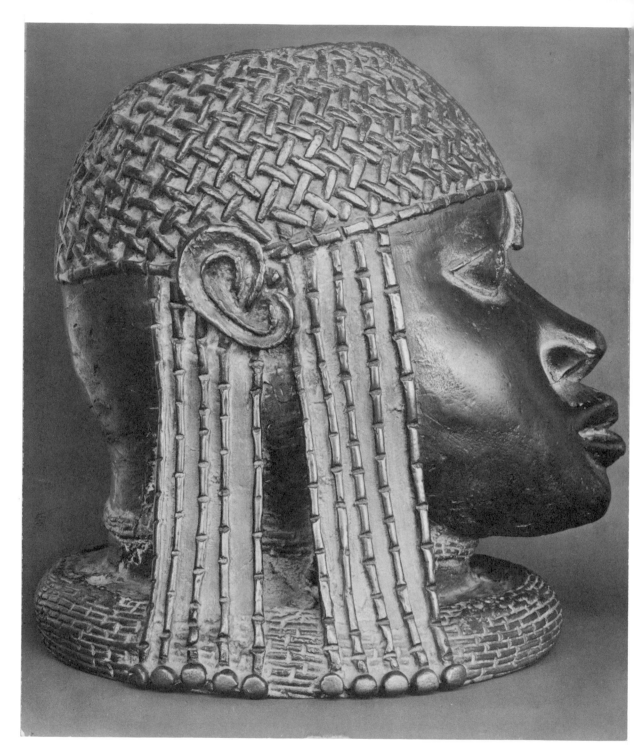

126. HEAD. Bronze, h. 8⅞ in. *Benin, Nigeria*

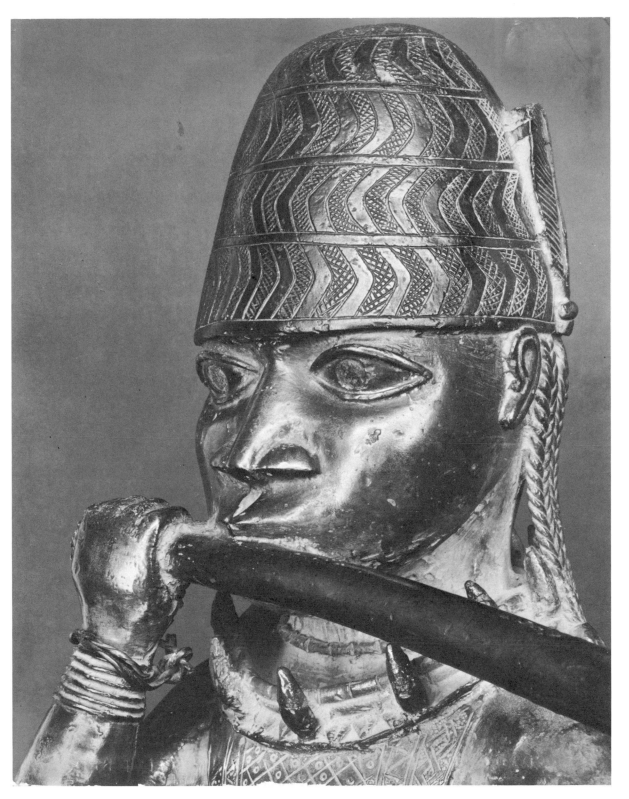

127. FIGURE. Bronze, h. 24⅝ in. *Benin, Nigeria*

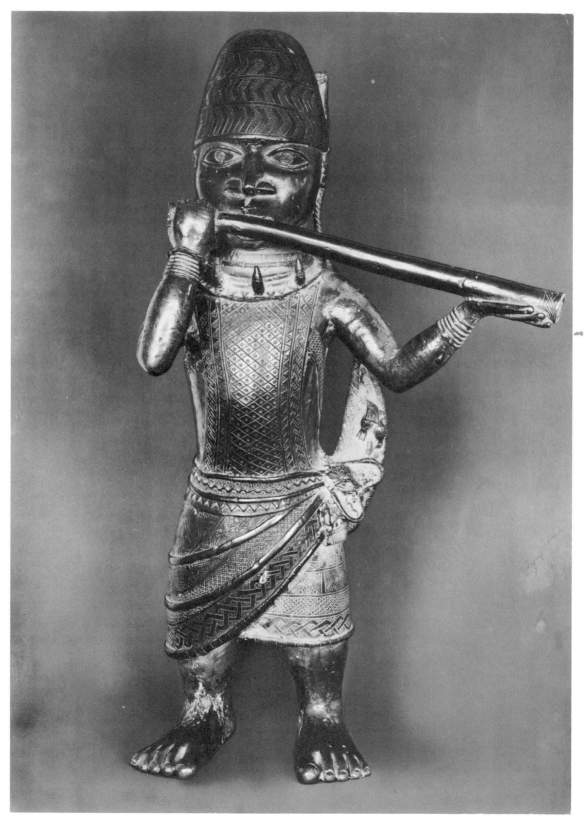

128. Same as plate 127, full view, front

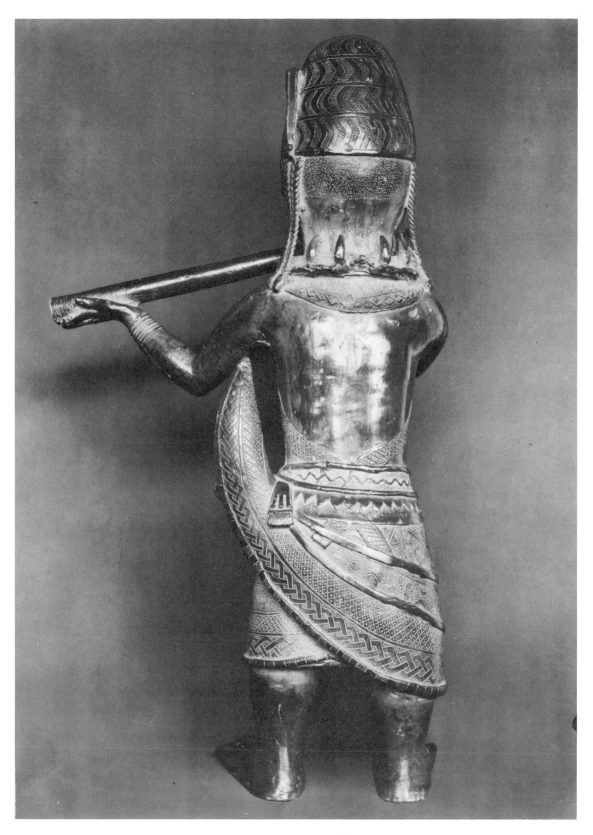

129. Same, rear view

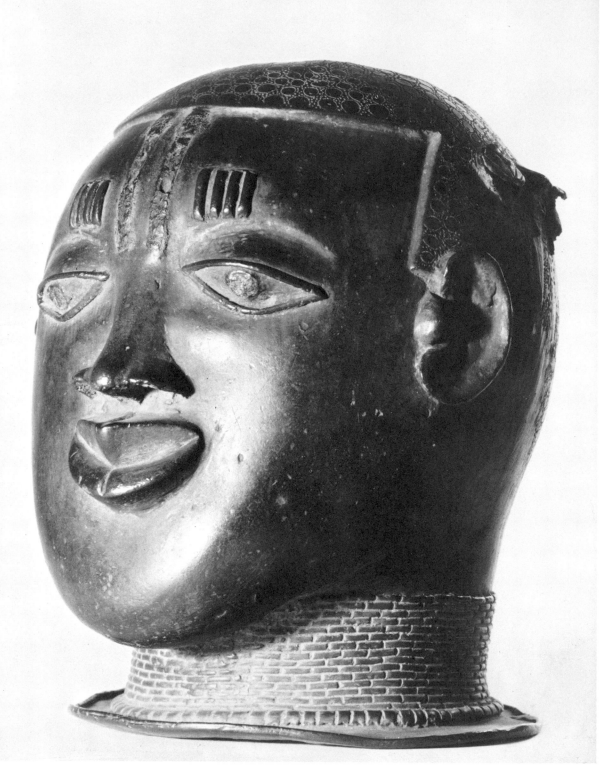

130. HEAD. Bronze, h. $7\frac{3}{4}$ in. *Benin, Nigeria*

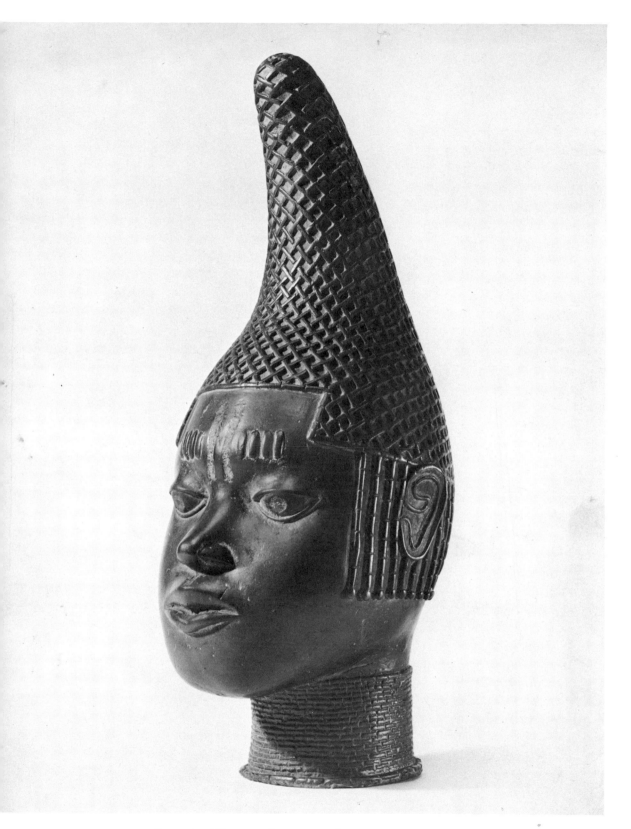

131. GIRL'S HEAD. Bronze, life size. *Benin, Nigeria*

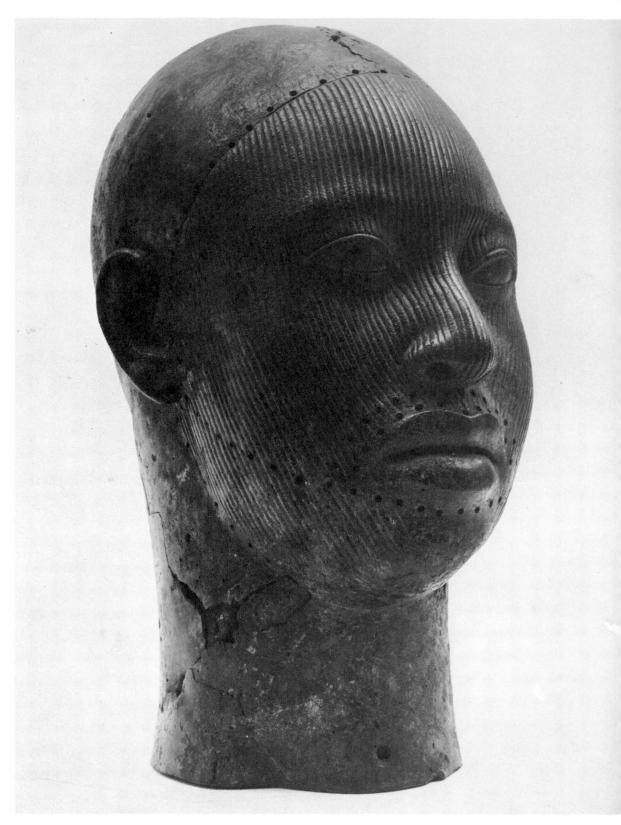

132. HEAD. Bronze, h. 13½ in. *Ife, Nigeria*

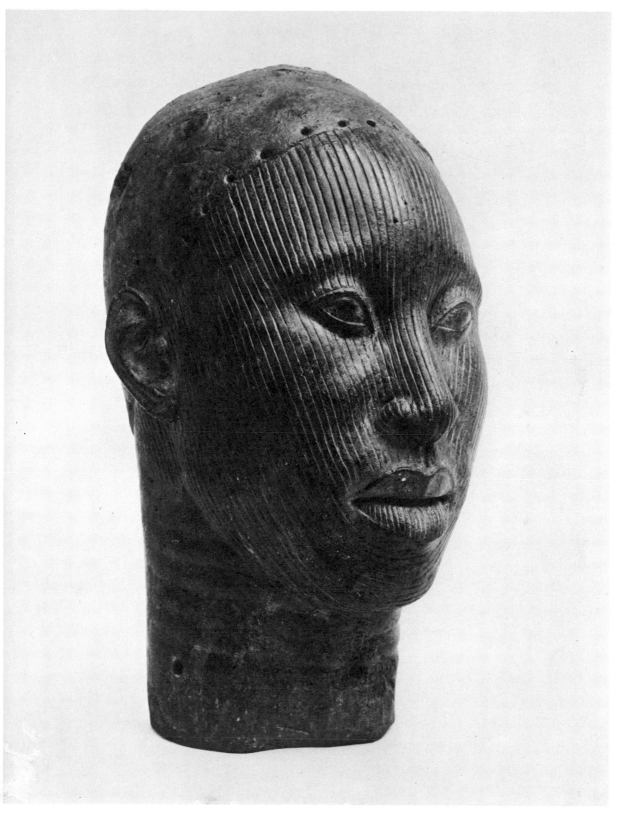

133. HEAD. Bronze, h. 11½ in. *Ife, Nigeria*

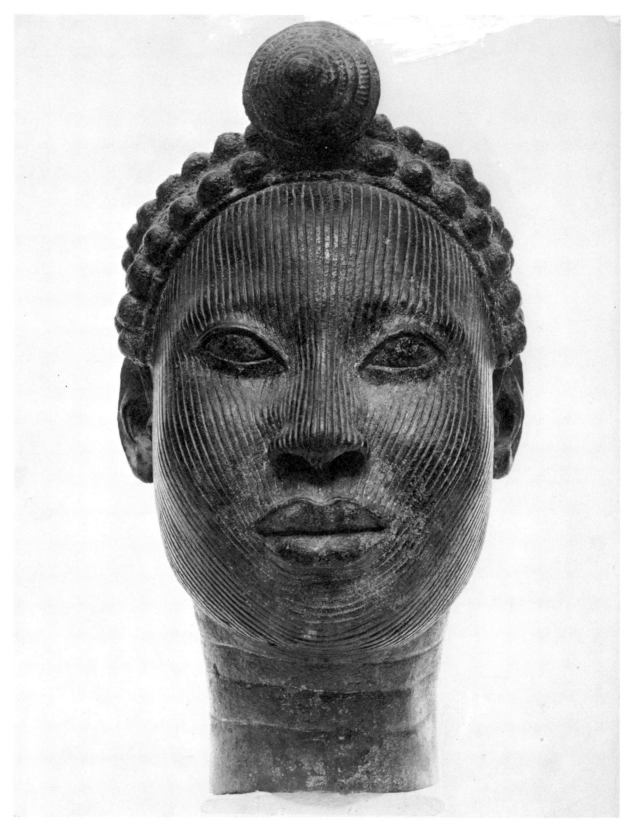

134. GIRL'S HEAD. Bronze, h. 12½ in. *Ife, Nigeria*

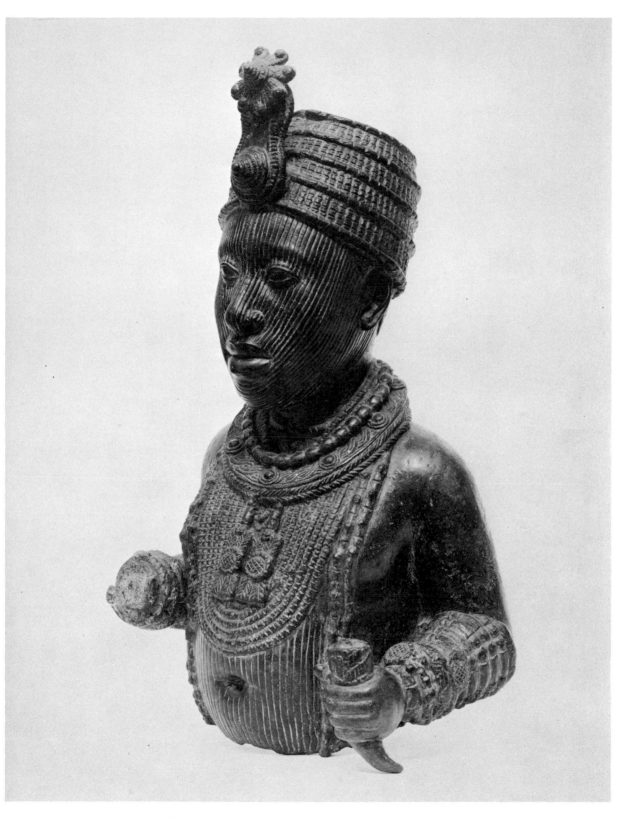

135. HALF-FIGURE. Bronze, h. 14½ in. *Ife, Nigeria*

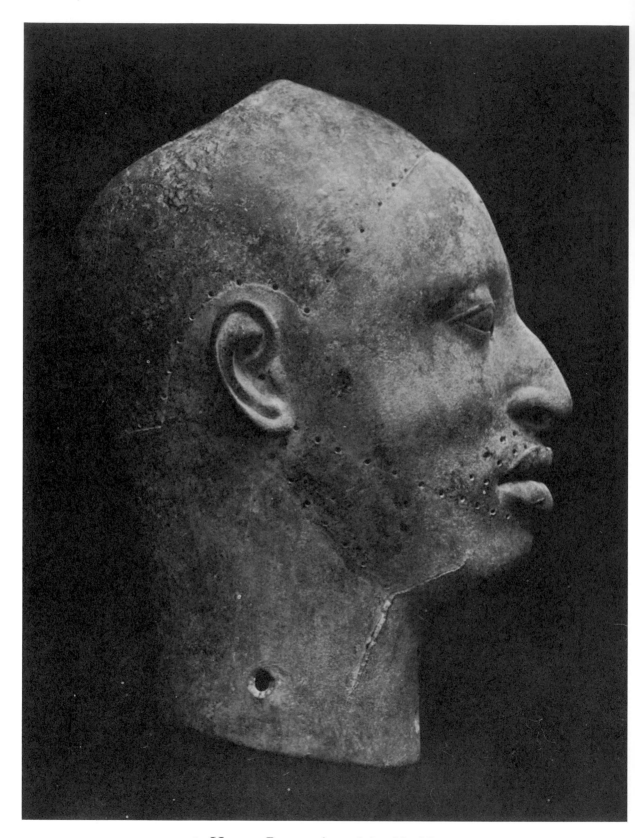

136. HEAD. Bronze, h. 13½ in. *Ife, Nigeria*

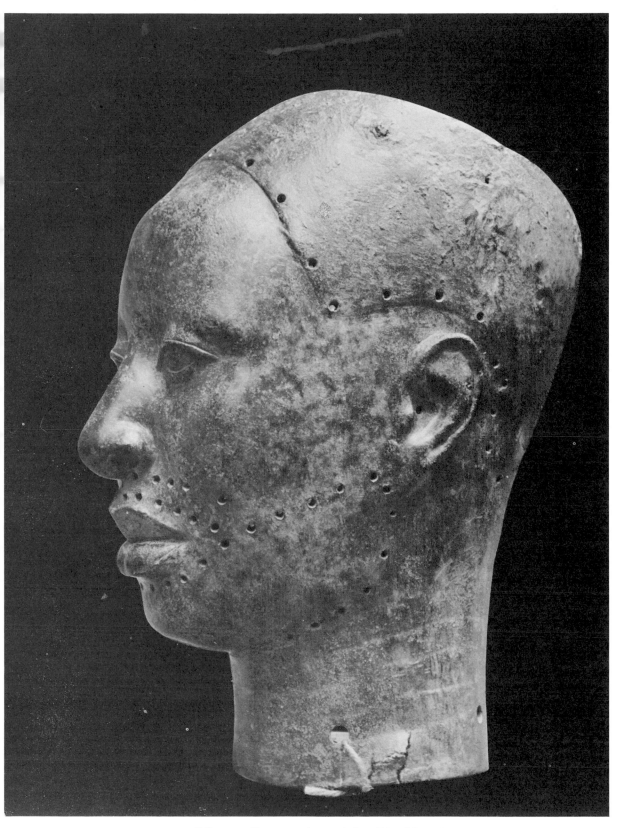

137. HEAD. Bronze, h. 13½ in. *Ife, Nigeria*

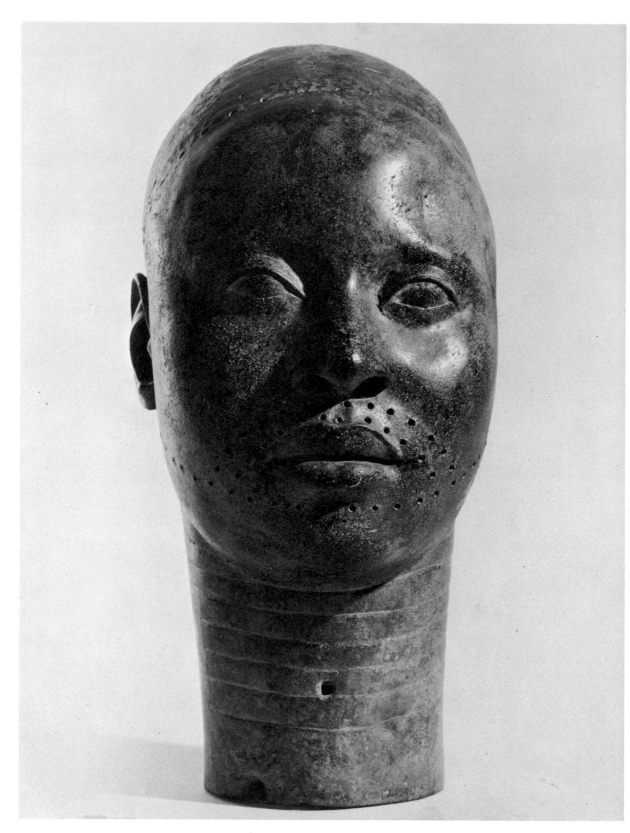

138. HEAD. Bronze, h. 12½ in. *Ife, Nigeria*

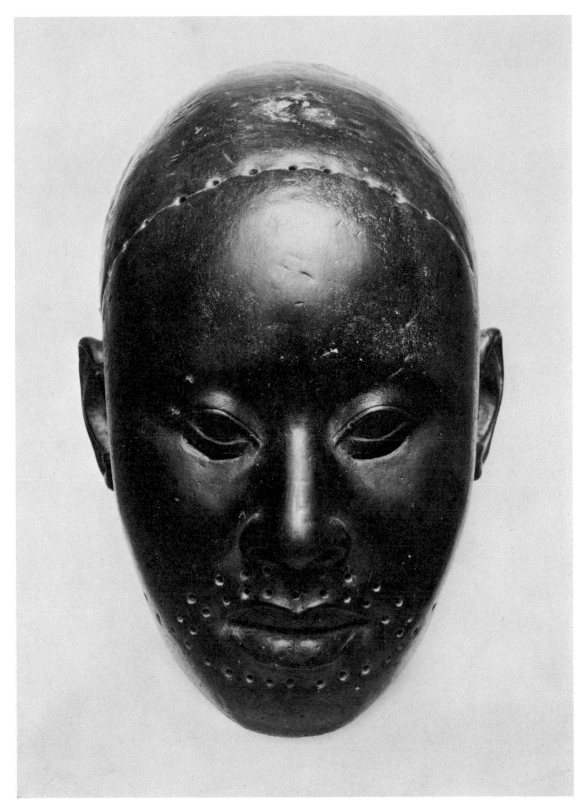

139. MASK. Bronze, h. 13 in. *Ife, Nigeria*

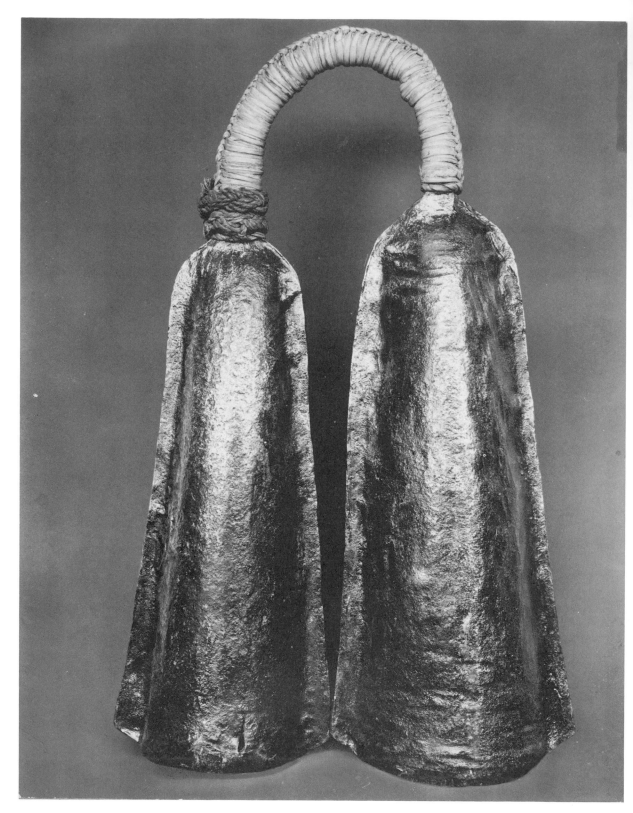

140. DOUBLE BELL. Iron, h. 24⅜ in. *Bamum, Cameroon*

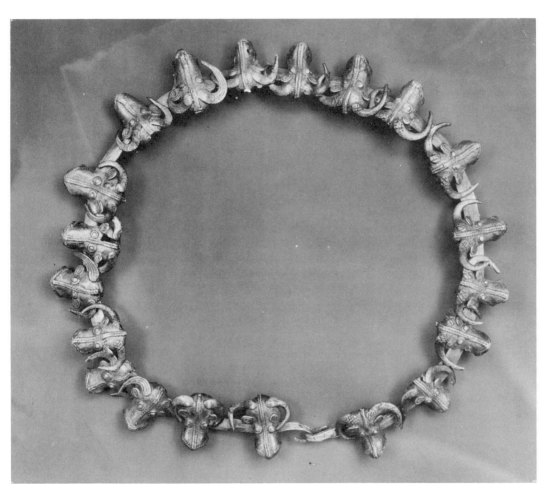

141. NECKLET. Bronze, diameter 10⅝ in. *Bamum, Cameroon*

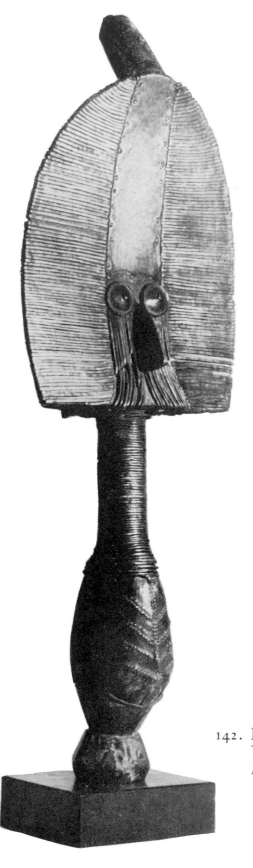

142. FUNERARY FIGURE.
Wood covered with copper strips, h. 22½ in.
Bakota, Gabon

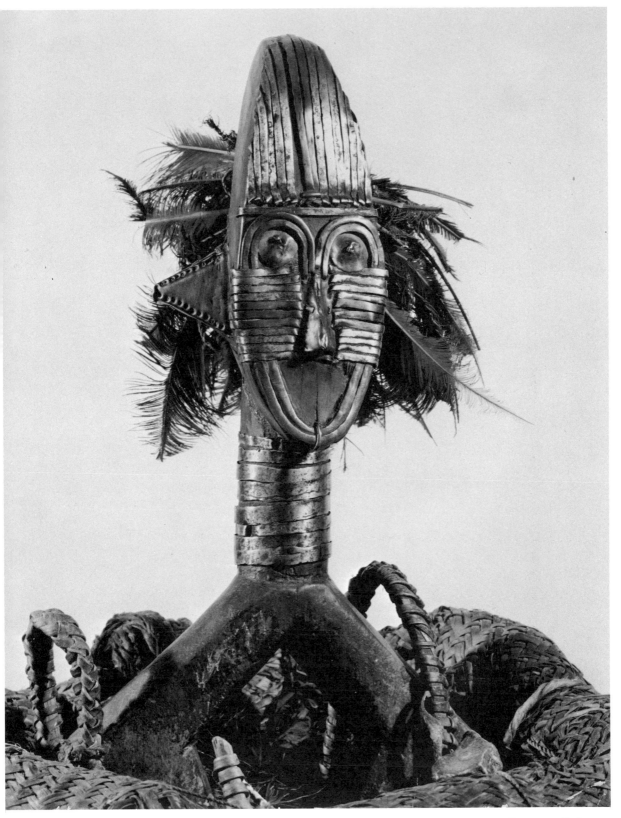

143. FUNERARY FIGURE. Wood covered with copper strips, h. 22 in. *Bakota, Gabon*

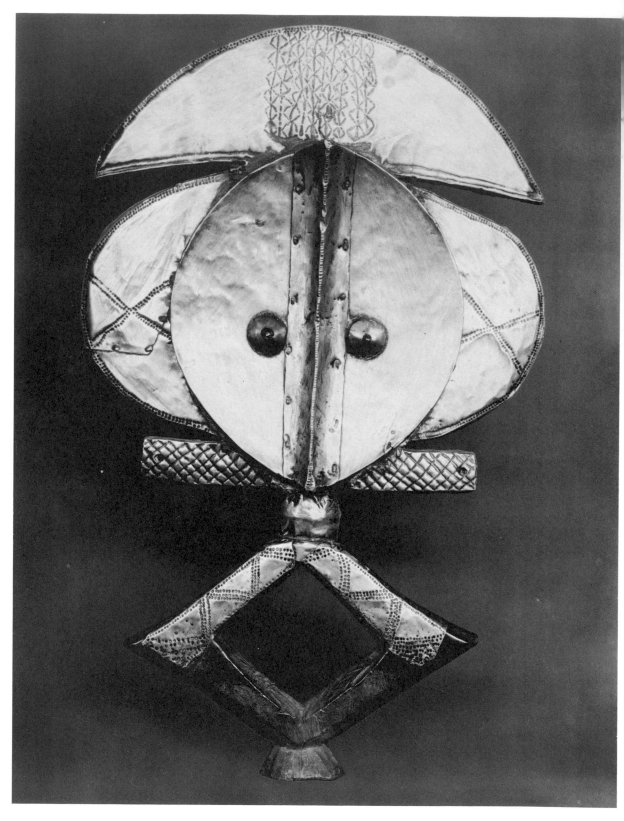

144. FUNERARY FIGURE. Wood covered with copper strips, h. 22½ in. *Bakota, Gabon*

145. BRACELET. Ivory, diameter 4½ in. *Guro, Ivory Coast*

146. BRACELET. Ivory, diameter 4½ in. *Guro, Ivory Coast*

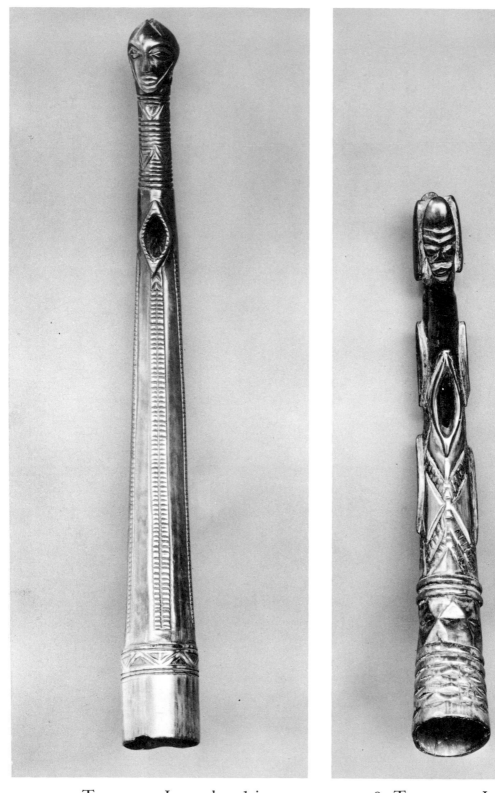

147. TRUMPET. Ivory, l. 21¼ in.
Upper Ogowe River, Gabon

148. TRUMPET. Ivory, l. 18⅛ in.
Upper Ogowe River, Gabon

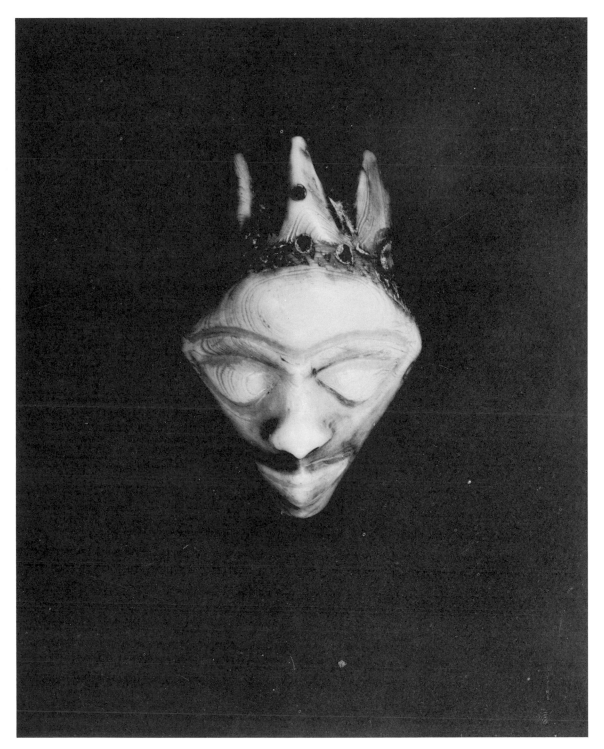

149. PENDANT. Ivory, h. 2⅜ in. *Bapende, Congo (Leopoldville)*

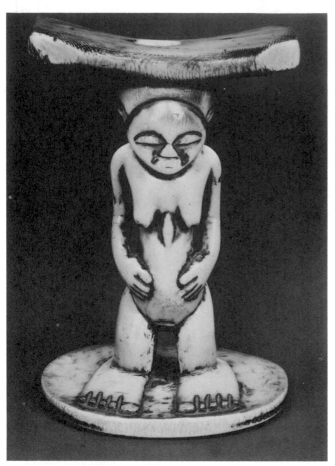

150. HEADREST. Ivory, h. 6½ in.
Baluba, Congo (Leopoldville)

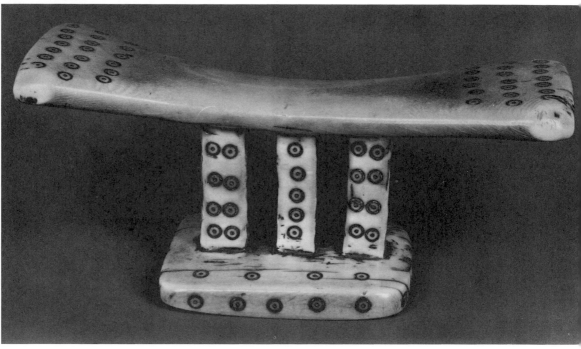

151. HEADREST. Ivory, h. 4 in., l. 10⅞ in. *Warega, Congo (Leopoldville)*

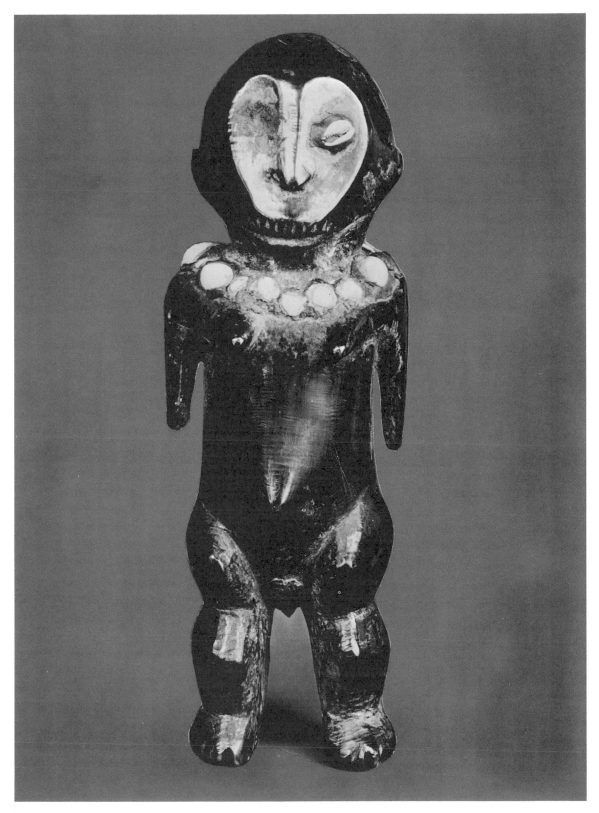

152. FIGURE. Ivory, h. 10¼ in. *Warega, Congo (Leopoldville)*

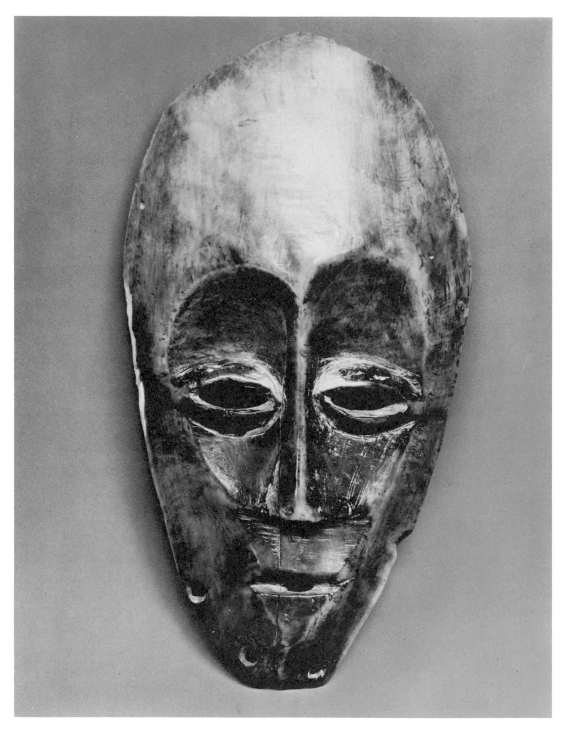

153. MASK. Ivory, h. 8¼ in. *Warega, Congo (Leopoldville)*

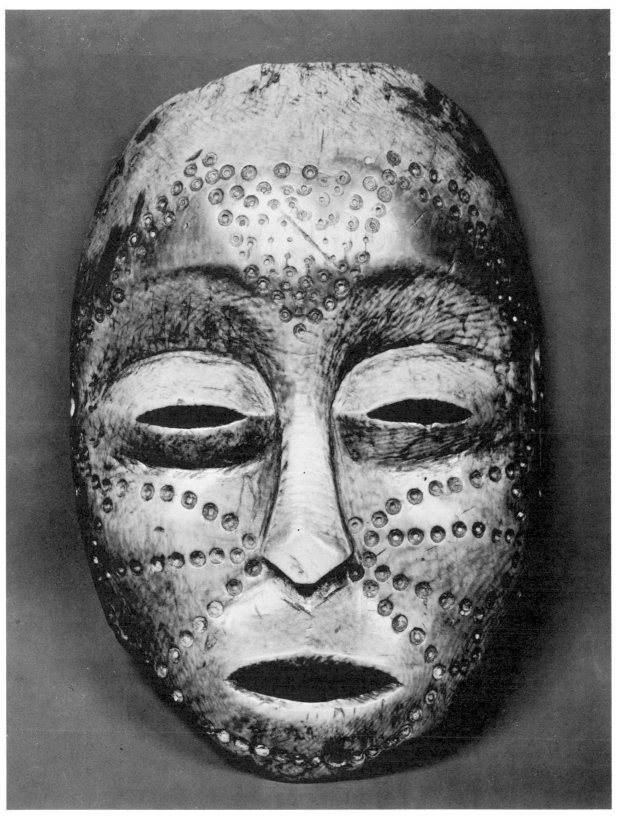

154. MASK. IVORY, h. 7⅝ in. *Warega, Congo (Leopoldville)*

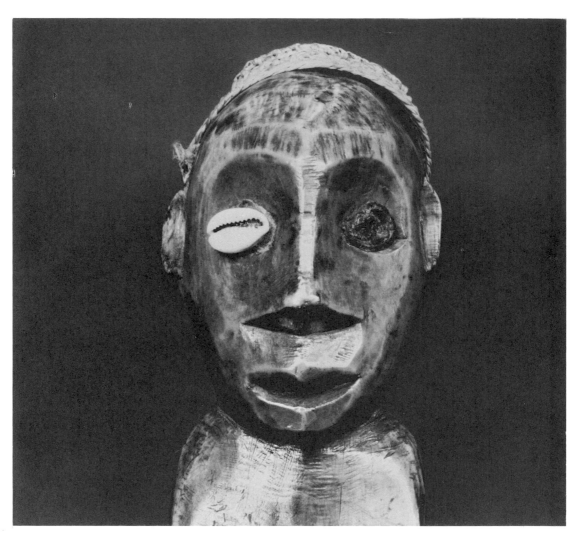

155. HEAD. Ivory, h. 6¼ in. *Warega, Congo (Leopoldville)*

156. BATON. Ivory, h. 5⅞ in.
Congo (Leopoldville)

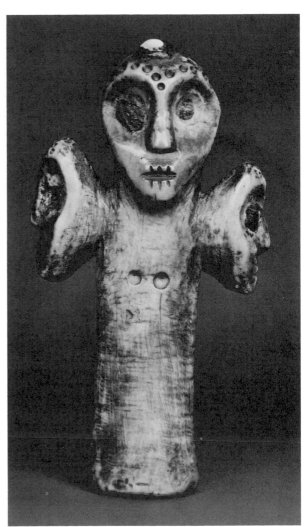

157. HEAD. Ivory, h. 4¾ in.
Warega, Congo (Leopoldville)

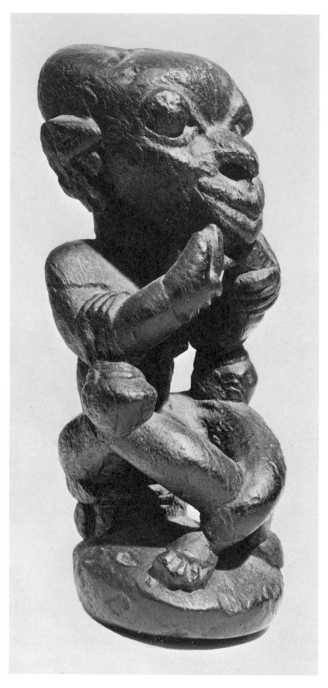

158. FIGURE. Soapstone, h. 9¾ in.
Sierra Leone

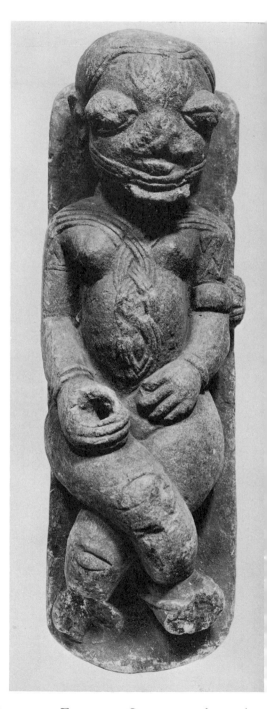

159. FEMALE FIGURE. Soapstone, h. 14 in.
Mende, Sierra Leone

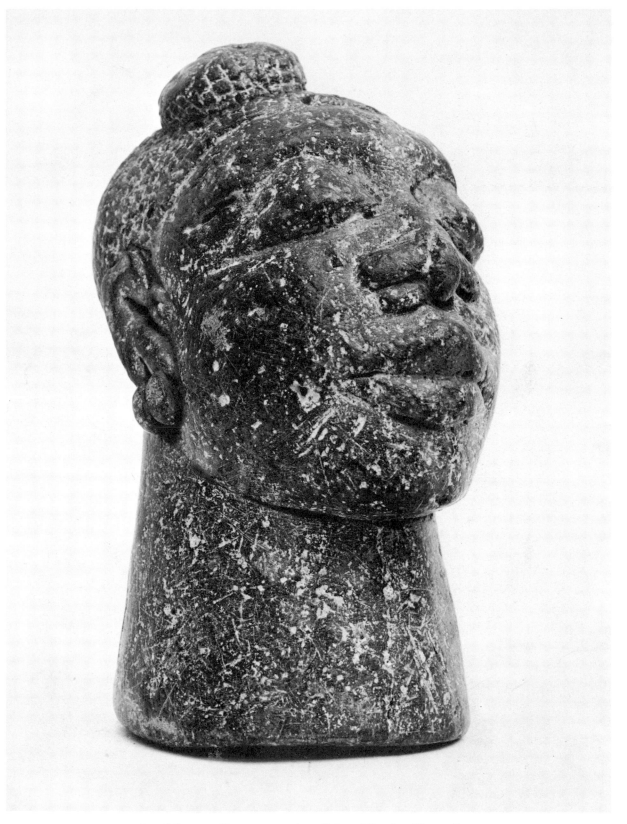

160. HEAD. Soapstone, h. 9¾ in. *Mende, Sierra Leone*

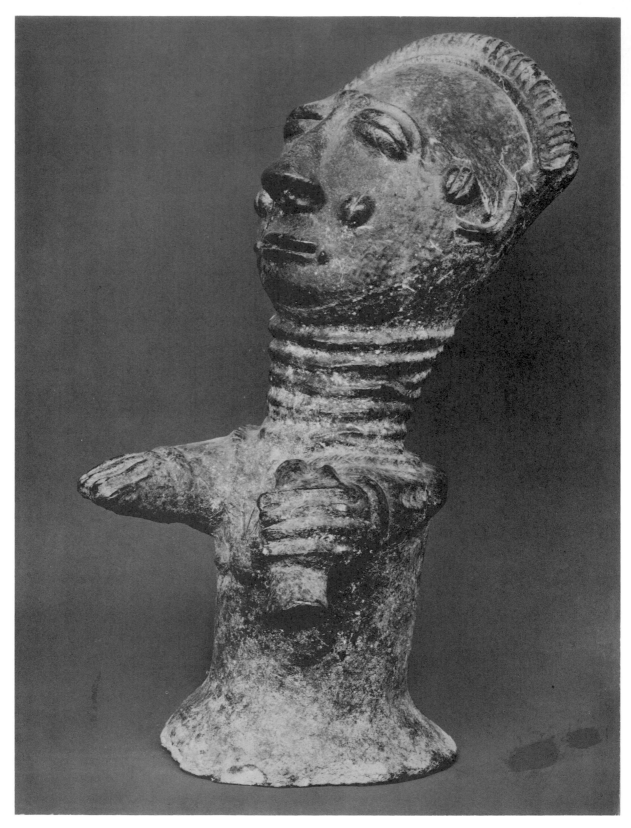

161. Funerary Figure. Terracotta, h. 15 in. *Agni, Ivory Coast*

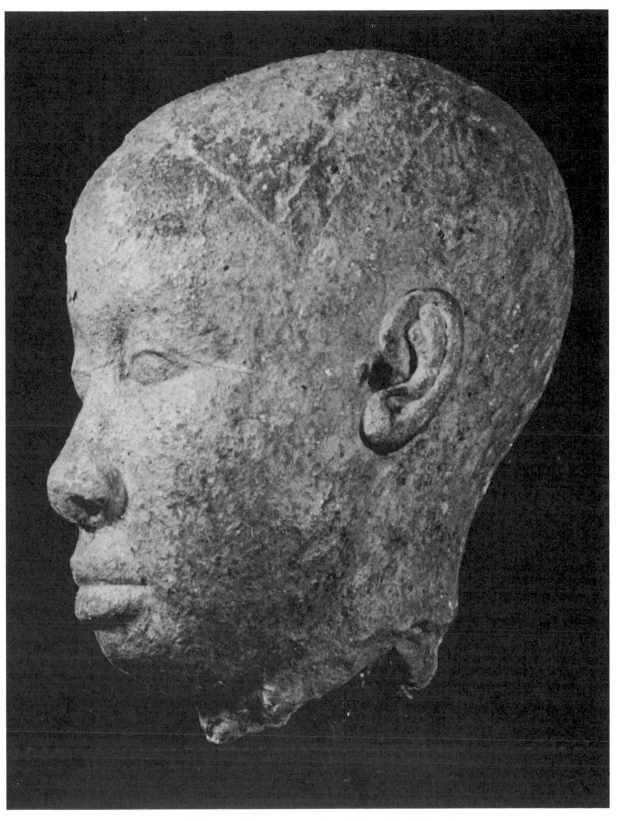

162. HEAD. Terracotta, h. 6½ in. *Ife, Nigeria*

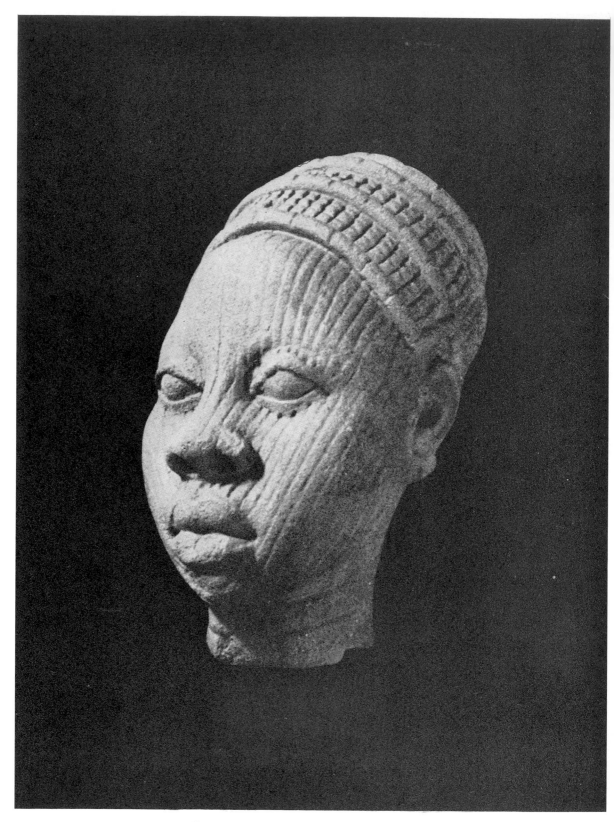

163. HEAD. Terracotta, h. 6¾ in. *Ife, Nigeria*

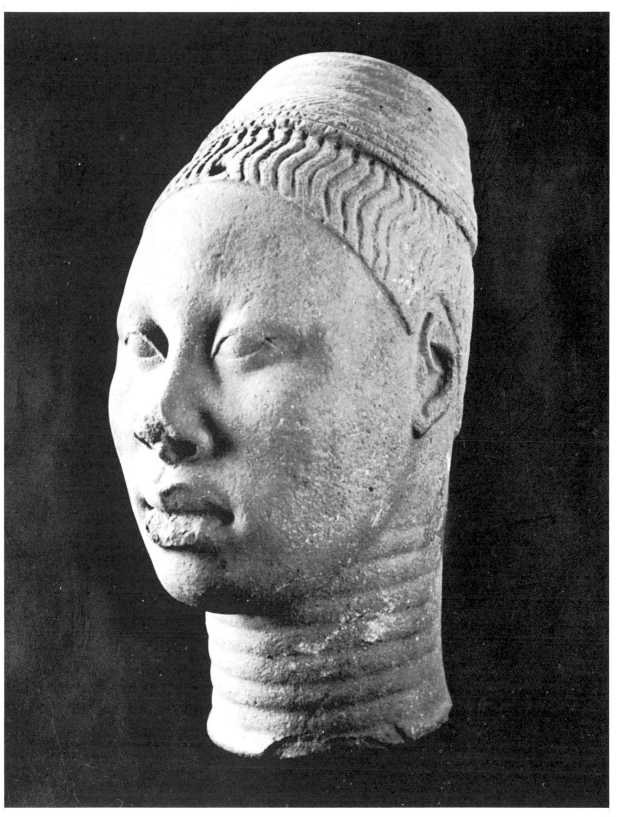

164. HEAD. Terracotta, h. $11\frac{1}{2}$ in. *Ife, Nigeria*

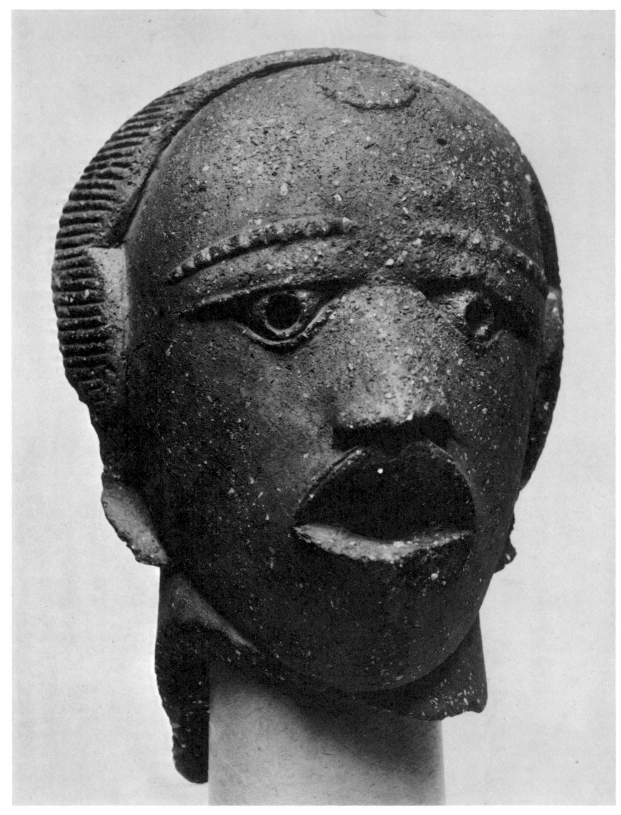

165. HEAD. Terracotta, h. 8¾ in. *Nok, Nigeria*

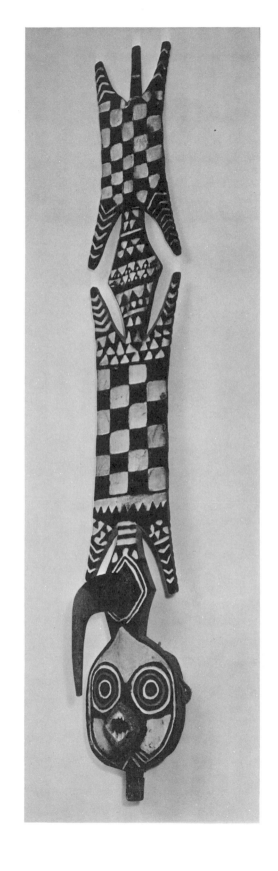

166. BIRD MASK. Painted wood, h. 72 in.
 Bobo, Upper Volta

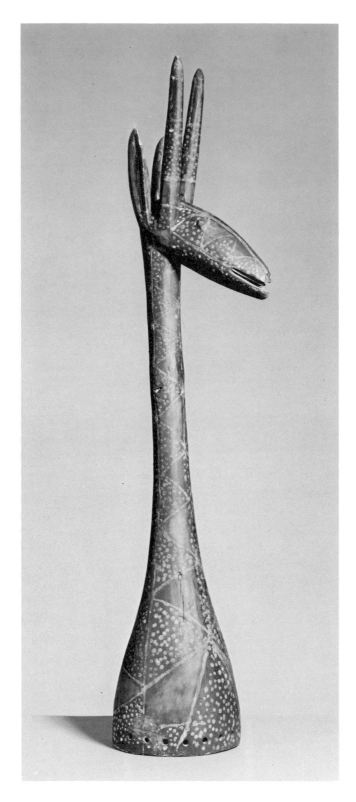

167. FEMALE ANTELOPE HEAD-DRESS.
Painted wood, h. 43¾ in. *Kurumba, Upper Volta*

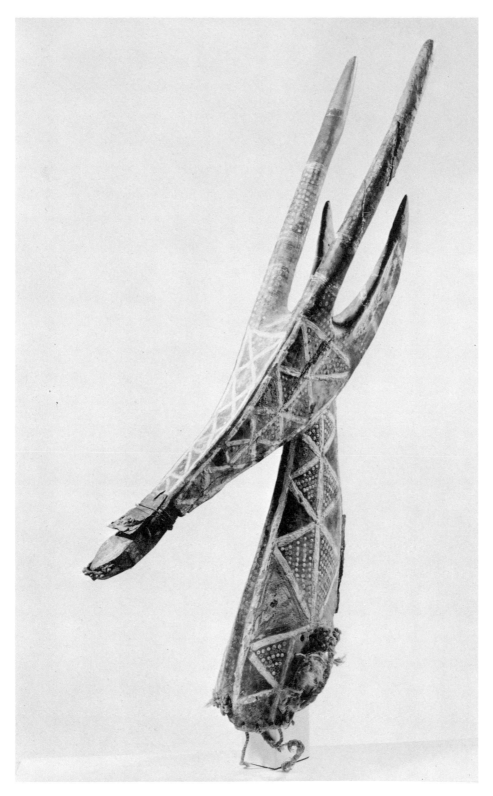

168. MALE ANTELOPE HEAD-DRESS. Painted wood, h. 36 in.
Kurumba, Upper Volta

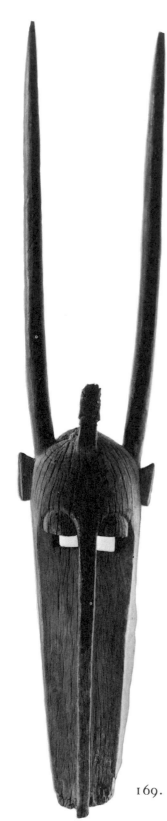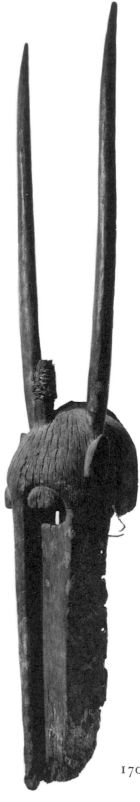

169. MASK. Wood, h. 62 in.
Bambara, Mali

170. Same, side view

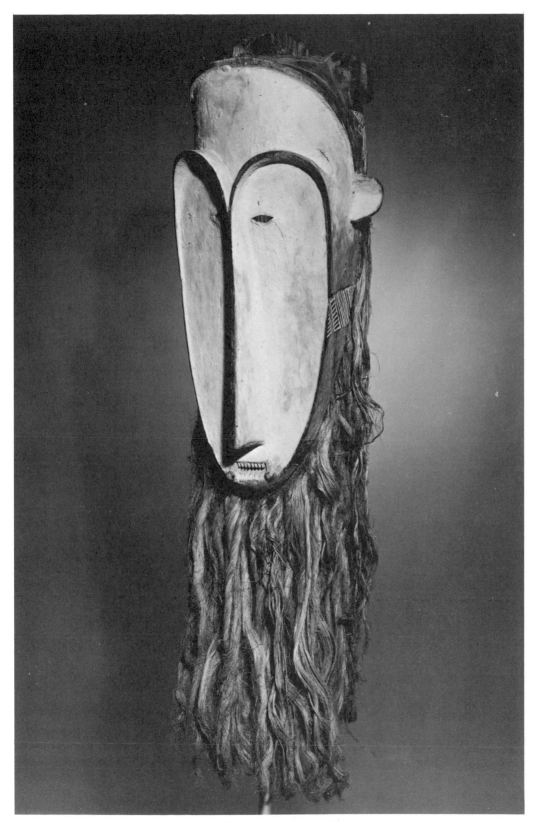

171. MASK. Wood and raffia, (mask alone) h. 24⅜ in. *Fang, Gabon*

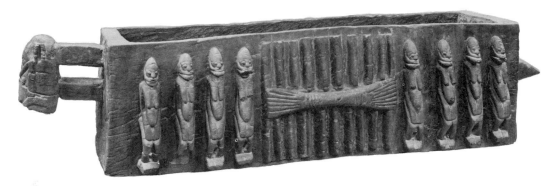

172. CULT OBJECT. Wood, 78 x 21 x 17½ in. *Dogon, Mali*

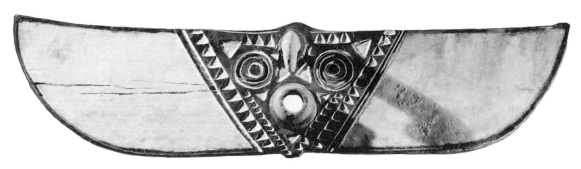

173. BUTTERFLY MASK. Painted wood and braided rope, w. 51¼ in. *Bobo, Upper Volta*

174. FETISH. Wood covered with mud, w. 20½ in. *Bambara, Mali*

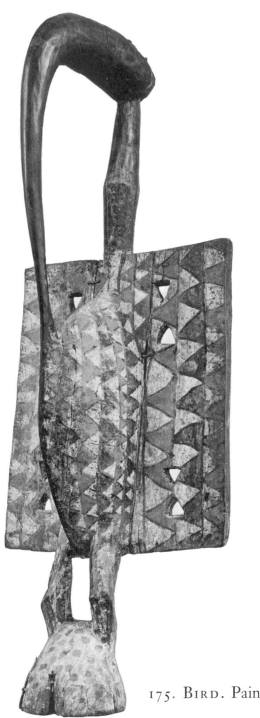

175. BIRD. Painted wood, h. 59⅝ in. *Senufo, Ivory Coast*

176. Ritual Object. Wood and metal, h. 19 in., l. 36½ in. *Baga, Guinea*

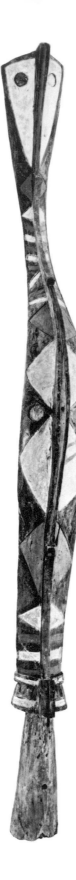

177. SERPENT. Painted wood, h. 102 in. *Landuma, Guinea*

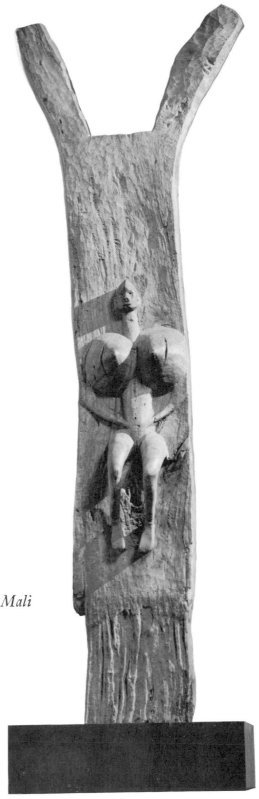

178. HOUSEPOST. Wood, h. 74¼ in. *Dogon, Mali*

179. FEMALE FIGURE. Wood, h. 10½ in. *Dogon, Mali*

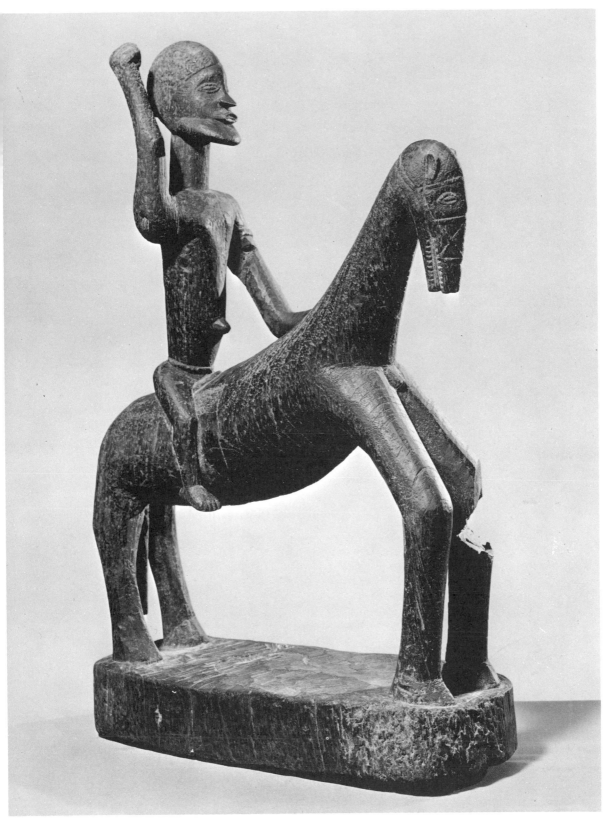

180. Horse with Rider. Wood, h. $27\frac{1}{8}$ in. *Dogon, Mali*

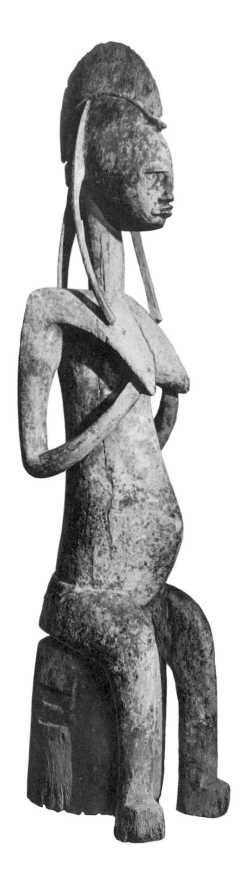

181. ANCESTRAL FIGURE. Wood, h. 40¼ in.
Bambara, Mali

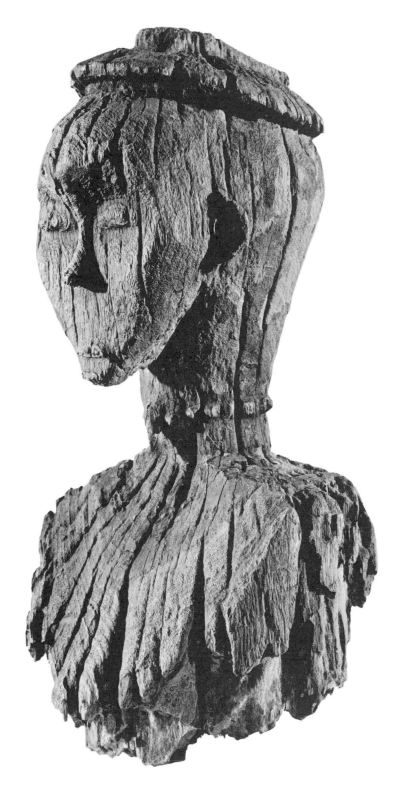

182. BUST. Wood, h. 18 in. *Bapende, Congo (Leopoldville)*

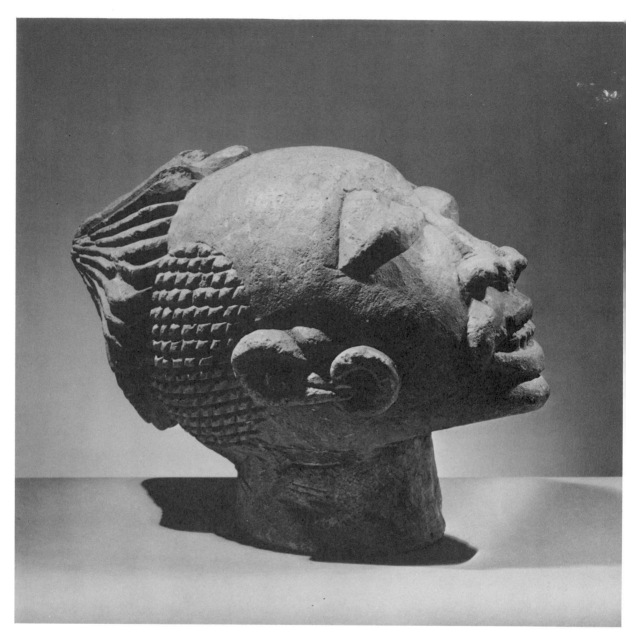

183. PREHISTORIC HEAD. Steatite, h. 10¼ in. *Kissi, Guinea*

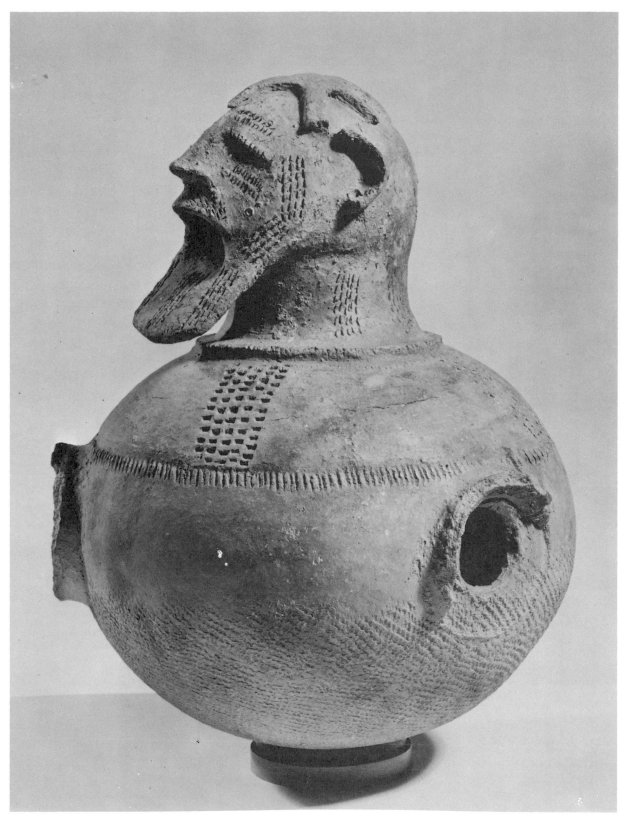

184. VESSEL. Terracotta, h. 14½ in. *Provenience unknown*

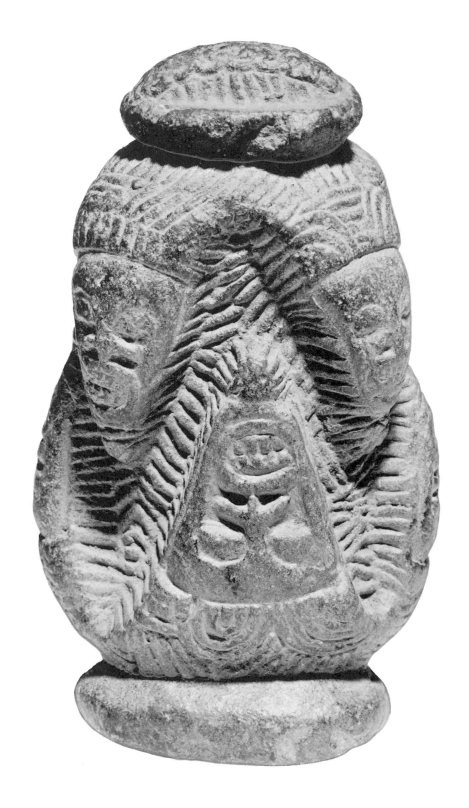

185. STONE SCULPTURE. Steatite, h. 9¾ in. *Provenience unknown*

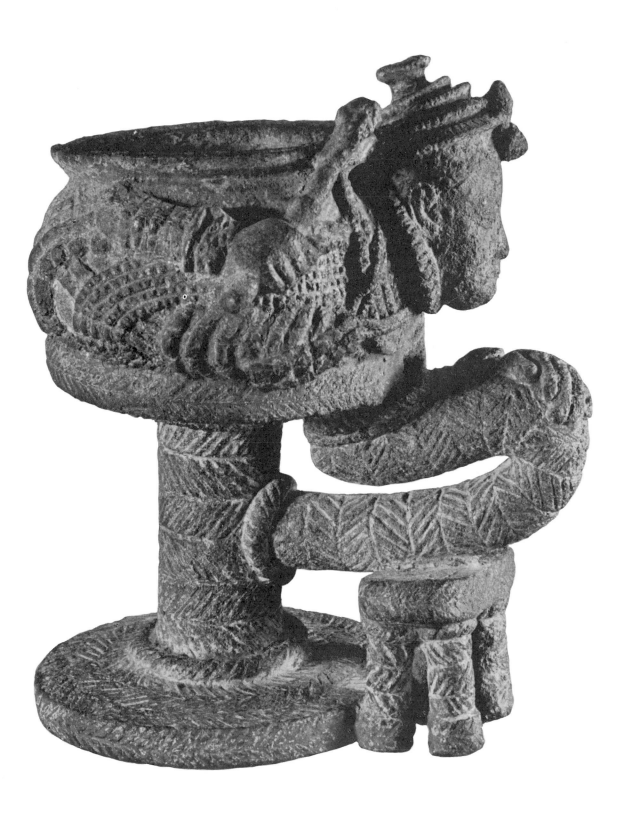

186. PEDESTAL BOWL. Bronze, h. 4¾ in. *Ife, Nigeria*

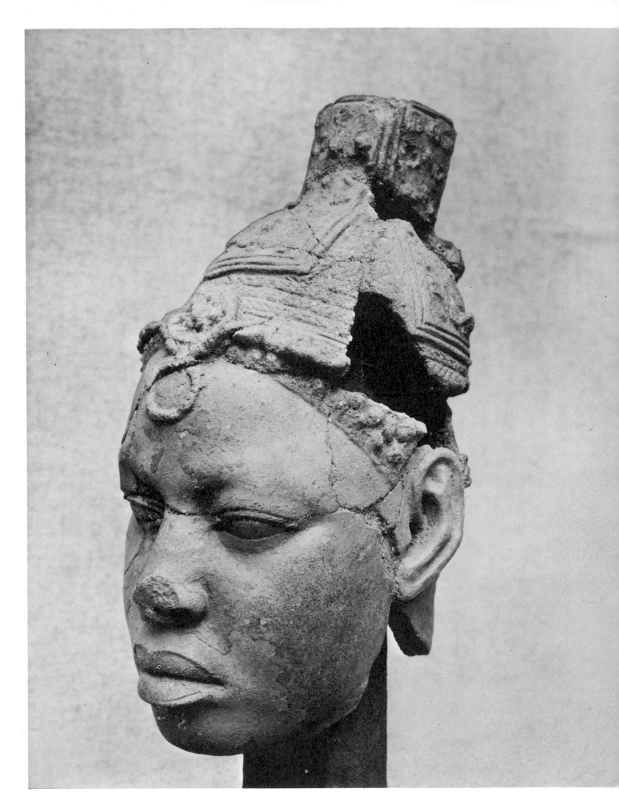

187. FEMALE HEAD. Terracotta, h. 10⅝ in. *Ife, Nigeria*

Catalogue of Plates

IN GENERAL, the whereabouts of the objects noted here are those which obtained when the photographs were made, and there is a likelihood that many of the pieces have subsequently changed hands. (Exception: the frontispiece and plates 166–187, which have been added to the second edition.) The objects photographed by Walker Evans were, in nearly every case, exhibited at the Museum of Modern Art, New York, in 1935, and those by Eliot Elisofon were made in 1951. Political names have been revised (1964).

Frontispiece: PAIR OF ROYAL FIGURES. Bronze, 12 in. high. Ife, Nigeria. *Coll. the Oni of Ife (photo: British Museum).*

12th–15th century; discovered in a mound at Ita Yemoo, near Ife, in 1957. These personages were perhaps a nobleman and his wife.

1. MASK. Wood, about 14½ in. high. Dogon, Mali. *Musée de l'Homme, Paris (photo: Elisofon).*

Represents a monkey. From the Mopti clan, Iréli village.

2. MASK. Wood, 25 in. high. Bambara, Mali. *Coll. Earl Horter, Philadelphia (photo: Evans).*

Used in the rites of a young boys' secret society; represents the N'tomo, a spirit effective against evil.

3. MASK. Wood, 22½ in. high. Toma, Liberia. *Coll. Jacques Lipchitz, Paris (photo: Evans).*

4. MASK. Polychrome wood, 9 in. high. Dan, Liberia, border of Ivory Coast. *Coll. Pierre Loeb, Paris (photo: Evans).*

5. MASK. Wood, 9⅛ in. high. Dan, Ivory Coast. *Coll. Miss Laura Harden, New York (photo: Evans).*

6. MASK. Wood, 9½ in. high. Dan, Ivory Coast. *Coll. Dr. Paul Chadourne, Paris (photo: Evans).*

7. MASK. Wood, 10⅝ in. high. Dan, Ivory Coast. *Coll. Paul Guillaume, Paris (photo: Evans).*

8. MASK. Wood, 18½ in. high. Bambara, Mali. *Coll. Louis Carré, Paris (photo: Evans).*

9. MASK. Wood, with metal plates, 15¾ in. high. Baule, Ivory Coast. *Coll. Paul Guillaume, Paris (photo: Evans).*

Surmounted by a bird.

10. MASK. Wood, 8 in. high. Dan, Liberia. *Coll. Princess Gourielli, New York (photo: Evans).*

In the form of a bird's head.

11. MASK. Wood, black and red, 15 in. high. Baule, Ivory Coast. *Coll. Felix Fénéon, Paris (photo: Evans).*

12. MASK. Wood, 17 in. high. Ekoi, Nigeria. *Coll. K. C. Murray, London (photo: Central Office of Information).*

13. MASK (HEAD-DRESS). Wood, $14\frac{1}{2}$ in. high. Mama, Nigeria. *Coll. Charles Ratton (photo: Ratton).*

Represents a buffalo, and is worn on the head, while a fibre garment covers the body.

14. HEAD-DRESS. Wood, painted red, 26 in. high. Mama, Nigeria. *Coll. Charles Ratton (photo: Evans).*

Represents an antelope.

15. MASK. Wood, $26\frac{3}{8}$ in. high. Bamenda, Cameroon. *Coll. Baron Eduard von der Heydt, Ascona, Switzerland (photo: Evans).*

16. Same, profile.

17. JANUS HEAD (one face). Parchment over wood, $9\frac{7}{8}$ in. Ekoi, Nigeria. *Coll. Antony Moris, Paris (photo: Evans).*

Represents a deceased ancestor. These heads are carved in wood, and the skin, formerly human but more recently monkey or antelope, is stretched over. They are worn on top of the head and used in funerary rites.

18. MASK. Wood, $17\frac{1}{4}$ in. high. Bamenda, Cameroon. *Coll. Baron Eduard von der Heydt, Ascona, Switzerland (photo: Evans).*

19. MASK. Whitened wood, $29\frac{1}{2}$ in. high. Fang, Gabon. *Museum für Völkerkunde, Berlin (photo: Evans).*

Kaolin is the usual whitening element, in such masks.

20. FOUR-FACED MASK, IN CASQUE FORM. Whitened wood, $13\frac{3}{8}$ in. high. Mpongwe, Gabon. *Coll. Paul Guillaume, Paris (photo: Evans).*

21. MASK. Polychrome wood, $9\frac{1}{2}$ in. high. Bakwele, Cameroon. *Coll. Tristan Tzara, Paris (photo: Evans).*

22. MASK, IN CASQUE FORM. Wood, about $24\frac{1}{2}$ in. high. Baluba, Congo (Leopoldville). *Musée Royal du Congo, Tervueren, Belgium (photo: Musée).*

Carved from a single block, including horns. The beard is probably raffia. Discovered 1899 by the Commandant Michaux.

23. MASK. Polychrome wood, metal, cloth, and cowrie shells, $12\frac{3}{4}$ in. high. Baluba, Congo (Leopoldville). *Schomburg Collection, New York Public Library (photo: Evans).*

24. MASK. Polychrome wood, about 20 in. high. Baluba, Congo (Leopoldville). *Musée Royal du Congo, Tervueren, Belgium (photo: Musée).*

25. MASK. Polychrome wood, $24\frac{3}{4}$ in. high. Basonge, Congo (Leopoldville). *Coll. Sydney Burney, London (photo: Evans).*

26. Same, front view.

27. MASK. Polychrome wood and raffia, 12 in. high. Bayaka, Congo (Leopoldville). *Schomburg Collection, New York Public Library (photo: Evans).*

28. KAKUNGA MASK. Wood and raffia, about 36 in. high. Bayaka, Congo (Leopoldville). *Musée Royal du Congo, Tervueren, Belgium (photo: Musée).*

Such a mask, one of the largest to be found in the Congo, was worn by a dancer impersonating the Kakunga, or male spirit, in an initiation rite.

29. MASK. Polychrome wood, $11\frac{1}{2}$ in. high. Bateke, Congo (Leopoldville). *Coll. André Derain, Paris (photo: Evans).*

30. MASK. Polychrome wood, 12 in. high. Baboa, Congo (Leopoldville). *Musée Royal du Congo, Tervueren, Belgium (photo: Musée).*

A war and dance mask. Characteristic of this type is the stylized representation of the ears by large kaolin-whitened rings.

31. MASK. Polychrome wood, $11\frac{3}{4}$ in. high. Kanioka, Congo (Leopoldville). *Museum für Völkerkunde, Hamburg (photo: Evans).*

32. Same, profile.

33. MASK. Wood, $8\frac{5}{8}$ in. high. Warega, Congo (Leopoldville). *Coll. Charles Ratton, Paris (photo: Evans).*

34. MASK. Wood, $23\frac{1}{4}$ in. high. Makonde, Tanganyika. *Museum für Völkerkunde, Berlin (photo: Evans).*

Representation of a rabbit, with monkey hair.

35. MASK. Wood, 10 in. high. Makonde, Tanganyika. *British Museum, London (photo: Museum).*

With monkey hair.

36. HOBBYHORSE HEAD. Wood, $14\frac{1}{2}$ in. high. Bambara, Mali. *Cleveland (Ohio) Museum of Art (photo: Evans).*

May represent a mule; presumably serves the same purpose as the object in plate 37.

37. HEAD-DRESS. Wood, $31\frac{7}{8}$ in. high. Bambara, Mali. *Coll. Antony Moris, Paris (photo: Evans)*.

Represents an antelope. The carving is mounted on a small cap of basketwork and worn on top of the head by a dancer, who imitates the leaps of antelopes in sowing and harvest feasts. The head-dress or mask is called the Tji-Wara, which is variously said also to be the name of evil spirits being propitiated or of a goddess of fecundity and earth.

38. HEAD-DRESS. Wood, 26 in. high. Mandingo (Suguni), Mali. *Coll. Louis Carré, Paris (photo: Evans)*.

See note on plate 37.

39. HERMAPHRODITIC FIGURE. Wood, $27\frac{1}{2}$ in. high. Dogon, Mali. *Coll. Louis Carré, Paris (photo: Evans)*.

See note on plate 40. From the region of Bandiagara.

40. MALE AND FEMALE FIGURES. Wood, about 15 in. high. Dogon, Mali. *Barnes Foundation, Merion, Pennsylvania (photo: Cahiers d'Art)*.

Such figures are believed to embody the spirit of the family. They commonly pass from one generation to the next, and are placed in the rock caves with the dead for several days. The female statuette wears a beard-like chin ornament. From the region of Bandiagara.

41. Same, rear view.

42. STATUETTE. Wood, $17\frac{1}{2}$ in. high. Dogon, Mali. *Musée de l'Homme, Paris (photo: Elisofon)*.

From the "Great Sanctuary" of the village of Yougo, Mali. Discovered by the Dakar-Djibouti expedition, 1931–33.

43. FIGURE. Wood, 30 in. high. Dogon, Mali. *Coll. Miss Laura Harden, New York (photo: Evans)*.

See note on plate 40. From the region of Bandiagara.

44. DOOR. Wood, $18\frac{7}{8}$ in. high. Dogon, Mali. *Musée de l'Homme, Paris (photo: Evans)*.

Probably the door or shutter of a granary.

45. URN. Wood, $29\frac{1}{2}$ in. high. Dogon, Mali. *Coll. Mme. Bela Hein, Paris (photo: Evans)*.

An equestrian figure surmounts the urn. Used for offerings at the spring festival of sowing.

46. FEMALE FIGURE. Wood, $21\frac{1}{2}$ in. high. Dogon, Mali. *Coll. Princess Gourielli, Paris (photo: Evans)*.

47. FEMALE FIGURE. Wood, $19\frac{5}{8}$ in. high. Bambara (?), Mali. *Coll. André Level, Paris (photo: Evans)*.

An ancestral figure.

48. FIGURE. Wood, 35 in. high. Senufo, Mali–Ivory Coast. *Coll. André Derain, Paris (photo: Evans)*.

49. Same, profile.

50. LATCH, IN FEMALE FORM. Wood, $21\frac{1}{2}$ in. high. Mali. *Coll. Raphael Stora, Paris (photo: Evans)*.

Tribal source unknown.

51. HEAD-DRESS. Wood, partly overlaid with metal, $40\frac{1}{2}$ in. high. Baga, Guinea. *Coll. Georges Salles, Paris (photo: Cahiers d'Art)*.

A kind of head-dress, carried by a dancer, whose body and the supports of this object were covered with a raffia garment. It was used in dances of the Simo secret society. Possibly represents a maternity goddess.

52. Same, detail of front.

53. TWO GONG HAMMERS. Wood, 9 and $6\frac{7}{8}$ in. high. Baule, Ivory Coast. *Coll. Paul Guillaume, Paris (photo: Evans)*.

54. SPOON. Wood, $8\frac{5}{8}$ in. high. Baule, Ivory Coast. *Coll. Félix Fénéon, Paris (photo: Evans)*.

55. SPOON. Wood, $8\frac{1}{4}$ in. high. Baule, Ivory Coast. *Coll. Paul Guillaume, Paris (photo: Evans)*.

56. BOBBIN. Wood, $5\frac{7}{8}$ in. high. Senufo, Ivory Coast. *Coll. Louis Carré, Paris (photo: Evans)*.

57. BOBBIN. Wood, $7\frac{1}{2}$ in. high. Guro, Ivory Coast. *Coll. Frank Crowninshield, New York (photo: Evans)*.

58. BOBBIN. Wood, $6\frac{1}{8}$ in. high. Guro, Ivory Coast. *Coll. Louis Carré, Paris (photo: Evans)*.

59. EQUESTRIAN FIGURE. Polychrome wood, $15\frac{3}{4}$ in. high. Yoruba, Dahomey. *Coll. Louis Carré, Paris (photo: Evans)*.

Represents Shango, god of thunder.

60. MOTHER AND CHILD. Wood, 20 in. high. Yoruba (?), Nigeria. *Horniman Museum, London (photo: Victoria and Albert Museum)*.

Probably from northeast Yorubaland, though it may come from a related culture further east.

61. RAM'S HEAD. Wood, 15 in. high. Yoruba, Nigeria. *Coll. Maurice Cockin, London (photo: British Museum)*.

From Owo.

62. ANCESTOR FIGURE. Wood, 42 in. high. Ibibio, Nigeria. *Coll. K. C. Murray, London (photo: British Museum)*.

Such figures, called Ekpu, were made by the Oron clan, of Calabar. Only men are represented.

63. DRUM. Wood, 44⅛ in. high. Bamenda, Cameroon. *Coll. Dr. Paul Chadourne, Paris (photo: Evans)*.

64. CHIEF'S STOOL WITH FIGURE. Wood, 71 in. high. Bekom, Cameroon. *Museum für Völkerkunde, Berlin (photo: Evans)*.

Also described as a grave figure—a mortuary representation of the royal stool. From Bamenda.

65. FIGURE. Wood, about 32 in. high. Bangwa, Cameroon. *Coll. Princess Gourielli, New York (photo: Man Ray)*.

An ancestor figure, holding a calabash. From Djang.

66. MENDICANT FIGURE WITH BOWL. Wood, 33⅛ in. high. Bangwa, Cameroon. *Coll. Charles Ratton, Paris (photo: Evans)*.

67. Same, front view.

68. ANCESTOR FIGURE. Wood, 23 in. high. Fang, Gabon. *Coll. Miss Laura Harden, New York (photo: Evans)*.

69. SEAT WITH FIGURES. Wood with traces of copper, 22 in. high. Yoko, Cameroon. *Coll. Etienne Bignou, Paris (photo: Evans)*.

Faces, hands, and feet of the figures were overlaid with copper, some of which remains. Used by nobles at council gatherings.

70. FIGURE. Wood, 17¼ in. high. Bamum, Cameroon. *Coll. Baron Eduard von der Heydt, Ascona, Switzerland (photo: Evans)*.

71. ANCESTOR FIGURE, HEAD. Wood, 17¾ in. high. Fang, Gabon. *Coll. Paul Guillaume, Paris (photo: Evans)*.

72. ANCESTOR FIGURE. Wood, 11¾ in. high. Fang, Gabon. *Coll. Dr. Paul Chadourne, Paris (photo: Evans)*.

73. Same, rear view.

74. MALE FIGURE. Wood, with eyes of copper discs, about 27 in. high. Fang, Gabon, border of Rio Muni. *Coll. Jacob Epstein, London (photo: Cahiers d'Art)*.

75. Same, detail of head, profile.

76. TWO MUSICAL INSTRUMENTS. Wood, about 6½ in. high. Loango (?), Congo (Brazzaville). *Coll. Princess Gourielli, New York (photo: Evans)*.

Small drums, played with the fingers or with rubber-headed mallets.

77. ANCESTOR FIGURE. Wood, 24⅛ in. high. Fang, Gabon, frontier of Rio Muni. *Coll. Louis Carré, Paris (photo: Evans)*.

78. DRUM. Wood, 39⅓ in. high, 79½ in. long. Yangere, Congo (Leopoldville). *Musée de l'Homme, Paris (photo: Emmanuel Sougez)*.

79. NAIL FETISH. Wood, about 3½ ft. high. Bakongo, Congo (Leopoldville). *Musée Royal du Congo, Tervueren, Belgium (photo: Elisofon)*.

Covered with nails and knife blades, each of which represents a petition.

80. DRUM. Wood, about 72 in. high. Bashilele (?), Congo (Leopoldville). *Coll. A. Blondiau, Brussels (photo: Raoul)*.

81. PORTRAIT FIGURE. Wood, about 24 in. high. Bakuba, Congo (Leopoldville). *Musée Royal du Congo, Tervueren, Belgium (photo: Elisofon)*.

Kata Mbula (fl. 1800–1810), 109th Bushongo nyimi. See note on plate 82.

82. PORTRAIT FIGURE. Wood, 24 in. high. Bakuba, Congo (Leopoldville). *British Museum, London (photo: Museum)*.

Shamba Bolongongo (fl. 1600), ninety-third Bushongo nyimi, or king. Most illustrious of Bushongo sovereigns, he established the custom of commissioning a carved wooden image of the king, a tradition that endured into the nineteenth century. Some dozen of these idealized portrait figures have been identified, all of them similar in attitude and style: the nyimi seated cross-legged, wearing the characteristic flat Bushongo crown, his body individually decorated, and before him some object symbolic of his reign.

83. FEMALE FIGURE. Wood, about 18 in. high. Baluba, Congo (Leopoldville). *Musée Royal du Congo, Tervueren, Belgium (photo: Elisofon)*.

Such begging figures are a frequent theme in Baluba sculpture. The kneeling woman represents the *kabila*, a spirit protective of maternity. During the period of childbirth, the figure is placed on the threshold, so that passersby may drop gifts into the bowl. Buli style, from the village so named.

84. FEMALE FIGURE. Wood, about 18 in. high. Baluba, Congo (Leopoldville). *British Museum, London (photo: Museum).*
 Wearing a skirt of raffia.

85. FEMALE FIGURE: DETAIL. Wood, approx. 5 in. high. Bena Lulua, Congo (Leopoldville). *Musée Royal du Congo, Tervueren, Belgium (photo: Elisofon).*
 The head of a figure such as that in plate 86.

86. CARVED BATON. Wood, about 14 in. high. Bena Lulua, Congo (Leopoldville). *Brooklyn Museum (photo: Museum).*
 Represents mother and child. In this and the two following objects, the intricate ornamentation, including tattooing, constitutes tribal markings.

87. Same, profile.

88. FIGURE. Wood, 17⅜ in. high. Bena Lulua, Congo (Leopoldville). *Museum für Völkerkunde, Berlin (photo: Evans).*

89. Same, profile.

90. CUP. Wood. Basonge, Congo (Leopoldville). *Museum für Völkerkunde, Munich (photo: Evans).*

91. BOX, WITH COVER. Wood. Bakuba, Congo (Leopoldville). *Coll. Mrs. Edith J. R. Isaacs, New York (photo: Evans).*

92. FIGURE WITH DRUM. Wood, 15¼ in. high. Kanioka, Congo (Leopoldville). *Coll. Baron Eduard von der Heydt, Ascona, Switzerland (photo: Evans).*

93. HEADREST. Wood, 6¾ in. high. Central Baluba, Congo (Leopoldville). *Coll. Baron Eduard von der Heydt, Ascona, Switzerland (photo: Evans).*

94. Same, rear view.

95. Same as plate 93, front view.

96. FIGURE. Wood (surmounting a calabash, with shells: see next plate), over-all 14⅛ in. high. Central Baluba,

Congo (Leopoldville). *Coll. Tristan Tzara, Paris (photo: Evans).*

97. Same, in full, rear view.

98. FIGURE. Wood, 9¼ in. high. Warega, Congo (Leopoldville). *Coll. John P. Anderson, Red Wing, Minnesota; formerly coll. Charles Ratton, Paris (photo: Evans).*

99. STOOL. Wood, 18½ in. high. Northeastern Baluba, Congo (Leopoldville). *Museum für Völkerkunde, Leipzig (photo: Evans).*
 Probably an ancestor figure.

100. Same, front view.

101. SCEPTRE. Wood, 15¾ in. high. Bachokwe, Angola. *Coll. Charles Ratton, Paris (photo: Evans).*
 Said to be a ceremonial staff, or a carrying stick. Such carvings are characteristically in a hard wood, highly polished, so that a metallic effect is attained.

102. Same, in full, front view.

103. FIGURE. Wood, 5¾ in. high. Bachokwe, Angola, *Coll. Frank Crowninshield, New York (photo: Evans).*
 See note on plate 101.

104. Same, profile.

105. ORNAMENTS. Gold, *cire-perdu* technique. (*Top*) 3½ in. long. Baule, Ivory Coast. (*Centre*) 2⅞ and 3½ in. high. Lobi, Ivory Coast–Upper Volta. (*Bottom*) 4½ in. long. Baule, Ivory Coast. *Colls. Tristan Tzara, Paris; Paul Guillaume and Georges Keller, Paris; and Tzara (photo: Evans).*
 Represent, top to bottom, a ram's head, a crocodile, and masks. All probably pendants.

106. WEIGHTS FOR MEASURING GOLD DUST. Bronze, *cire-perdu* technique, approx. actual size. Ashanti, Ghana, or Baule, Ivory Coast. *Colls. Miss Laura Harden, New York, and Charles Ratton, Paris (photo: Evans).*

107. WEIGHTS FOR MEASURING GOLD DUST. Bronze, *cire-perdu* technique, approx. actual size. Ashanti, Ghana, or Baule, Ivory Coast. *Colls. Louis Carré and Charles Ratton, Paris (photo: Evans).*

108. WEIGHTS FOR MEASURING GOLD DUST. Bronze, *cire-perdu* technique, approx. actual size. Ashanti,

Ghana, or Baule, Ivory Coast. *Colls. Miss Laura Harden, New York, and Mme. Bela Hein, Paris (photo: Evans)*.

109. MAN'S HEAD. Bronze, *cire-perdu* technique, 6 in. high. Bron, Ghana. *Coll. Webster Plass, London (photo: collector)*.

110. FEMALE FIGURE. Bronze, 30 in. high. Yoruba, Nigeria. *Coll. Nigerian Government (photo: Victoria and Albert Museum)*.

From the Ogboni Society house, Apomu, Ibadan. Found in 1917, said to have been lost when Apomu was abandoned, about 1800. One of the largest bronzes known from the Yoruba.

111. MASK. Gold, hollow cast, about $\frac{1}{8}$ in. thick, $6\frac{7}{8}$ in. high, weight 3 lb. 6 oz. Ashanti, Ghana. *Wallace Collection, London (photo: Collection)*.

"Part of the treasure of King Koffee-Kalkalli of Ashanti brought from Coomassie on the occasion of the late Field-Marshal Viscount Woolseley 1873–1874. Burial mask of virgin gold. It was the custom on the death of the Chief of a tribe to bury his likeness together with the body."—Label on the object.

112. FIGURE. Hammered brass, $41\frac{1}{2}$ in. high. Fon, Dahomey. *Coll. Charles Ratton, Paris (photo: Evans)*.

Said to represent a god of war. From the treasure of Behanzin, last king of Dahomey, who reigned 1889–93.

113. Same, detail.

114. Same as plate 115, detail of head, side view.

115. FIGURE. Iron, 65 in. high. Fon, Dahomey. *Musée de l'Homme, Paris (photo: Evans)*.

Said to represent a god of war, Egbo. Probably made from old ship's iron.

116. PLAQUE: HUNTER. Bronze, $18\frac{1}{2}$ by $12\frac{5}{8}$ in. Benin, Nigeria. *Museum für Völkerkunde, Berlin (photo: Evans)*.

Such reliefs as this and the two following were put up to cover wooden columns of the Benin king's palace.

117. PLAQUE: FRUIT-GATHERERS. Bronze, $21\frac{7}{8}$ in. high. Benin, Nigeria. *Staatliche Museen, Dresden (photo: Evans)*.

See note on plate 116.

118. PLAQUE: FISH. Bronze, 17 by $7\frac{1}{8}$ in. Benin, Nigeria. *Coll. Charles Ratton, Paris (photo: Evans)*.

See note on plate 116.

119. LEOPARD. Bronze, 28 in. long. Benin, Nigeria. *Coll. Charles Ratton, Paris (photo: Evans)*.

From the collection of G. W. Neville, who was a member of the Benin Punitive Expedition, 1897. Leopards such as this were placed at either side of the entrance to the king's palace.

120. NECKLET. Bronze, 10 in. diameter. Benin, Nigeria. *Coll. Charles Ratton, Paris (photo: Evans)*.

Represents predatory birds devouring the vitals of manacled human figures.

121. REPTILE HEAD. Bronze, $20\frac{1}{8}$ in. long. Benin, Nigeria. *Museum für Völkerkunde, Berlin (photo: Evans)*.

Probably part of an entire creature. Similar figures were reported in 1701, hanging from the walls of the king's palace.

122. FIGURE. Bronze, $13\frac{3}{8}$ in. high. Benin, Nigeria. *Museum für Völkerkunde, Berlin (photo: Evans)*.

With a bell at the neck.

123. Same, back view.

124. HEAD. Bronze, $6\frac{3}{8}$ in. high. Benin, Nigeria. *Museum für Völkerkunde, Berlin (photo: Evans)*.

125. Same, full view.

126. HEAD. Bronze, $8\frac{7}{8}$ in. high. Benin, Nigeria. *Coll. Louis Carré, Paris (photo: Evans)*.

Said to be the portrait of a queen mother.

127. FIGURE. Bronze, $24\frac{5}{8}$ in. high. Benin, Nigeria. *Coll. Louis Carré, Paris (photo: Evans)*.

Represents a flute-player.

128. Same, full view, front.

129. Same, rear view.

130. HEAD. Bronze, $7\frac{3}{4}$ in. high. Benin, Nigeria. *Coll. Capt. A. W. F. Fuller, London (photo: Elisofon)*.

Tribal marks are on the forehead.

131. GIRL'S HEAD. Bronze, approx. life size. Benin, Nigeria. *British Museum, London (photo: Elisofon)*.

Wearing a coral-bead head-dress.

132. HEAD. Bronze, $13\frac{1}{2}$ in. high. Ife, Nigeria. *Coll. the Oni of Ife (photo: Elisofon)*.

This head, and the next five, were excavated in 1938–40 near the walls of the palace of the Oni of Ife. Those which are adorned with head-dresses were almost certainly portraits of early

Onis, and possibly the others were also. The striations on some of the heads may represent ritual scarification; however, they resemble present-day tribal marks of the Yoruba. The holes in the face may have been intended for human hair, as beard, but more probably for some ritual band or veil. These pieces have been tentatively dated thirteenth century.

133. HEAD. Bronze, 11½ in. high. Ife, Nigeria. *Coll. the Oni of Ife (photo: Elisofon)*.
 See note on plate 132.

134. GIRL'S HEAD. Bronze, 12½ in. high. Ife, Nigeria. *Coll. the Oni of Ife (photo: Elisofon)*.
 See note on plate 132.

135. HALF-FIGURE. Bronze, 14½ in. high. Ife, Nigeria. *Coll. the Oni of Ife (photo: Elisofon)*.
 Perhaps half of a seated figure. Probably thirteenth century. The dress is the same as that still worn by the Onis at coronation.

136. HEAD. Bronze, 13½ in. high. Ife, Nigeria. *Coll. the Oni of Ife (photo: Bernard Fagg)*.
 See note on plate 132.

137. HEAD. Bronze, 13½ in. high. Ife, Nigeria. *Coll. the Oni of Ife (photo: Bernard Fagg)*.
 See note on plate 132.

138. HEAD. Bronze, 12½ in. high. Ife, Nigeria. *Coll. the Oni of Ife (photo: Elisofon)*.
 See note on plate 132.

139. MASK. Bronze, 13 in. high. Ife, Nigeria. *Coll. the Oni of Ife (photo: A. C. Cooper)*.
 Said to represent the Oni Obalufon II.

140. DOUBLE BELL. Iron, 24⅜ in. high. Bamum, Cameroon. *Museum für Völkerkunde, Berlin (photo: Evans)*.

141. NECKLET. Bronze, 10⅝ in. diameter. Bamum, Cameroon. *Coll. Charles Ratton, Paris (photo: Evans)*.
 The elements represent buffalo heads.

142. FUNERARY FIGURE. Wood covered with copper strips, 22½ in. high. Bakota, Gabon. *Musée de l'Homme, Paris (photo: Elisofon)*.
 These stereotyped ancestor images, which are found among various tribes of the Gabon area, are placed upon baskets or boxes containing the skulls of ancestors. Their purpose is to keep strangers away. They are also called *bieri*.

143. FUNERARY FIGURE. Wood covered with copper strips, about 22 in. high. Bakota, Gabon. *Musée de l'Homme, Paris (photo: Elisofon)*.
 See note on plate 142. The basket containing skulls may be seen below the *bieri*.

144. FUNERARY FIGURE. Wood covered with copper strips, 22½ in. high. Bakota, Gabon. *Coll. Princess Gourielli, New York (photo: Evans)*.

145. BRACELET. Ivory, 4½ in. diameter. Guro, southeast Ivory Coast. *Coll. Charles Ratton, Paris (photo: Evans)*.

146. BRACELET. Ivory, 4½ in. diameter. Guro, southeast Ivory Coast. *Coll. Charles Ratton, Paris (photo: Evans)*.

147. TRUMPET. Ivory, 21¼ in. long. Upper Ogowe River, Gabon. *Coll. Paul Guillaume, Paris (photo: Evans)*.
 Curved, following the shape of the ivory tusk.

148. TRUMPET. Ivory, 18⅛ in. long. Upper Ogowe River, Gabon. *Coll. Charles Ratton, Paris (photo: Evans)*.
 See note on plate 147.

149. PENDANT. Ivory, 2⅜ in. high. Bapende, Congo (Leopoldville). *Coll. C. G. Seligman, Oxford (photo: Evans)*.
 In mask form; an amulet, worn suspended around the neck on a string.

150. HEADREST. Ivory, 6½ in. high. Baluba, Congo (Leopoldville). *Coll. Charles Ratton, Paris (photo: Evans)*.

151. HEADREST. Ivory, 4 in. high, 10⅞ in. long. Warega, Congo (Leopoldville). *Coll. Louis Carré, Paris (photo: Evans)*.

152. FIGURE. Ivory, 10¼ in. high. Warega, Congo (Leopoldville). *Coll. Alphonse Stoclet, Brussels (photo: Evans)*.
 The ivory has become much darkened.

153. MASK. Ivory, 8¼ in. high. Warega, Congo (Leopoldville). *Coll. Alphonse Stoclet, Brussels (photo: Evans)*.
 This and the following mask were used in the rites of the Mwami secret society.

154. MASK. Ivory, 7⅝ in. high. Warega, Congo (Leopoldville). *Coll. Louis Carré, Paris (photo: Evans)*.
 See note on plate 153.

155. HEAD. Ivory, $6\frac{1}{4}$ in. high. Warega, Congo (Leopoldville). *Coll. Mme. Bela Hein, Paris (photo: Evans)*.

With a cowrie shell for one eye, and originally for both.

156. BATON. Ivory, $5\frac{7}{8}$ in. high. Congo (Leopoldville). *Coll. Tristan Tzara, Paris (photo: Evans)*.

With three heads. Tribe unknown, though in style this object resembles Warega or Bapende work.

157. HEAD. Ivory, $4\frac{3}{4}$ in. high. Warega, Congo (Leopoldville). *Coll. Mme. Bela Hein, Paris (photo: Evans)*.

158. FIGURE. Soapstone, $9\frac{3}{4}$ in. high. Sierra Leone. *Fuller Collection, London (photo: British Museum)*.

See note on plate 160.

159. FEMALE FIGURE. Soapstone, 14 in. high. Mende, Sierra Leone. *British Museum, London (photo: Museum)*.

See note on plate 160.

160. HEAD. Soapstone, $9\frac{3}{4}$ in. high. Mende, Sierra Leone. *Fuller Collection, London (photo: Central Office of Information)*.

This unusually large soapstone head is typical of these *nomori*, as they are called, of the Mende country. They are found buried in the ground; the modern Mende do not know their origin, and their style is completely different from modern wood carving. Still, their stylistic similarity to certain old wooden figures carved in the *nomori* style indicates that they cannot be of great antiquity. Such heads and the soapstone figures of the region (plate 159) are used in the cult of the rice spirit.

161. FUNERARY FIGURE. Terracotta, 15 in. high. Agni, Ivory Coast. *Coll. Tristan Tzara, Paris (photo: Evans)*.

162. HEAD. Terracotta, $6\frac{1}{2}$ in. high. Ife, Nigeria. *Coll. the Oni of Ife (photo: Bernard Fagg)*.

Excavated at Abiri in 1949, accidentally, by a Yoruba farmer who was preparing foundations for a building. A number of other objects of terracotta were later found, in archaeological investigation, including the next object.

163. HEAD. Terracotta, $6\frac{3}{4}$ in. high. Ife, Nigeria. *Coll. the Oni of Ife (photo: Bernard Fagg)*.

Perhaps the portrait of an early Oni. See note on plate 162.

164. HEAD. Terracotta, about $11\frac{1}{2}$ in. high. Ife, Nigeria. *Coll. the Oni of Ife (photo: Bernard Fagg)*.

Said to be a representation of Lajuwa, an early usurper of the throne of Ife.

165. HEAD. Terracotta, $8\frac{3}{4}$ in. high. Nok, Nigeria. *Coll. Nigerian Government (photo: British Museum)*.

Found at Jemaa, northern Nigeria, about 25 miles northeast of Nok, whose ancient culture has provisionally been dated, on geological evidence, to the latter half of the first millennium B.C. It has come to light only within the past eight or nine years, through excavations in tin-bearing gravel about 25 feet deep.

166. BIRD MASK. Painted wood, 72 in. high. Bobo, Upper Volta. *The Museum of Primitive Art, New York (photo: Charles Uht)*.

The round face of the mask suggests an owl and is surmounted by a high board painted in a checkerboard pattern. It is used mostly in hunting rites.

167. FEMALE ANTELOPE HEADDRESS. Painted wood, $43\frac{3}{4}$ in. high. Kurumba, Aribinda region, Upper Volta. *Dominique and John de Menil Collection, Houston (photo: Taylor and Dull)*.

Used in mourning ceremonies to drive the souls of the deceased out of the village.

168. MALE ANTELOPE HEADDRESS. Painted wood, 36 in. high. Kurumba, Aribinda region, Upper Volta. *Private collection (photo: Taylor and Dull)*.

See note on plate 167.

169. MASK. Wood, 62 in. high. Bambara, Mali. *Coll. Mr. and Mrs. Arnold Newman, New York (photo: Newman)*.

An animal mask used by the Koré society of the Bambara.

170. Same, side view.

171. MASK. Wood and raffia, mask alone $24\frac{3}{8}$ in. high. Fang, Gabon. *Coll. Mr. and Mrs. Gustave Schindler, New York (photo: Taylor and Dull)*.

Said to be a mask for the Ngi secret society, which is based upon a cult of fire and symbolized by the gorilla. Initiates of the society kept order in the villages by detecting and punishing sorcerers and criminals.

172. CULT OBJECT. Wood, 78 in. long, 21 in. wide, $17\frac{1}{2}$ in. high. Dogon,

Mali. *Museum of Fine Arts, Houston, gift of Dominique and John de Menil (photo: Taylor and Dull).*

Ceremonial vessel for secret-society rituals. The form suggests a horse, whose trunk is a hollow box with relief sculpture on its sides.

173. BUTTERFLY MASK. Painted wood and braided rope, $51\frac{1}{4}$ in. wide. Bobo, Upper Volta. *The Museum of Primitive Art, New York (photo: Charles Uht).*

This mask is used in a dance celebrating the approach of spring, when there are swarms of butterflies.

174. FETISH. Wood covered with mud, $20\frac{1}{2}$ in. wide. Bambara, Mali. *The Museum of Primitive Art, New York (photo: Charles Uht).*

This type of fetish, known as a *boli*, serves as an altar in the rites of the Komo, a secret society important in the religious and social life of the Bambara people.

175. BIRD. Painted wood, $59\frac{5}{8}$ in. high. Senufo, Ivory Coast. *The Museum of Primitive Art, New York (photo: Charles Uht).*

Such figures, *porpianong*, are worn as headdresses during certain rituals of the Senufo initiation society.

176. RITUAL OBJECT. Wood and metal, $36\frac{1}{2}$ in. long, 19 in. high. Baga, Guinea. *Georges de Menil Collection, Houston (photo: Taylor and Dull).*

This object, called an *anok* or *matchiole*, and associated with the Simo secret society, is believed to house a protective spirit. The headpiece combines human and animal features.

177. SERPENT. Painted wood, 102 in. high. Landuma, Guinea. *Dominique and John de Menil Collection, Houston (photo: F. Wilbur Seiders).*

A stylized representation of the Gabon viper, a type of snake common in Guinea. This serpent figure, *kakilambe*, symbolizes fertility.

178. HOUSEPOST. Wood, $74\frac{1}{4}$ in. high. Dogon, Plain of Séno, Mali. *The Museum of Primitive Art, New York (photo: Charles Uht).*

Houseposts are frequently given more than utilitarian importance by being carved in the shape of symbolic figures.

179. FEMALE FIGURE. Wood, $10\frac{1}{2}$ in. high. Dogon, Bandiagara region, Mali.

Dominique and John de Menil Collection, Houston (photo: Taylor and Dull).

Probably used as a ritual implement and dating from the 19th century.

180. HORSE WITH RIDER. Wood, $27\frac{1}{8}$ in. high. Dogon, Mali. *The Museum of Primitive Art, New York (photo: Taylor and Dull).*

181. ANCESTRAL FIGURE. Wood, $40\frac{1}{4}$ in. high. Bambara, Bougouni region, Mali. *The Museum of Primitive Art, New York (photo: Charles Uht).*

This type of figure, also known as "Queen," functions as an ancestral as well as a fertility image.

182. BUST. Wood, 18 in. high. Bapende, Congo (Leopoldville). *Coll. Mr. and Mrs. Harold Rome, New York (photo: Arnold Newman).*

Presumably from a housepost; found in a riverbed, possibly the Kasai.

183. PREHISTORIC HEAD. Steatite, $10\frac{1}{4}$ in. high. Kissi, Guinea. *The Museum of Primitive Art, New York (photo: Charles Uht).*

Of unknown origin and date, such heads as this one are found in the area of the Kissi, who regard them as images of deceased ancestors and use them as implements of divination.

184. VESSEL. Terracotta, $14\frac{1}{2}$ in. high. Provenience unknown. *Dominique and John de Menil Collection, Houston (photo: Taylor and Dull).*

Shows impressions of a basket mold around bottom; use unknown.

185. STONE SCULPTURE. Steatite, $9\frac{3}{4}$ in. high. Provenience unknown. *Private collection (photo: Taylor and Dull).*

Eight human faces carved in the round; use unknown.

186. PEDESTAL BOWL. Bronze, $4\frac{3}{4}$ in. high. Ife, Nigeria. *Coll. the Oni of Ife (photo: British Museum).*

12th–15th century. The body of the bowl is encircled by a royal female figure holding a staff with a human head; a ritual vessel which was probably associated with human sacrifice.

187. FEMALE HEAD. Terracotta, $10\frac{5}{8}$ in. high. Ife, Nigeria. *Coll. the Oni of Ife (photo: British Museum).*

12th–15th century; discovered in a mound at Ita Yemoo, near Ife, in 1957.

Index

Place names and tribal names are listed, the latter in small capital letters.

INDEX

196